BREAKING INTO
FREELANCE
ILLUSTRATION

BREAKING INTO FREELANCE ILLUSTRATION

the guide for artists, designers and illustrators

Holly DeWolf

HOW
BOOKS
Cincinnati, Ohio
www.howdesign.com

For more excellent books and resources for designers, visit www.howdesign.com.

13 12 11 10 09 5 4 3 2 1

Distributed in Canada by Fraser Direct, 100 Armstrong Avenue, Georgetown, Ontario, Canada L7G 5S4, Tel: (905) 877-4411. Distributed in the U.K. and Europe by David & Charles, Brunel House, Newton Abbot, Devon, TQ12 4PU, England, Tel: (+44) 1626 323200, Fax: (+44) 1626 323319, E-mail: postmaster@davidandcharles.co.uk. Distributed in Australia by Capricorn Link, P.O. Box 704, Windsor, NSW 2756 Australia, Tel: (02) 4577-3555.

Library of Congress Cataloging-in-Publication Data

DeWolf, Holly.
 Breaking into freelance illustration : a guide for artists, designers+ and illustrators / by Holly DeWolf.
 p. cm.
 ISBN 978-1-60061-197-1 (pbk. : alk. paper)
 1. Commercial art--United States--Marketing. I. Title.
 NC1001.6.D49 2009
 741.6068--dc22

 2009004400

(fw)
media
Edited by Scott Francis
Designed by Grace Ring
Cover designed by Terri Woesner, based on a design by Grace Ring
Cover photography by Richard Deliantoni
Production coordinated by Greg Nock

DEDICATION

For Reagen, Hannah and Todd for supporting me in all my latest and future creative endeavors. Thank you.

ABOUT THE AUTHOR

Holly DeWolf is an illustrator who creates handmade experiences in paint. Ever since childhood she has been living an experimental life that led her to NSCAD University in Halifax, Nova Scotia. After five years she left with a bachelors degree of fine arts, an associates degree in design and many big plans. With an eye for detail, whimsy and color, Holly's style works well for children's publishing, greeting cards, packaging, magazines, advertising, corporate, and editorial markets. Her one-of-a-kind images are created by a process based on good creative relationships and an eye for design combined with a strong attraction to narrative. In addition to being an illustrator, Holly is an artist, writer, mentor and teacher. She has combined her interests and focuses on teaching the business of creativity and helping promote good business foundations. Holly now calls herself an illustration advocate and hopes to help make the industry a strong one for the future. She currently resides in picturesque Nova Scotia with her family.

HOW TO REACH THE AUTHOR

HOLLY DEWOLF
Illustrator, Writer and Illustration Advocate
"Creating a handmade experience."
www.hollydewolf.com
holly@hollydewolf.com

CONTENTS

INTRODUCTION
UNDERDOGS OF THE ART WORLD

"There's no need to fear. Underdog is here!"

I love underdogs. Underdogs are people who aren't expected to win or succeed. We hear this term thrown around a lot in sports—underdog competitors often achieve success even when the odds are stacked against them. Underdogs have stories to tell and a pile of experience; however, they can be misunderstood at times.

Illustrators are the link between design and fine art. We are not designers, nor are we fine artists. We work in a commercial industry that provides images for clients in a sort of lending atmosphere. Because we generally do not sell our original work outright, we fall into an odd category: We create images that sell ideas, push boundaries of the imagination, sell products, decorate and compliment text like nothing else. We are in a unique creative zone.

I was once an underdog. Not only did I face many challenges while getting started, I also dealt with many expectations from certain people around me. One day I stopped worrying. I was going to make it on my own one way or another. If this meant falling down and making tons of mistakes, that was okay with me. I hope my ever-so-humbling mistakes and experiences as an illustrator will help you in your pursuits toward your own illustration business.

Mark Twain wrote "It's not the size of the dog in the fight, it's the size of the fight in the dog," which means it often pays to be the underdog. It means never compromising. Being the underdog means sticking to your guns despite opposition. Big hype and flashy awards are not always important—underdogs just want to work. Don't believe me? Google the word

underdog. Your search will find many designers, illustrators and other creative studios that incorporate the underdog concept into their brand.

The Apple computer company was once seen as an underdog. However, the company found a big gap and filled it. It promised ease of use and a well-designed product. It did not compromise its philosophies. Apple "thinks different," and it paid off in the end.

"I think I can break the odds."
—JOSÉ FERNANDEZ

How did I break the odds? I remained focused on my idea of an ideal career. My big life goal was to be self-employed as a creative illustrator, which came down to learning from many mistakes. You may have heard the expression that doing the same thing over and over again and expecting different results is a form of insanity. When something went wrong in my mission for self-employment, I actually did the opposite of my instinctual reaction, and it worked. All those baby steps slowly added up to a career.

"Life is a vibrant paint box of experience."
—MARK BRYAN

There are moments in everyone's creative career when you stop and look back at your beginnings. As I was preparing to write this book, I spent a lot of time thinking about how I've evolved in my illustration career. People, events, education, mistakes and life lessons, plus many successes, came to mind. Writing this book was a way to speak louder and share my experiences. If I wasn't heard before—well, I would be now!

Carl Jung once asked, "What did you do as a child that made the hours pass like minutes?" Nothing occupied my time more than drawing. My first Ed Emberley book (www.edemberley.com) was like entering into another dimension. He is a creative superhero who makes drawing fun and easy. I was hooked. I pursued art all the way to high school. I knew at an early age that I was going to do something art related.

Funny Heads series: Ed Emberly inspired me to look for shapes when creating concepts.

Eventually, my big ideas led to art school—it was both a frightening and exciting adventure in learning. There's nothing like entering a school that was 24-7 learning and never seemed closed. Creative freedom was all around me. I loved every exhausting, though sometimes frustrating, moment of it. Then I graduated.

When I graduated I felt as though I was starting another adventure. This sense of adventure ended quickly when I realized I didn't know what I was doing. I wasn't ready for this type of career yet, which was a hard reality to admit after having gone to school for five years. Somehow along the way I'd gotten lost. I had to stop and get back to basics to rediscover why I wanted to be an illustrator in the first place.

My first humble mistake was believing I was too green in the beginning. I believed being new to the industry was a bad thing (or so I was told). This almost stopped me in my tracks. I soon learned that being new could be a positive thing. I just had to change my thinking a bit. Inexperience can be a good thing at times because it allows for new ideas and ways of looking at things. It's important to find the energy and excitement of starting something new. At the same time, remember to be flexible, determined and open to new ideas. We all want to succeed when getting out there; you just need to be willing to take the risk.

Another issue I had was not being able to let go of the work. I really loved everything I produced. Putting it out there felt as though I no longer had control of it. I was identifying with my work too much; I had to

learn to separate myself from the work and let it be judged. My solution came by selling work in a few galleries. It was not easy to give my work the freedom to exist without me, but I did it anyway, and in the end it was a liberating experience.

At one point I became too comfortable working at home. I developed some very bad habits. My husband worked the night shift, and that shifted my schedule as well. Suddenly my day was all over the map. I began sleeping in, which resulted in fuzzy-brained thinking and total lack of focus. I was distracted by too many things. Working at home was a new concept. We bought our first house and did a lot of renovating, and that became a full-time distraction. The end result was that I was working only when I felt like it. I couldn't get into a groove to work, and it was becoming a problem. Not having a schedule helped me on my way to being undisciplined. I got lazy!

I realized I was getting nowhere fast and that I needed to make a lot of changes. I had to learn what working at home meant, and I had to be willing to motivate myself, which involved a lot of self-discipline. I couldn't allow myself to get distracted with things better suited for the weekend. These are learned skills, and I had a lot to master, so I began to concentrate on business. I decided to tap into the left side of my brain, which had been lying dormant.

I have been asked why I kept going with my self-employment, even though I wasn't getting any work or making a living on my illustrations. My simple answer has always been that I was finishing what I had started. The need to be self-employed became a very large passion. Suddenly money, notoriety and awards were no longer the main focus. I stopped personalizing failure, rejection and the lack of experience. What became important was getting my butt out there.

I can sum up my creative life so far in three words; a handmade experience. These words describe what I do. They are my brand. The words are on my website, business cards and promotional materials, and they indicate that I have done a lot of my work on my own—not an easy way to learn, but I've done it, and now I'm living my creative dream.

What is a handmade experience? For me it is doing what I love to do with clear, defined goals, mixed with talent, to produce illustrations that sell. A handmade experience is about how I create my work with paint. It means combining all my failures and successes and having the courage to try unusual things. It also means having the ability to work outside my comfort zone. I'm pretty sure at this point that I can make almost anything work!

I wish the same for you in your illustration career.

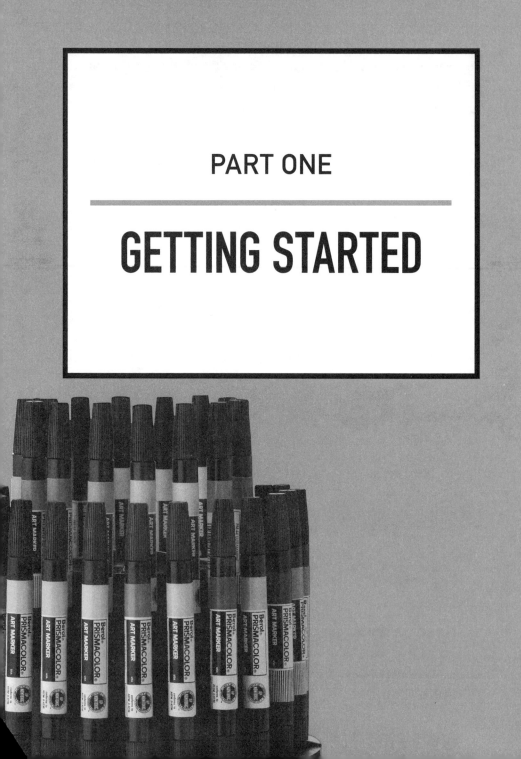

PART ONE

GETTING STARTED

CHAPTER 1
THERE WAS A HOLE IN MY EDUCATION

"The education of the will is the object of our existence."
—RALPH WALDO EMERSON

Tell me if you've heard this one before: There once was a girl who graduated from art school. She had big plans, lots of talent and a portfolio. She stepped out into the world of work and tripped and fell on her face.

The concept was simple: I was to go to art school and then graduate into a career. So I went for five long, creative and expensive years. Many have applauded me for my dedication to my education. Others have asked me if I was nuts. Crazy or not, I left with many great skills and experiences. All I needed to do was change my direction a bit.

"Graphic design will save the world right after rock and roll does."
—DAVID CARSON

I originally went to art school with the purpose of studying design. This was around the time *Ray Gun* magazine was created, as well as when the grunge era began. Design was being turned on its head again. Typography was intensely interesting, thanks to American designer David Carson—one of the most influential designers of the nineties, whose eye-catching magazine design and experimental typography centered around music, skateboard-

I have you fast in my fortress,
and will not let you depart,
but put you into the dungeon
in the round tower of my heart.

And there I will keep you forever,
yes, forever and a day,
till the walls shall crumble to ruin,
and moulder in dust away!

Henry Longfellow –
"The Children's Hour"

Illustration by Holly DeWolf

ing and surfing. I could not help but be intrigued by it all. My new school's traditional philosophies suddenly seemed stale. Rules were being broken. Computers were becoming an important tool for new ways of making design. Design seemed too clean for me. I needed an edge. The old ways were being altered, and so was my way of thinking.

"Never mistake legibility for communication."
—DAVID CARSON

I could no longer fight my natural tendency to do things my way. Everything changed when I took a course named "Making Verbal and Visual Narratives." The course was exactly what I had been looking for. It required painting, drawing and text. I was no longer a design student. I had chosen a new route—illustration.

BENEFITS OF ART SCHOOL

Despite the many challenges of attending art school, there were many good things that came my way:

1. Creative freedom
2. Access to equipment
3. Small class sizes
4. Access to a studio space
5. Help in stepping outside my comfort zone and self-sufficiency
6. Exposure to like-minded people
7. Critiques and helpful feedback
8. A trained eye and a trained hand

9. A portfolio I could use to show potential clients

10. A good background in art and design history

11. The ability to think conceptually

12. An understanding of the importance of deadlines

13. The idea of not having to live a nine-to-five life working for someone else.

There are, however, some things art school won't teach you. Steven Heller (www.howdesign.com/dailyheller) wrote "Very simply, the truth is not always taught in art school—what is unspoken could fill volumes..." I couldn't agree more. What I saw in my five years at school was that business seemed almost frowned upon. Often when I brought up questions regarding business to my professors, I was told their course did not cover that, but I could look into business classes elsewhere. To this day I believe business is a fundamental concept that should not have been missing from my education.

Here's what illustrator Holli Conger has to say about her art school experience:

"Looking back, my first two years of college were very hard and very challenging. I had two really great instructors who pushed and inspired me to do great things. My last two years, not so much. I felt as though I wasn't getting what I had gotten the first two years, so I had to make up for it on my own. I think my determination to learn and begin a freelance career (in graphic design) in my second year of college gave me the momentum I still have today. (That was ten years ago—wow, ten years. Hard to believe!) In my last year of school I did have a class that was geared toward promotion, but I didn't really learn anything. I think my instructor didn't really get it.

If I taught a class, it would have to be a class about promoting yourself as an artist, and I would be really hard on my students. They'd

have to fight for that A. It is so important to know how to promote yourself. You can have all the talent in the world, but if you aren't able to let people know about that talent, what good is it?"

Art schools should offer their students the complete package. When the artists who attend these creative institutions graduate, they should not leave the schools scratching their heads, wondering what paths to take when they come to those inevitable forks in the road. Business study—specifically for creatives (people who have the ability to create original and imaginative work)—should be a part of every art school's curriculum. Unfortunately, this is not the case, so do your research carefully when choosing an art school and try to find one that provides you the necessary business skills. You'll be glad you did.

Another downside is burnout. Art school can be contradicting sometimes because it can give you creative freedom, but then some classes actually stop the progression of that creativity. For me, this usually happened when I was told that things about my work were wrong or that my ideas were not good. How do you grade ideas?

Five years of fostering ideas, working on projects and a lot of studying took its toll. I needed a huge break after art school. I took three years off after I graduated and worked outside my field. I reeducated myself by researching the industry on everything I could get my hands on. I took business classes. I filled in the blanks.

Realizing that students need to be proactive about their education, I asked renowned illustrative designer and instructor Von R. Glitschka about the usual challenges of teaching illustration and what things he feels are left out in many art schools. Here's what he said:

"The challenge, ironically enough, is getting the students to draw and refine their work. They, for the most part, don't spend enough time on the conceptual end of things—sketching, brainstorming, etc.—so most of their final art lacks that unique or clever idea, though it may be rendered well. The first day of class, I always say to my students, 'I

can teach you good creative habits and a well-crafted creative process, but I can't teach you how to be creative.' I teach digital illustration, but many students are kind of shocked when I have them do drawing exercises. Regardless, if you want to be designer or illustrator, you should be a good fundamental drawer because this skill set will improve your ability to think through problems, visualize your ideas with more clarity and overall improve your level of work. A designer should never say, 'I am a designer. I don't draw.' That to me is an oxymoron.

"The biggest problem I see in design schools now is they are churning out what I'd call 'toolers'—students who know how to use tools well but don't have a very well-defined creative process or ability to coherently work though a concept and refine it. It's the pull-down menu generation, if you will. No one teaches 'conceptual thinking,' yet that is a core skill set needed, and many students fail to understand how to approach a project or how to think through ideas, weed out the bad ones and isolate the strong ones."

Some new creatives are opting not to go to art school at all. The Internet and technology have made this easier with tutorials, how-to websites and software that encourage self-teaching and being self-made. Many creatives just don't want to follow anyone else's rules. Calling the shots is a new thing in illustration: Instead of listening to instructors, artists are creating communities for themselves that involve relationships with like-minded illustrators. These communities help many people land jobs when they are lacking in experience and are considered too young by some potential clients. Personally, I did both. I'm schooled *and* self-educated. It worked for me.

THE ILLUSTRATOR'S ROLE

"Making money is art, and working is art and good business is the best art."
—ANDY WARHOL

How does one become an illustrator? Do you choose the job, or does the job choose you? One thing is for sure: To be an illustrator, you need to know what the career entails. I once asked a class of illustration students what they thought the definition of *illustration* was. After a long pause, I got a few answers. I was told illustration was "creating pretty pictures." Another response was that illustrators create images for design. Lastly, I heard, "It is like being an artist, except you get paid." Not a very good start.

To be an illustrator, you must understand the purpose of your industry. I describe it this way: Illustration is the interpretation of a problem that requires imagery to solve it. This imagery compliments, explains, decorates or tells a story. Fortunately, illustrators see possibilities. Illustrators think in pictures and bend imagination from reality.

ILLUSTRATION HAS MANY FUNCTIONS

1. It is thinking made visual.
2. It drives perception.
3. It's a visual break from text.
4. It compliments text.
5. It adds a personal statement.
6. It shows interesting points of view.
7. It moves the message and helps explain an idea.
8. It establishes mood.
9. It grabs attention.
10. It decorates.

How does the world benefit from an illustrator's work? We make things look good. Great illustration gets attention. Unique and original work can make business cards and book covers come to life. Good illustration

moves the message along. Images in children's books open up imaginative possibilities for young minds, like in Maurice Sendak's *Where the Wild Things Are*. Illustration explains ideas that are sometimes hard to describe in text—like in instruction manuals. Images can illustrate possibilities, such as concepts for cars and fashion. The uses for illustration are endless.

What makes a good illustrator? Illustrators need to be able to balance talent, business, marketing, promotion, quality and service, all rolled up together. Your personality, dedication and style say a lot to your clients and your creative community. You are essentially creating something that begins as an idea's blank slate. From there, you put your art to work. Your audience needs to quickly understand what you are communicating. Remember that illustration is the oldest and most versatile form of communication—there are more than a few cave walls to back that statement up. Illustration is limited only by your imagination.

IS ILLUSTRATION A BUSINESS OR A HOBBY FOR YOU?

"It's a great hobby ... You get addicted to it and want to do it more."
—KAREN BROWN

To clear up some questions, I once attended a seminar on taxation for artists. The speaker began her presentation with a question: "Are you a business or a hobby?" *That was a weird question,* I thought to myself. Of course I was a business! Everyone seemed as puzzled as I was.

Basically, she wanted to know how we saw ourselves as a business. Did we know how to make a living from our work? Did we know how to keep on top of our paperwork? She wanted to know if we really knew how to run a studio as a self-employed artist, illustrator or designer. Turns out we all had a lot to think about.

Many great creative careers begin as hobbies. It is very appealing to start a business doing what you love to do. Money isn't always the driving factor; in some cases money isn't important at all. I know quite a few

people who have given up high-paying jobs to do something more important to them. For many people, working for themselves is their dream.

Some say an illustrator isn't an illustrator until someone discovers her. I disagree. You can be an illustrator in business or as a hobby. One makes money, and the other does not. Money does not determine whether you're in this industry. Rather, what determines an illustrator is a combination of creativity, talent, business and determination. Caring about this industry makes you a part of it. Add a sprinkle of luck and you have a winning mix. Keep in mind that luck usually shows up to those prepared for success. The other thing to keep in mind is that careers do not happen overnight. Careers evolve and grow when managed properly. Smart work habits will get you from point A to point B more quickly.

You are a "hobby" if you're creating work with no intention of getting that work out there. You are not working with a future client in mind or a future audience.

If you're having trouble letting go of creative control but have the desire to be an illustrator, you are in conflict. To be a "business," you need to be able to step out of the office and away from your desk. Clients do not knock on doors—that is your job. No one is going to send out a search party for you.

Your illustration career will continue to be a hobby if:

1. You're not proactive about getting work.
2. You're not actively getting your work out there.
3. You're missing opportunities right in front of you.
4. You're letting fear take over.
5. You're not sure who your market is.
6. You don't know whom you would like to work for.
7. You don't see yourself as a business.
8. You aren't actively seeking new markets for your work.

Business is actually the biggest priority when a person is starting out as an independent illustrator. Your talent comes naturally, so why is business put on the back burner? Why are illustrators so reluctant to discuss business? Have you ever seen a "successful" illustrator and asked yourself how they got to be successful? Most likely it was because they threw themselves in front of prospective clients and didn't wait for work to come to them.

I think, for some of us, that business is put on the back burner because of a combination of not being around business growing up and not having the opportunity to take business courses in art school. Often we get caught up in creating, and business falls to the bottom of the priority list. Discussing ideas is more fun than discussing boring old business stuff. It's easy to complain about business and how things aren't going our way instead of finding a solution. Business avoidance usually happens when we don't have the confidence to mingle both ways of thinking—creative and business—on a regular basis. Many illustrators focus on what they do best: illustrating. Does this make them hobbyists? It doesn't have to.

It's nice to think there's some magic formula to getting started. Well, here it is: Hard work, visibility and persistence. Remember what lured you to this industry in the first place: You wanted control over your own career. You wanted to use your specialized talent and get paid for it. You wanted to be your own boss.

MYTHS AND OTHER MISUNDERSTANDINGS

With any industry there are always many myths and misunderstandings. Here are some illustration myths I have encountered on a regular basis during the past ten years:

1. **Illustration is dead:** Illustration is not dead; illustration has changed. The glory days of illustration may be long gone, but we have a new industry on the rise that involves many new technologies and talent all over the globe. Blogs, websites and online forums have changed how we present ourselves to the world. Sending a prospective client a link to your website is a whole lot easier than dropping off a portfolio. The system has changed. Things are being made easier. Old ideas are being pushed around. Illustrators are controlling the industry and finding work in different ways.

2. **Illustrators do not know anything about business:** Not so. Many illustrators are making a good living from their work because business is the most important aspect of what they do. I asked Claudine Hellmuth about the biggest myth she encounters about business, and here's what she had to say:

 "I think one of the myths held by other artists—as well as other, nonarty people (I call the nonart people "civilians")—is that when you are an artist you don't have to be or are not a good business-person. I look at my art as a business, and I enjoy the business aspect of [my art] as much as any other aspect of working as an artist. I love reading business/marketing books even if they are not directly linked to art."

3. **Illustration is like fine art:** Fine art tends to be a little freer when it comes to ideas and the final outcome. Fine artists do not typically create with a client in mind but rather focus on self-expression. Some fine artists do consider the client if they have been commis-

sioned for a specific piece, but they have much more creative freedom than an illustrator. How artists sell their work is also different. Many sell their work online, in galleries, at art fairs or in art shops. Illustrators generally keep all rights to their work and sell copies of it. We are essentially lending the use of an image to clients. Fine artists generally sell their work outright. Some illustrators see themselves as both illustrators and fine artists—they do work for clients and also have shows in galleries.

4. **Digital illustrators do not know how to draw:** Wrong! To get to the digital part means there must have been some idea laid out somewhere. Many digital illustrators lay it out on paper, scan it into the computer and add their own personal digital touch to it. The computer is just another tool to create work with. While the outcome can be different, the basic fundamentals are still there.

5. **"My sister's boyfriend's employer's wife just wrote a children's book. You should illustrate it. I'll get her to give you a call, okay?"** You most likely will never hear from this children's book author. I cannot tell you how many times in a year I hear suggestions like this one. Even if the person follows through, publishers pick their own illustrators. The writer rarely has any say unless they are self-publishing. If you choose to work with a self-publisher, insist on a contract. Cover your butt.

6. **Illustrators are starving artists:** False. The illustration industry would not be around as a career choice if no one were making a living at it. Why would anyone bother? But if you do not work at it daily, i.e. get yourself out there and think of yourself as a business, you'll be starving, all right.

7. **"Why don't you draw things more realistically to resemble photographs?"** It all comes down to style: Some of us see things differently. Our personal vision makes our work unique. Technical or

medical illustrators represent things on a more realistic level; some medical textbooks need to represent imagery in an almost photographic style, as opposed to children's book illustrations, which can be more whimsical in style. It all depends on how you want to work and what types of clients you want to pursue.

8. **Illustration is just a hobby:** We expect to be treated as a business and to get paid for our time and work. We would never expect a plumber or a mechanic to do their work just for the fun of it. They would laugh us right out of the room!

9. **Illustrators are right-brained thinkers only:** Not necessarily. Many of us use both sides equally. This may be natural for some; others may require practice. Think of using both sides of the brain as creativity meeting an organized sock drawer. You are mixing logic with your playful side.

10. **"Illustration? That's design, right?"** Illustration is closely linked to design. Many design principles can be applied to illustration, especially if you are a digital illustrator. Some illustrators work in both industries.

11. **"This project shouldn't take any time, right? How about getting that back to me in an hour?"** Yeah, right! Illustrators rarely work that quickly. Many of us choose quality projects over just any project. We need a certain amount of time to work through ideas and concepts to get to a finished piece. You should never take on a job that compromises your business philosophies, quality and style. It's just bad for your business.

12. **Creative people are miserable:** I have never felt miserable while in the flow of creativity; it's an oxymoron. The myth of the suffering artist is a romantic ideology. The perfect example is van Gogh. As you know, he was not at all kind to himself. He was isolated, cut off

his ear and later took his own life. Did he do this because he was an artist? Not quite. He had a whole set of issues in play way before he was a painter. In a nutshell, he was hard on himself. But would he have been happier if he had been an accountant? Probably not. There are miserable people everywhere doing all sorts of jobs. All you have to do is turn on the TV or go to the mall to see that. How many miserable people are artists? Not too many. For some people it is easier to be pessimistic than to be happy and hopeful. For others it is easy to criticize a career they simply do not understand.

SOBER EXPECTATIONS

To be sober is to have a clear view of the way things actually are. Getting a gig to illustrate the cover for *The New Yorker* probably won't happen right away (though stranger things have happened). Working hard at illustration could result in getting your dream gig down the road, but you have to start somewhere.

Expectations for yourself need to be based in your own reality. Sometimes when we look to other illustrators and see them doing what we want to do, we want to know how they got there. What steps did they take? Try to turn that focus onto yourself. What are you doing every day that will benefit your business? The comparison habit can sometimes leave us feeling like we don't measure up. Stay in your own zone of reality, not someone else's.

Expectation can be defined as "the act or state of anticipating something about to happen"—in other words, anticipating something we look forward to or a prospect of something good for our future. To me the future of illustration looks good. I see many innovators, movers and creators. I see a lot of illustrators creating online communities and networks. Illustration is great again, and it will be as great as long as we work at it. I expect illustration will grow and change like it has always changed. I expect illustrators soon to take this industry back and mold it into a business that will benefit everyone. I expect this community to stick together.

THE CREATIVE HABIT

"We're very thankful to all of you out there for continuing to let us play in our corner of the sandbox."

—JOEL COEN

Creativity is the foundation of any great illustration career. This is why illustration is such an appealing business for many of us. I often think, *I'm getting paid to think and create stuff?* That's when I pinch myself.

RECOMMENDED READING

Check out Keri Smith's *Living Out Loud: Activities to Fuel a Creative Life.*

There is a heavy demand for creativity. Problem solving and creative business sense are desirable qualities for an illustrator to have. Illustrators work in an industry that requires them to be "on" at all times, but being creative on command is easier said than done sometimes. You need to have a complete package of skills. Creating your own system of thinking saves time, allows you to play and gets the job done. It all comes down to the creative habits you keep.

Your creative habits start early—on the floor with a box of crayons. Hard to believe you can turn childhood play into a career. The goals are basically the same then as now: to have fun, think big, make stuff and put that stuff on display. In essence, illustration is a way of acting on a creative idea to make that idea visual. The big difference between childhood play and professional illustration is that illustrators create images for clients and get paid for it. It's a business.

Creativity is often on the fence between luck and play. Creativity needs to be cultivated in order to grow. Mix in a challenge and you've got something to work toward. You also need the ability to be creative under pressure. Let's

say it's 1 A.M. and you're feeling exhausted: If you can keep going, you've passed the ultimate test to the playful side of your imagination.

This industry has ups, downs and lots of deadlines. Developing good creative habits will help you stay productive on a regular basis. Good habits will also keep you out of that dreaded zone called "creative block."

So what is a creative habit? A *habit* can be defined as "an activity done without thinking." *Creativity* can be defined as "using your imagination to produce new things and ideas." Combine the two and you get a natural, imaginative state that results in original products or ideas on a regular basis. A creative habit is your own system for generating ideas quickly. This automatic thinking style comes from a deeper understanding of your true creative nature.

RECOMMENDED READING

Keri Smith's *Wreck This Journal* is a great book for inspiration and keeping yourself motivated.

Good Creative Habits

Keep an Idea Journal

An idea journal is an important tool to keep near you at all times. I never leave home without one. Ideas are sneaky; they can pop up at the strangest moments. It may be 3 A.M., but your creative brain doesn't know that. You've got to be able to jot those ideas down quickly before they get away. Once they leave your brain, it's hard to find them again.

There isn't a right or wrong way to approach a journal—just write it down. Glue in snippets of doodles, write notes and add clippings from magazines or ideas written on napkins. This helps ideas grow. One idea may lead to many down the road. Ideas are contagious. Think of your

idea journal as an infinite idea generator. You can recycle thoughts and tidbits for many projects.

It's not a bad idea to have many journals. I have one in my bag, one in my bedroom, one in the office and one in the living room. Writing down tidbits is a big part of my day. I treat every idea with the potential to be something. In fact, this book came from an idea I jotted down five years ago and kept adding to. Then one day I picked it up, and it seemed it was time to put the idea out there.

Create an Image Binder

Sometimes you need reference material for certain projects. A binder full of different images can help greatly when in a pinch. Good places to find images are flyers, magazines, junk mail or packaging. Instead of recycling these right away, try chopping out what is useful. One thing to keep in mind: It's never a good idea to put other illustrators' work into your binder as a reference. Looking at someone else's completed work can inhibit your own creative process. Instead, collect images that inspire you (these can be sketches to unfinished projects).

A NOTE ABOUT COMPING IMAGES

Comping is short for "comprehensive rendering," which is often done when pitching ideas to clients. Use care when comping or downloading images for reference as not to plagiarize another illustrator's work.

Play With Opposites

Combining opposites or unrelated things can exercise your brain. Try to come up a relationship between two things off the top of your head. Some similarities may be obvious. For other combinations you may need to play around with a few ideas.

Read

Words and word associations can pop ideas into your head very quickly. Magazines are a great source for this because they use buzzwords, taglines and headings that can be very descriptive and visual.

Music

Music lyrics are another great source of inspiration. There's something very simplistic about music lyrics, depending on what you like to listen to, that can create lots of visual cues. A good source to look up song lyrics is www.letssingit.com.

Get a Thesaurus

These handy little references are all about mingling words. Thesauruses often give a definition along with examples of phrases and sentences. Synonyms help you look at a possible idea in another way. Using a thesaurus is basically wordplay. Let your left and right brains duke it out.

Start a Quote File

Snippets of thoughts, ideas or observations can be very visual. For example: Elias Canetti said, "In eternity everything is just beginning." This particular quote caught my attention back in art school. It makes me think of an eternity symbol, which is quite nice in its simplicity. Here are a few websites to get you started:

http://en.wikiquote.org
www.quoteland.com
www.coolquotes.com
www.quotedb.com

Try Writing

Make your own verbal narratives and work backward. Create visuals from your own text. If you like to write, create images to go along with the words. Create text from illustrations or from doodles to make some sort of story. Sometimes this is how children's books happen.

Stop Overthinking

When we force ideas, the end result is usually frustration. Have you ever heard the expression "Think less so you can do more"? It's amazing what can happen when we relax and get out of our own way. Remember to play; spontaneous actions can break a slump. We all have a bad habit of taking things too seriously. We spend too much time in our heads. It's often a good idea to pull back and start over. Find a happy medium.

Have a Creative Break

I try to do little hour-long projects every day as a break from my assignments. I call this time my creative hour. The concept is simple: Create something spontaneous in an hour. The result will be fresh eyes and a fresh perspective. The nice thing is that sometimes these ideas can find their way into some of my work.

Another way to break things up is by adding some humor to your day. Laughter has a funny way of relieving stress. A touch of comedy will help put you into a more positive frame of mind.

Push the Idea Around

You can change the idea, flip it or chop it up. Change the color or size. Don't get discouraged if an idea isn't working at first. Don't dump it—tweak it. Look at the idea another way. Do the opposite. Test it. Experiment with it.

Ask Yourself Lots of Questions

Do you always start a project the same way? If you normally work big, why not try working small? Do you always use five colors? How about using three colors instead?

Research

Learn about your subject. Go to the library. Hit the mall. Go online. Read. The more knowledge you arm yourself with, the better. Creativity is also an exercise in learning. Your brain is a sponge—fill it up with good stuff. You never know when you may need that information down the road.

Show Up

Woody Allen once said, "Eighty percent of success is just showing up." Sit down and get to work. A dot turns into a line, and that line becomes a doodle. One word will lead to a sentence. Just start.

Break Your Own Rules

Step away from the computer and get back to basics. Get out the paint, some junk and some glue. Wreck your ideas. Create without a plan. Thomas Edison wrote, "To invent, you need a good imagination and a pile of junk." It's good to loosen up and try new ways to create things because it's easy to get too rigid in your style of working. Letting go and working the opposite of how you normally work can really help you discover new skills you may not have known you had.

Tackle a Weakness

Resolving creative issues puts those issues to rest. The best way to stop that inner nagging is by conquering the problem. Not good at drawing hands? Practice until you have a system that works for you. Had a typo on your last promotional postcard? Redesign it. Breaking through a creative barrier will be another personal success for you.

Go Prospecting

You should always be on the lookout for new ideas. Never feel finished—there will be more assignments on the horizon and new promotional ideas you'll need to get out there. Ideas can be like an archeological dig. Start at the beginning and look back at your idea journal.

So, What Can Go Wrong?

We lose creativity for a number of reasons: We get into stale routines that can sometimes stifle our natural curiosity. We let life get in the way. We worry about the outcome. We're told creativity isn't important. Or, worse, creativity is taken out of schools. Oftentimes practical thinking gets the attention, while creativity is treated as a dispensable luxury. When educa-

tion budgets get tight, what are the first programs to go? The fun ones—art, music and gym. When recessions hit and business budgets get squeezed, companies often resort to using clip art instead of hiring an illustrator. These are unfortunate realities we face as creative illustrators.

Another reality is getting stuck in a creative slump. Slumps are big freeloaders because they can suck the ideas right out of your brain if you aren't paying attention. Some freeloaders are as follows:

1. **Negative feedback:** Creativity is helped along when it's supported. The reality is that while many will love your work and ideas, there will unfortunately be some who won't. Focus on the positive feedback. Writer and illustrator Keri Smith once wrote, "Keep forward movement." This is especially important to do when we face rejection.

2. **Lack of time:** Having to come up with ideas under tight time restraints is the worst way to try to be creative. Our brains have a funny way of rebelling while under pressure. Rushed creativity can leave you feeling beaten down—those deadlines are looming, and that clock is ticking faster and louder. This is usually when people start making mistakes, and those mistakes can be costly. You need to set aside certain amount of time for proper productivity.

3. **Fatigue:** Feeling exhausted takes the creative spirit out of things. What once seemed exciting makes the tired mind feel like it needs a vacation. A rested mind finds assignments fun. When you're tired you can miss obvious solutions. Ideas happen with a prepared mind. Those six cups of coffee will only work to a certain degree! What may have taken two hours to complete may end up taking longer if you aren't in the mood for proper creativity.

4. **Isolation:** This is a large trap that's easy to fall into. Working at home can be a solitary exercise, but idea generating doesn't have to be. Hook up with like-minded creatives for coffee. Join an illustration group online. Feedback is very important and often overlooked.

5. **Noisy environments:** As illustrators we need to feel productive, have purpose and enjoy feeling creative. This is often hard to do when the dog is barking, the baby is crying or someone is playing his music too loudly. Real focus requires a comfortable atmosphere in which you are at your best. You must pay attention for creativity to come in.

6. **Complacency:** Getting too comfortable can have its downsides. Your illustration work is supposed to be a business. That means turning off the TV and focusing on the tasks at hand. You have a certain amount of freedom when working at home, but there is a limit. Remember that freedom needs to mingle around projects and running the office.

7. **Bad dialogue with yourself:** Nothing kills an idea faster than negativity. Be kind to your ideas. Be kind to yourself. Stop the intrusive, negative chatter in your head. Develop good positive-thinking habits. In a funk? What language can you use to get out of it? What activities can you do to get back on track? What you believe is what you are. Remember, whether you think it is or it isn't, you are right!

Illustration is definitely an uncommon professional adventure. It is a small industry that requires a lot of skill and talent. No one said it was going to be an easy career choice—being an illustrator requires a certain amount of fearlessness and tenacity to be able to stick it out even when the money isn't coming in. Illustration is the route that says, "Visual career: This way." We get to play with our inner creativity while learning daily. We push ideas and change the way we see the world around us. I cannot think of a better career to be in.

CHAPTER 2
HOME IS WHERE THE CREATIVITY IS

"So, that's it, I'm a freelancer! I will now grow a beard,
work in my pajamas and watch bad daytime television.
And I will walk my daughter to school."
—EDEL RODRIGUEZ (WWW.EDELRODRIQUEZ.COM)

Traditional business thinking does not always work for illustrators. The usual fundamentals of business education focus on how to run a business—leaving out the whole section on how to run an office in our homes. Home businesses sound easy in theory to those who work outside the home. In actuality it is a balancing act many learn by doing.

Working at home means having a certain amount of control. I have this need to control my time and career and not let someone else decide that for me. I have not always been self-employed, so I can appreciate the out-of-home jobs and tireless hours many people experience every day. The worst job I ever had was one I took during art school. I painted lawn ornaments for a summer. And, yes, you are correct, that sucked. But the pay was surprisingly good. It was a small sacrifice I made to help lead me to where I am today. So if you have just left a job or are combining self-employment with a second job, I applaud you. It takes a certain kind of person to do both. It takes guts to make the big leap and work

on your own. Self-employment is not for everyone. It is a huge exercise in courage and patience.

THE CONVENIENT COMMUTE

A home office means different things to different illustrators. For some it means working in a robe, and for others, like myself, it means a very delicate balance of work and kids. I use the word balance loosely because some days are better than others. To be honest, working at home feels like two full-time jobs. Time becomes a precious commodity when you mix in diapers, piles of laundry and, above all, your illustration work. That romantic idea of sitting in a leather-backed chair while listening to Mozart sounds nice. The sounds I often hear are "SpongeBob" and my kids running around. That is my reality. I try to keep it productive, happy and fun even though it can be quite a handful of activities at any given moment. My house is an official jungle gym!

Working at home is tough for many. This is because your office is in your home. You are adding another routine. Normally home is for rest, recreation, eating, sleeping and taking care of children or pets. What was once personal space for downtime is now a place of business. The home office can turn a house literally upside down if you aren't careful.

Working-at-home rule of thumb: Adjust, adjust and then adjust some more. This will be a constant in your adventures of self-employment. Finding a system that works for you is the true test to working at home as an illustrator. Your own unique system of experimentation will have to cater to your own needs. Some days everything will work out, and some days you will simply have to adjust to whatever is going on. Working at home means trying to maintain your creative business while at the same time maintaining house duties that need to be done. It's all part of the package. You call the shots, so you need to work timely and effectively.

Being your own boss means you often have to get tough with yourself by saying no to the trip to the beach if there's a deadline looming. The

upside is you have a certain amount of flexibility. Get the job done early and you can spend the next two days at the beach!

Your short trip to your office means you must always show up and get down to work. There's this idea that many of us go to our home office in our robes while wearing fluffy slippers. Sure—why not? Being at home has a certain amount of casualness to it. Scott Adams, the creator of *Dilbert*, works at home and doesn't bother to get dressed at all. Ironically, he created a comic about the corporate world he'd gotten fired from. His job now pokes fun at that nine-to-five life. He admits to overworking but enjoys the isolation and the twenty-second commute.

Getting down to work for me means showering, eating, grabbing a coffee and getting dressed (not always in that order). It helps put my brain into the mode to work. I just can't seem to wake up when I'm in my pj's and my hair is defying gravity. Early on in my career, working at home was casual to the extreme. Why get dressed up? I'm at home, so why bother? Funny how I didn't get much done.

I have been warned that some clients know when you're sitting in your pj's slouched and half asleep. It has something to do with the way you project yourself on the phone and online. When you're "on," it comes across to your audience. As for me, I may be at home, but I feel I need to project a certain image to maintain professionalism. Wearing jogging pants means off time; being fully dressed means work time. My advice: A bit of structure helps you get into a professional and creative frame of mind.

The illustrator Andi Butler says she has mixed feelings about working at home. "I love being at home and working at my own pace. I'm with my boys and have been able to experience everything from the moment they were born until now (they're getting to be elementary school age). However, I used to work in a corporate environment, and while stifling most times, one also has camaraderie with fellow artists in the same boat. And you're with other creatives all the time. Sometimes working from home can be alienating if you aren't careful."

UPSIDES OF WORKING AT HOME

The fastest commute ever: I call it my convenient commute. There's no need to worry about traffic and time wasted sitting in a car. Plus, the money you might otherwise have spent on gas can now be used for something else. In fact, my husband and I choose to own only one car. I often bike my daughter to school when the weather cooperates. I get exercise and time to think, plus I'm doing my part when it comes to the environment. It's amazing how much we save on extra gas, car payments, insurance and car maintenance. Cars are never kind to your bank account.

Freedom: You can work at the times of the day that are best for you. You do not need to ask for sick days, vacation time or justify leaving the office if you need to leave early. You can just go. You decide your time, your work and your worth. You also get to focus on what's important to you instead of someone else's "to do" list. As a bonus, there's more time with the kids, loved ones and other creative endeavors.

You control the money: You get to decide what projects to do and how much work you can handle at one time. Working at a home office means low overhead. The money is basically yours, minus the bills and taxes. Instead of securing a contract for a company that will make that company thousands, you can secure a contract all by yourself and reap the rewards. And when it comes to taxes, you can write off a certain amount of your business expenses.

Flexibility: If the toaster blew up this morning, you can go get another one now instead of waiting for the weekend. You get to run errands when the world is quiet. You can work early and spend the rest of the day doing something fun.

You're the boss: You get all the credit. There is no outside pressure forcing you to be busy. I know many self-employed people are proud to be unconfined from working for someone else. If the idea of being the boss seems odd to you,

spin it so that your kids are the bosses! My kids call the shots. If I don't work hard and efficiently, my kids could lose out on things they need and quality time with me.

Every day is casual Friday: No suits or high heels means total comfort while at your desk. Plus, it's amazing how much you can save when you can cut your wardrobe budget in half.

Better quality of life: This isn't a concept that can be measured directly; we base it on how we feel physically and psychologically. Physical benefits may be improved health, better sleep and less stress. Psychological benefits may be the pleasure and pride you get from doing what you're meant to do. Following your dreams and talents can help you feel complete.

AND NOW FOR THE DOWNSIDES ... (YOU KNEW THEY WERE COMING!)

Little job security: Sometimes there will be a lot of work, and sometimes not. All expenses are on you, including health and dental expenses and computers on the fritz. No paid sick days, vacations or paid time off means you need to be careful how you spend your money for those "just in case" moments. Have a backup plan.

Juggling many roles: Running an illustration business from home often means being a mix of illustrator, marketer, bookkeeper, housekeeper (for lack of a better word), accountant, promoter and organizer. It all rests on you.

Deadlines: You must work even though you might want to be digging in the garden or going to that antiques fair. Sometimes the work never seems to end (the client wanted it done last week). If you're disciplined, you may be able to

reward yourself more often. It's easy to slack off if you've been invited to go on someone's boat or to the coffee shop. Just make sure you can make up that time later. (It's always hard to pass up a good cup of java—come on!)

Isolation: Can you stand yourself all day? Can you push forward even though you feel you've been cooped up in the house all day ... all week? Can you be your own best friend even when it's been a long workday? It's nice to be able to bounce ideas off someone every once in a while. Try not to let yourself become a creative hermit. Go out for coffee or to a networking meeting. Look for some sense of camaraderie. Avoid loneliness.

Mess: It's easy to get too comfortable when working at home. You may find yourself not dressing the part (as mentioned earlier) or letting the mess pile up in the house. It's important to look and feel good. Sitting in your pj's day after day does not say "self-employed professional." Treat yourself well, and your self-esteem will stay in check. Also, you need to project a professional image while on the phone. For instance, screaming kids or a barking dog will not help you convey the image you want to convey. It's easy to let things go. Mess is a regular, daily event: Set aside time to combat it. It's very difficult to concentrate when you can't find anything, let alone your desk.

Distractions: Sometimes family and friends don't understand that you're working simply because you're at home. Your friend may ask you to help move her to a new apartment. Someone else might need you to help them with an errand or to babysit. Someone may call at a busy time that puts your schedule off. Plus, there are other distractions, like the TV, household chores that are piling up, surfing the Internet and the boredom of always being at home. How do you get yourself back on track? If you have a deadline, you'd better think quick!

Overworking: There's a danger to overworking and not being able to shut off and get out of the studio. It's easy to stay up till 1 A.M., so you must learn to define work time and off time. Repeat after me: "All work and no play makes you

a really dull illustrator!" Try to maintain a firm but flexible schedule. Block out times you need to exercise, spend time with the kids, walk the dog or just stop and look around. Self-employment is supposed to resemble a better life—make sure you have one every once in a while.

So what does working at home have to do with being an illustrator? No matter how you look at it, business is part of this industry—it's a huge part! The majority of illustrators seem to work at home, which means we need to be very creative in how we get things done efficiently. That creativity needs to mingle nicely with the left side of our brain. Even seasoned professionals need to keep themselves focused while at home. It's all about setting up your own system—which I will discuss in this chapter.

YOU'VE GOT TO HAVE SPACE

"If a cluttered desk signs a cluttered mind, of what, then, is an empty desk a sign?"
—ALBERT EINSTEIN

No matter where in your home you decide to work, you must have a space that works for you. It could be a dining room table, a studio off your home, an attic space or a spare room. Make sure it suits your needs to some degree.

THINGS TO CONSIDER

• **Good lighting:** High-quality lightbulbs and natural light are definite assets to your space. Harsh shadows can make your work turn out differently. Dim light can tire your eyes.

- **A comfortable chair:** A chair that supports you properly is a must. A swivel chair designed for a desk setup is best.

- **Organization:** Shelving, baskets and a filing cabinet will be your best additions to your office. Throwing items in baskets saves time because you can organize it later when you have a moment. A good filing cabinet is needed for bills, invoices and tax information.

- **Two workstations:** It's a good idea to have a table for your computer and a table for production. Give yourself room to create.

- **Sound:** Music helps keep you moving. It's also very sensory, so it may help stimulate ideas.

Work-Space Options

There are many space options, such as rented spaces, communal work spaces, shared studio spaces and an office in your home. Make sure you consider the benefits of each option so you can achieve the work space that works best for you.

Home-Office Benefits

Having a home office is basically free space if you can afford giving up a room. This may also be a great solution if you have kids. There are several benefits: You're in control of your own space, you aren't paying extra rent, low overhead, a quick commute and flexible work hours. You can be as comfortable as you need to be.

Rented-Space Benefits

Renting a space may help you feel more like a business. There is a smaller chance of overworking, as closing up the shop may help turn off the working side of your brain more easily. This space can also be utilized

for other things like seminars, classes and networking shindigs. You'll be able to have clients visit without them walking through your house to get to your office.

Shared-Office Space

With shared-office space, you get to cut the cost of rent in half. Working with someone else can help you avoid that isolated feeling you may get working from home. A shared environment may help you feel more productive and could lead to more work. If your space is in a design studio, the studio could need your expertise every once in a while. Plus, you might gain access to equipment you may not have otherwise had on your own.

Communal Work Spaces

Communal work spaces often combine many types of creative industries under one roof. These spaces could help you mingle your way into a creative community that could lead to more work, seminars or classes. They could also provide you greater access to equipment or equipment rentals. California-based illustrator and graphic designer Kimberly Schwede says, "I just found an amazing communal work space where other creatives such as photographers and architects work. I find it more inspiring to work around other people versus alone in my home."

TEN HOME-OFFICE PROBLEMS

1. Endless disruptions: You are in a constant stop-and-start motion that leaves no time to actually follow through on any desired task. Are there busy children running around your office? This could be the time to shut the door and make it a kid-free zone. Got a noisy roommate? Ground rules or relocation might help. Let everyone know you're working and cannot be disturbed right now. Let them know when you intend on leaving the office. Working at home requires a cooperative effort from everyone you live with.

2. Losing track of time: Not realizing what time it is and where the time has gone is a sign you've been working too long. This is especially easy to do when your office is at home and you don't necessarily punch out for the day. If you're wondering what day it is, you need a much deserved break or a mini vacation.

3. Too much coffee and poor diet: Working from home may offer certain temptations, such as eating whatever you want, whenever you want or making a cup of joe any time you like. An improper diet can make you irritable and can interfere with your production. Also, try to decaffeinate every so often. Coffee helps, but it's no replacement for sleep or eating.

4. Middle-of-the-day slumps: If you feel tired, distracted and uninspired to work in the middle of the day, then don't! Going against the creative grain will only make you feel worse. Perhaps breaking things up and recharging your brain with a nap, a walk or something mindless could be what you need.

5. Too many distractions: Got a TV in the office? Got an enticing, comfy chair in the corner with your name on it? Make your space fun, comfortable and functional, but remember not to make it so comfortable that it becomes a recreational space.

6. You cannot find your desk: Make it a ritual to clean up when you're done for the day or week. Dedicate time to dealing with all the papers, bills and other bits that make it to your desk. It's amazing how paper takes over a space; it almost multiplies when you're not looking!

7. The office is doubling as another space: Is your office a dining room? Do guests take over your space because it's also doubling as a guest bedroom? Relocate your space or come up with another solution so you can get the time you need.

8. Office furniture is working against you: Is your desk too small? Does your office chair make your butt fall asleep? Maybe upgrading will help. Hand-me-down furniture can wear out quickly. Using the wrong type of chair that doesn't

help your posture, knees or butt will make working an uncomfortable experience. Think of it as an investment in your productivity. Plus, you can write it off as a business expense.

9. You aren't getting any work done: Are there too many other things to do that take attention away from your pressing work? Perhaps laying down a fixed schedule you and everyone else can live with will help. A change of working hours could help you focus better. Trying to work when the household is at its busiest will not make your job any easier. Consider working when the house is quiet.

10. Your chosen space just isn't working out: If your space is too cold, too dark, too cramped or does not inspire you to work, consider an office makeover. Redecorate, add some color to the walls or add some mirrors to project space. Eliminate the clutter and extra furniture. Once again, if worse comes to worse, a relocation may be needed.

Creating the Perfect Office Space

What would be your ideal office space? Think of its usage and function. Make your space fun. Will clients ever see your space? If so, keep it organized. Make it inspiring and interesting. Try to add color, images and some decorative touches. I have an "inspire wall" on which I have pictures, cutouts and snippets of things I love to look at. Your inspiration could be fabric swatches or greeting cards. You're a creative person, so create your ideal space. Add some life to your office with plants or a fish tank. Do you need that designer chair? Maybe not. Use what you have or alter existing furniture. We may not all be able to afford something out of a Pottery Barn catalog, but we can come up with something just as good, I'm sure.

To make a space functional, you should adopt a paper-sorting system. This system will help with assignments, invoices, mail and payments re-

ceived. Having a filing system that keeps everything in order will help keep you sane. My approach involves having things within easy reach so I can find them quickly. A good rule of thumb: If you had to find it quickly, could you? Also, if you're in the habit of losing things, you need to make organizing a priority. It isn't fun asking your client to resend important paperwork because it disappeared. Saying the dog ate it will work only once!

Another thing to consider is comfort. Allow for good posture and take care of your eyes and joints. Your eyes should be about 24" to 36" (61cm–91cm) from your computer screen, and the top of your monitor should be below or at eye level. Both feet should be able to be planted flat on the floor. Your chair should be in a slightly reclined posture to help reduce lower-back pain. You might want to have your working hand in a comfortable position so as not to create repetitive strain. Take care of yourself and doing so will help your creative efforts in the long run.

RECOMMENDED READING

Illustrator Linzie Hunter created a great blog called "On My Desk," where artists share images of the stuff on their desks.

www.on-my-desk.blogspot.com

CREATING MORE TIME

"Everything happens to everybody sooner or later if there is time enough."
—GEORGE BERNARD SHAW

Be honest. When was the last time you were able to do what you wanted to do without interruption? It would be nice just to focus on work and

nothing else, but then there's this thing tapping everyone's shoulder called reality.

It's amazing how time becomes so important when we grow up. As kids we had all the time in the world to make messes and fiddle around. We did whatever sprang to mind without a care. When you're self-employed, time seems to disappear in the blink of an eye.

RECOMMENDED READING

Lee Silber's *Time Management for the Creative Person* offers original, resourceful and innovative time-saving solutions.

Lee Silber wrote that the biggest time-saver of all is as simple as saying no. Brilliant! I have tested this simple yet effective theory, and it works. The concept of saying no does not come easily, however. We're taught to be agreeable and nice and not to put anyone out. This concept takes a lot of practice. You may need to say no if:

1. You're already overcommitted.
2. You're tired of interruptions.
3. You're getting complaints about how much time you're working already.
4. You forget what the word *weekend* means.
5. You cannot remember your last holiday.

Gently excuse yourself. No need to be grumpy about it. Keep your answers brief, but be honest about your life. For example, "Normally I would love to go to that show opening, but I have committed myself to spend some quality time at home tonight. Thank you for the invitation though."

"Time is what we want most, but what we use worst."
—WILLIAM PENN

I once heard someone say your day is basically a period of twenty-four hours mostly misspent. Add up all you have to do in the course of a day. Look at how long everyday tasks take you. This helps us gauge how well we're spending our time—or wasting it, in some cases. Need a time make-over? Things to consider:

- How long do you spend e-mailing?
- How long do you spend surfing the Internet?
- How long does it take to come up with ideas and concepts?
- How long does it take for you to complete an average illustration?
- How long do you spend on errands and cleaning?

Now subtract that from twenty-four hours, along with sleep time, cleaning and eating. You might be quite surprised how much time you have left—or how much time you may be wasting. We're all guilty of it. Perfection is not the goal here. Keeping your work-at-home sanity is.

"The present is a point just passed."
—DAVID RUSSELL

TIPS TO GET MORE DONE

• **Hire professional help:** No, not therapy. Get an accountant to tackle the tax junk. Does html take too long for you to do? Hire a web designer to update your sites. Outsourcing things like this can take an enormous load off your shoulders.

• **Hire a babysitter while you work:** When I lived in Ontario I had a sitter come twice a week to entertain my oldest daughter while I worked. It was amazing what I got done in a two-hour period. It was cost-efficient, fun and also safe because I was still in the house. I highly recommend this as a possible solution.

• **Close your door:** Being in a space without interruptions and background noise can help you keep your focus.

- **Keep a time record:** Logging your efforts can help you prioritize what's really working and what isn't. This may also help you with pricing your work. Don't undersell your time.

- **Set up a daily schedule and try your best to stick with it:** If you know you have only an hour to do e-mails, it's probably not a good time to see what everyone is doing on the Internet. A schedule only works when you are in the habit of following one.

- **Get up early:** Getting up early can free up the afternoons and evenings for other things like networking meetings.

- **Keep an eye on your goals:** Check off what you have done. This boosts your confidence—you're successfully getting stuff done!

- **Return phone calls once per day:** Chunking all your calls in one period will help get them off the to-do list.

- **Ignore e-mail if you're focused on a specific task:** Find a better time to check e-mails, like in the morning or afternoon. Don't stop your project—you could lose creative momentum.

- **Use your voice mail:** Record a message that states when you will be returning calls or when you are available to receive calls. For instance: "You've reached Holly's voice mail. Please leave a message. Calls today will be returned between 1:30 and 4:30. Thank you. Have a creative day!"

- **Recognize when you aren't balancing your time well:** It isn't easy to admit we're time challenged. You'll feel better when you discover you can actually add five hours to your day by changing your habits.

- **Prioritize:** What's urgent? What's important? Overfocusing on all the little things can take up a lot of your time.

> • **Economize:** Do less to get more done. Group tasks together that you can do at the same time, like cooking the pasta and making a phone call. Multitasking is a skill that takes practice, but it will add more time to your day.
>
> • **Eliminate things that are taxing your time:** Perhaps it would be better to do the home renovations on the weekend instead of during peak work hours. Focus on your to-do list, and it will get done.

I asked the highly skilled digital illustrator Andi Butler about her methods of organization.

> "I try to be very organized, with the emphasis on 'try'! I keep every receipt, and then at the end of each month I clip them together for that month and keep a copy of all my invoices so I can put the payment stub to it. I reconcile those periodically. ... I used to keep a folder for each client; now, instead, I keep a digital folder on my laptop and it stays there (with a color: red for clients, purple for me, yellow for reference ... you can do that on an Apple) until I send the invoice (and a copy for me as well). Then it's moved off the desktop to a client folder. ... I have two fancy boxes—one for invoices *due* (until the payment arrives) and the other *paid* (the stub is stapled to my copy of the invoice and filed here). Some days I have way too many balls in the air!"

If all this sounds pretty basic and common sense—well, it is. But common sense becomes past tense when you get too busy to do the little steps that help you reach your goals. We forget that somewhere along the line we need to make plans and lists while having some sort of routine. When we fall off that organization wagon, we struggle with the mounds of paperwork, assignments, errands and business. Instead of running all day after what needs to be done, ask yourself, "What needs to be done today?" Make a small list. Throw the big-list approach away; a list that's pages

long only makes things seem overwhelming and almost unachievable. If you spend all your energy on the small duties that come up, you'll never have time to do the things that are important to you. Don't major in minor things. Pay attention to what's crucial to your business and happiness.

Don't think of it as managing your time. Time goes on fine all by itself. Try managing yourself, your environment, your calendar and what's important to you. Lack of time can make us lose touch with our top priorities. Our illustration work could suffer. When all is said and done, we naturally want to do what's important. That's why you're in this career, and that's why you're here. You're doing what you believe is important—right now—that will lead to things down the road. Don't ignore what's right in front of you.

Creative people always want to do it all. Guilt often sets in when we don't finish everything. That "I should be working harder" feeling sets in. Write down what needs to get done right now, by the end of the week and by the end of the month. Put things in order of importance. Write down all the steps you need to accomplish to make your goals.

Another approach is doing things in small chunks. Even if you're doing tasks in fifteen-minute increments, they'll eventually get done. I may not be able to work a steady eight-hour day, but I manage to chunk bits of time that lead to a whole workday. I grab a couple hours in the morning, two hours when the baby is sleeping, another hour after supper and two more hours after everyone nods off to sleep. I am often asked if I work on the weekend, and the answer is yes. I have to. But it isn't at the expense of kid time and family outings. My kids come first at all times.

Illustrator Lori Joy Smith describes her day this way:

"I try to squeeze all my work into the time my daughter is at preschool. There are lots of distractions working at home, so I try really hard to stay focused. I ignore dirty dishes and the lack of food in the fridge; things can be dealt with when my daughter is home with me. My alone time is totally devoted to working. I try to break up the day with little deadlines; otherwise there is no immediacy and nothing gets

done. I have to say most days I'm just getting to my best work when it's time to go pick my daughter up. I work best under pressure. In the evenings I do things like answer e-mails or paperwork or things that don't require intense concentration."

When it comes to time, there is a need for acceptance. Accepting that the house is a total disaster zone means cleaning it later. Didn't get that e-mail out? Make it a top priority tomorrow. Caught a cold? Try to rest so you can get better soon.

Illustrator Holli Conger is a perfect example of busy talent combined with motherhood. I asked her if she has moments where she just needs to stop.

"There are times when I just can't work because I am a stay-at-home mom. I have to play dress-up, sing, read a book, clean the house, do the laundry (my husband would laugh out loud at that one!), fix dinner and anything else a child or household may need. I have discovered the Crock-Pot is my friend, and if you clean the house once and work to keep it that way, it stays clean. I wish my studio had those same rules though."

Digital and felt illustrator Roz Fulcher describes her work life this way:

"Because I have three children, I work when I can. Sometimes that's for fifteen minutes, other times several hours. The kids go to school full days now, so I have many hours I can call my own. Summer break and vacation time is challenging. If you have a deadline, you have to find a way to still get the work done. I have very supportive family members, and that makes all the difference in the world."

BALANCE IS IN THE PLANNING

"Well begun is half done."
—ARISTOTLE

Balance is a habit of calm behavior and judgment that creates a state of equilibrium—it's a lot of give-and-take mixed with acceptance. Sometimes we have to let things go to get to the balanced part of life. Are you balancing your life and illustration career well? If not, you have some planning to do. Balance has its moments. We cannot have things in harmony all the time. Thinking ahead helps.

The 20/80 Rule

Working at home means always thinking three steps ahead to get the little tasks done. However, planning is a precarious thing. You must be flexible to some degree because you just never know! The 20/80 rule helps keep me in perspective. The philosophy says 20 percent of what you do will account for 80 percent of your success. In other words, the little things you do daily, however small they seem, add up to a lot. It's all about perspective. One week may result in a lot of tasks getting finished. Some weeks you may fall short of your goals. Combine all your checked-off tasks, and you might be surprised what you got accomplished. This is often hard to see when we feel frantic and rushed by our day-to-day lists.

Another spin on that concept is that if you goof off 20 percent of your day, it won't mess up your productivity. That 80 percent is still a high percentage when it comes to being self-employed. There will always be distractions. If your distractions are only 20 percent, you will be just fine.

I asked Andi Butler if she had any tips for working at home. "My tips? Sleep, exercise make lists and work outside when it's nice. The first three are vital for me! I try to get at least six hours of sleep—doesn't seem like a lot, but I know creatives who do a lot more on a lot less, and what a struggle! I know that when deadlines loom, we have to do what we have to do, but do it too often and we're zapped of energy and it affects our judgment and how we interact."

Recognize when your self-employment is working and all coming together for you. Success leaves clues. If your planning isn't working, try another approach. Plans need to work out in order for you to feel your work and business are making a difference. If your last promotion was a bust, don't repeat it: Try another theme.

What is meaningful to you? Are there things you're putting focus on that aren't helping you in your future success? Winging it as an illustrator in business is not a method. *Plan* your success. *Plan* your promotions, your phone calls, your work time and your online networking time. If you're all over the map, you'll never arrive in one piece.

"Now it's time for my well-thought-out and college-educated plan!"
—PLANKTON FROM *SPONGEBOB SQUAREPANTS*

Every Sunday in our house we get ready for the week. This preparation includes lists, goal checking, laundry, prepping food and a good house-cleaning. No one is born organized; it takes practice. Illustrator Holli Conger breaks down each of her weekdays for specific tasks, which is quite smart. For example, she starts her week with Marketing Monday and so on. This helps her stay in check with specific tasks she feels she must accomplish daily. She's very success-minded, and it shows.

Why do this? It's good planning. Setting up a day-to-day list helps you know what to expect and what to focus on. Here's a quick checklist:

- Make a decision.
- Have clear goals and objectives.
- Plan every day in advance.
- Separate urgent tasks from important tasks.
- Define what's the most valuable use of your time right now.
- Don't forget to throw in some "me" time as well.

It's good to prioritize your time in a calendar. Every day I try to list things in an organized way so I keep what's important in the forefront. My *A*-to-*H* of organization goes like this:

A = Action: What are the important to-dos today?

B = Buy: Make necessary purchases that must happen today or sometime this week.

C = Call: Who do I need to call immediately and by the end of the week?

D = Dinner: Make meal plans for the week so I'm not wasting time wondering what's for supper. It sounds very anal-retentive, but it's amazing how smooth it makes going to the grocery store—I buy only what I need.

E = E-mails: I bundle them together so I'm not spending all hours of the day sending them out when I need to be doing something else.

F = File: Collect paper, such as bills and notes, at the end of the day or every other day and put them in the right places.

G = Go out: Go for a walk, for coffee, to the park or walk the dog. Pencil it in. You must leave your studio at some point!

H = Happy: Do something every day that makes you happy. It might be exercise, a funny show or movie or goofing around with the kids. Call it breaking for sanity.

The Two-Career House

The two-career house has its challenges. When you're in a situation like I am where there are two businesses going on under one roof, it makes things really interesting. My husband and I are doing two unrelated things but are both quite busy. I have my career, and my husband is a health and fitness professional. I am very much grounded, and he travels to his clients. There is a lot of give-and-take and helping each other out as far as getting the bulk of the daily tasks done and raising the kids. If you have a home life and work life like this, I recommend setting aside quality time as a family. What can happen is that you "share" space and time together because of work, but not a lot of quality time happens. Don't fall into that trap.

We do what makes us happy and creative. That's what this whole career is about—a combination of business, creativity and play. Unfortunately, you'll never have trouble finding aspiring illustrators who are feeling overwhelmed. Being an illustrator is a lot of work. When we look at all the little tasks that come as part of this career, no wonder it can feel scary to be self-employed. The nice thing is that creative business does not have to be tedious. Try to apply the 20/80 rule to your business daily. If you're getting 80 percent done, that 20 percent isn't going to sideline you.

YOUR CREATIVE PEAK TIME

"You cannot mandate productivity, you must provide the tools to let people become their best."

—STEVE JOBS

As creatives we seem to work when we're in the mood to. This could be any time from the wee hours of the morning to really late at night. Are you paying attention to when your peak time is? Are there certain times of the day when you're on fire with ideas? Getting in tune with your work nature lets you know when you're the most productive.

Claudine Hellmuth starts her workday in the afternoon. "I am usually in the studio from about 1 P.M. to 10 P.M. with e-mails and other business tasks working their way into that time slot. After about 10 P.M., I am blogging, and then I like to watch TV and relax for a little bit!"

I used to be a night owl, but now that I'm a busy mom I have had to shift to working when it feels easy. I call it working in the path of least resistance. My day starts around 3:30 A.M. Sounds early to most, but it works for me. The house is quiet, and I get to wake up on my own instead of having kids jumping on me. It's a good time for me because I can get the tedious stuff done like e-mails, paperwork and planning. Then when the kids wake up I can stop, knowing I'm organized to pick up where I left off later.

The Second Job

Some of us may need to juggle two jobs. Going at illustration full time may not be bringing in enough income for you right now. Second-job advice: Try to do something that either educates you or interests you to some degree. I say this because you want to be focusing on your illustration work most of the time. If you have taken on a job that's completely awful, it will become a very long day and that taps all your energy. A job at the mall may not hold your interest long enough and could really make you miserable in the long run. You will need to store some energy for creativity on your time off. Second jobs that are interesting and fun will not drain you and make you feel frustrated that you aren't doing illustration full time.

Early on in my career as an illustrator, I had a few different jobs. I was a veterinarian's assistant, which was great because I love animals, especially dogs. What I learned from this job was how to be diplomatic. People take their pets very seriously and want the best care for them, especially when they get sick. I didn't always agree with the pet owners' choices, but I had to learn to suggest alternative options for care or to agree to their wishes. This was not always easy.

Another job I had was at an environmental store. This store sold products that are friendly to the environment, recycled, natural and innovative. What I learned was different ways to package my work. It helped me think about paper a different way. I also learned about Earth-friendly companies that are making a difference.

Lastly, I worked in a health-food store that steered me away from the usual thinking about health. It also got me interested in how products are packaged. Natural products are generally more expensive and exclusive, so good imagery and design are very important to make them stand out to the prospective buyer. Working in this industry also taught me how to discuss issues of health and alternative solutions. Many clients had special needs such as allergies and other issues, so approaching them in a sensitive way was a must. All these positions taught me to be patient with the client and listen to their needs.

Working at Home With Kids

Balancing kids with work will alter your schedule in more ways than one. Let's face it: Kids like to be busy! They may not be able to help you in your business necessarily, but there are ways to swing it so you can get them involved. Things to consider when you have kids:

• Set up playdates.
• Set up an easel or chalkboard to encourage the artist within.
• Hire help.
• Arrange for day care.
• Set up day camps.

I was once told by another self-employed individual that having a business at home with small children was a bad idea. I disagree. Having a self-employed illustrator mom is all my kids have ever known; they get to grow along with my business. The big bonus is they will learn from me and take those skills into their future careers. If I were to wait until they were teenagers, they might not appreciate my work the same way they appreciate it now. My work life is part of the house routine, and that's fine with them. Success can be contagious.

Andi Butler describes her work-filled day with children as a test. "It's a challenge, and not the same challenge every day! Sometimes the days are just easy: The boys keep themselves amused, I can work a little bit (although I do most of my work after they're in bed or when they're in school), the house is clean, my mind is clean, I've worked out—all around, the day goes great. Then other days it's like I'm in slow motion, and nothing I do can help me catch up: The boys act up, my equipment acts up, phone spammers are bugging me. That's when I try to take everything (weather permitting) outside!"

Holli Conger has this to say about being a self-employed mom: "It is a real juggling act! I have a four-year-old daughter, and she is really good about me working. I guess she doesn't know life without me working."

Working at Home With Roommates

Roommates are another challenge for those who work at home. You're sharing rent and space, but there needs to be cooperation on both sides so everyone gets along. It's not easy to live with a roommate, even at the best of times. Things to consider when you have roommates:

- Lay down some ground rules as far as cleaning duties.

- Keep them informed of your schedule.

- Make sure they know your illustration career is very important and there are times when you wish not to be disturbed.

- Make sure you have some sort of area that's yours to work in.

- It's always a good idea to set up meetings outside your space to keep things professional.

Don't be afraid to learn by doing. There are some things you can figure out only as you go along. Be open to change because being self-

employment can be unpredictable sometimes. What is your motivation? Personal success, money and independence are huge motivators. If you're self-disciplined mixed with entrepreneurial spirit, heartfelt commitment and a clear vision, you are well on your way.

REALISTIC GOAL SETTING

"Life, as it is called, is for most of us one long postponement."
—HENRY MILLER

When I was packing up the office before our big move to Nova Scotia, I found lists and goal sheets from seven years ago. Apparently, these papers had gotten filed and did not see the light of day until I sadly found and recycled them. That's how I used to tackle the concept of goals. You could call it wishful ambition; I did not have a clue. I now make lists and goal sheets and practically guard them with my life!

Ambition is the wish, power and ability to begin and follow through with a plan or task. Step one is getting it down. Then you have to organize it, prioritize it and do something with it. The step called "action" is the one we often forget. Why?

There are two problems that arise from goal setting: Goals are often not specific enough, and there is no follow-through. Many issues come up when your list of goals is too long. It's overwhelming to look at a set of goals that's five pages long. In our minds it feels unachievable because there's so much to do.

Lists have to correspond with your calendar and frame of time. An illustrator living on his own and single has a different time frame than one who juggles kids and work. They may have the same amount of work, but each person's sense of time is way different. The ambition levels may be the same, but the goals may happen at two different times. This is another good reason not to compare another illustrator's achievements with your own: It's all relative.

I like the word *gumption*. It sounds very matter-of-fact. It's common sense and ambition rolled up in two syllables. Look at your goals as your very own common-sense plan by asking a few questions:

1. Do I need to do this?

2. When do I want it finished by?

3. If I put it off, will it make it any easier tomorrow, next week or next month?

Goals can be divided into different sections or time frames. One set of goals can be for today, another for the week and another for the month. Then you can focus on long-term goals such as one-year goals, three-year goals, five and so on.

Ask Yourself What You Want in the Future

1. Do you want an agent down the road? When? Who do you want to contact?

2. Do you need a website makeover next month? When do you want the layout to be done?

3. Planning on attending an upcoming HOW conference? What do you want to do there, and whom do you want to talk with?

4. Do you want to try a new market for your work like children's publishing? When do you want to start that portfolio, and whom do you want to contact?

Focus is the main reason to have goals. Many of us like to create on a whim when it suits our schedule. Try looking at goals as good creative planning. This sounds like a combination of invention mixed with flexibility that allows us to play. While it's good to have plans, try not to frighten yourself by making them too rigid.

THE CREATIVE BUBBLE

"Hello, in there, Cliff. Tell me, what color is the sky in your world?"
—DR. FRASIER CRANE FROM *CHEERS*

When we don't venture out of the old office, we can start to feel like the good china. We keep ourselves all locked up away from dust or, even worse, the sun! Remember that working at home is supposed to resemble the good life. You are working, not hiding!

I asked illustrator Jannie Ho if she ever feels she's in a creative bubble. "Being an illustrator is sometimes a lonely profession, so online networking such as blogs are a great way to meet like-minded people/artists from all over the world. And for shy people like me, even better! I started my blog about two months after I started freelancing full time as an illustrator. It's such a part of my day-to-day creativity now, either posting on my own blog or reading someone else's. I just came from a conference where I met face-to-face for the first time people I've come to know online. If it wasn't for the Internet, the conference would have been a totally different experience for me."

We are social beings by design. We aren't meant to be cooped up in our offices all day. Taking breaks often actually helps your work. Stepping away can give you fresh eyes and a new perspective. If you're constantly staring at a computer screen, try looking at something else every ten to fifteen minutes to shift your focus a bit. This exercises your eyes and prevents that tired feeling.

We need feedback as illustrators. We need to connect. When we're feeling frustrated by a job that didn't work out, it helps to get prospective from another illustrator. Knowing we aren't alone in our ups and downs helps a lot. Don't bottle up your career concerns—talk it out.

We need to escape the office. Illustrator Keri Smith feels that walking is a really good way to take a much-deserved break. Look around. Look at all the details while walking, from interesting wrappers on the ground to interesting graffiti on the wall. Look for patterns. We often overlook

these visuals. Often people who have been in an accident or mugged cannot easily describe the person they came in contact with. Why? We get into a habit of not actively looking at what goes on around us. Look at the details and make note of them. The more you see, the more you will know about your world. This can actually improve your work.

Illustrators today are lucky to be able to connect with other illustrators around the world. The web has helped our community come together. You may not be able to have coffee with an online friend in England, but you can do the next best thing by throwing ideas around and critiquing each other's work. This is what it means to get out of the creative bubble.

CREATIVE DIVERSIONS

"F-U-N spells fun!"

—FROM THE CHILDREN'S EDUCATIONAL TELEVISION SERIES *ARTHUR*

A deviation from the usual day-to-day routines can feel like a mini vacation. Small moments of total enjoyment and play can really reactivate a tired creative mind. Keri Smith is the expert on this and has dedicated a lot of books to the act of "momentous play." I like that. It makes my inner child happy.

Designer, illustrator and photographer Jeff Andrews talks about some of his creative diversions:

"When I'm not spending time with my wife and family, I enjoy getting outdoors. Also, I'm a collector: I collect vintage toys and books and *Superman* memorabilia. My office is becoming quite a visually stimulating place for it—in fact, I'm currently running out of room. I also enjoy collecting and listening to vintage radio programs ... very imaginatively stimulating while you work. I love them!"

Diversions are anything outside of your business and illustration that brings you joy and a much needed creative breather. Diversions are im-

portant to add to your life because without a change, life would become too routine. Many of us are talented at many things and continue to pursue other interests from hobbies to sports.

RECOMMENDED READING

Leif Peng's blog, http://todaysinspiration.blogspot.com, is all about vintage illustration from the forties and fifties.

Another fun way to add to your creativity is by doing so online. Illustrator Leif Peng has a blog called Today's Inspiration. He posts images of vintage illustrations from magazines. Holli Conger has a site she describes as "art with my daughter almost every Wednesday." She also invites viewers to participate in the fun. Holli says, "As she got older, I involved her in my work; that's probably why she loves to draw and make things today. A couple ideas even spawn from working with my daughter: woogiewednesday.com and bigandlittleart.com."

RECOMMENDED READING

Holli Conger's http://woogiewednesday.com: "Art with my daughter almost every Wednesday."

Blogs have become a very good creative diversion for many illustrators. We get to put a different spin on our online presence that can involve tips, rough sketches, ideas, interesting finds or just keeping your blog followers up to date with what you're doing. The nice thing about blogs is they are quite user-friendly.

DIVERSIONS

Photography: I studied photography the whole time I was in art school. It taught me the concept of framing and organizing objects within one space. Because you're working in a frame, you're limited by the camera and lens. It's like they always say: Use less to create more! Photography allows you to create by chance.

Collage: Cutting and pasting images is a fun way to make illustrations. All you need are some old magazines or newspapers and glue.

Antiques and vintage items: It's great to look at vintage packaging, design and illustration for some classic inspiration. Many illustrators derive inspiration from this style of work—from old postcards to fifties-style magazines.

Odd collections: I collect old View-Masters and reels. The hobby began as a chance find at a tag sale when I discovered an old View-Master from the thirties for only fifty cents. Then I just kept finding them. *Thrifting* needs to be a verb because you are actively digging—searching for something that catches your attention or inspires you in some way, or even something that reminds you of your childhood.

Magazines: Poring over nicely designed magazines like *I.D.* can really help you feel lost in ideas and inspiring images. It's good to look at what advertisers, designers and typographers are doing because they're such a huge part of the creative industry.

Sports: Sports helps teach team building and cooperation and is good for your health. Sometimes you win, and sometimes you lose. Sport philosophies can help you tackle challenges you may be having with your business (a good example would be martial arts, which encourages discipline, confidence and persistence).

Exercise: Our brains like exercise. It releases all those juicy endorphins that actually help you think more clearly. Bonus: It gives you energy And boosts your immune system and your mood. Andi Butler makes exercising a habit. "I walk/jog an hour a day, every day, and use weights three days a week at home, before the boys get up, so I am up at 4:45 every morning: coffee, breakfast, news, treadmill ... I absolutely have to. Having two sons, I need to be able to keep up and still have the energy to work later."

Humor: Add some humor to your day—an uplifting distraction that doesn't require a lot of action. Great sources for this can be funny TV shows, movies or stand-up comedy. It just depends on what you find humorous. How does this help? It's good to laugh, especially when life gets too busy or too stressful. Humor diffuses a really bad day.

Music: It's true that music can take you somewhere else. I'm not sure I would have survived too well in high school without headphones. Tuning out to sound, poetic lyrics or really heavy bass can jump-start your mood and ideas.

There's an expression: "To be interesting, be interested." What you allow into your world says a lot about your character, whether superhero worship or antiques. When it comes to collections, I'm not entirely sure who likes Playmobil more in my house, my daughter or me! Creatives are fascinated by what other creatives find interesting, and this means we're fun and not willing to be too overly mature. Maturity is overrated!

PUNCHING OUT

"Isn't this great, Squidward? We'll be working for hours and hours and hours, and then the sun will come up, and we'll still be working!"
—SPONGEBOB SQUAREPANTS

Do you know when to stop for the day? Many of us don't. There's always something else to do. There will always be e-mail, ideas to jot down and mess to clean up. Shutting off helps when you make it a priority. Self-employment does not mean working endlessly, though we may have to do that on occasion when there's a tight deadline. However, for our sanity it is best to stop every once in a while and do something else. Our creative side needs time to play and decompress a bit.

Do you know how to shut off your work brain even though you're no longer in the office? Some of us are always working, even though we aren't at our desks. It becomes a habit to be constantly thinking and coming up with new ideas. But when it becomes a distraction, that's a problem. You may be so busy thinking you aren't paying attention to someone talking to you, or worse, you start forgetting things that have to be done right now.

Being an illustrator is a full plate of duties and other tasks that can feel overwhelming at times. Getting your friends and family to remind you to stop for the day helps, too. Make yourself accountable to someone. If you have a dinner date at five, have someone call you as a reminder. Set your alarm on your computer calendar to pop up to motivate you to stop. Use an alarm clock.

Sometimes it's as easy as patting myself on the back and saying, "Good job today, Holly." This does not always mean I got everything done on my list, but it means I put in a good day's effort that has inched me closer to my future goals. Looking at all you get accomplished in a day, however large or small, helps you close the office door for another day. It's all about perspective.

"I take care of me. I'm the only one I've got."
—GROUCHO MARX

We need to have more in our lives than just our illustration businesses. Blocking off "me" time on your schedule says you're taking care of the most important thing you've got—yourself. It isn't selfish or egocentric to look after yourself every so often: It's healthy. You won't be able to help

yourself or anybody else if you're sick, burned out or working nonstop. There needs to be a certain amount of selfishness to your day to maintain sanity. Without you, you won't be in business very long.

TIPS TO END YOUR DAY SUCCESSFULLY

- Organize your desk so you can pick up where you left off.
- Make a list for tomorrow.
- Organize your calendar.
- Shut the door.
- Change clothes—sweats and T-shirts can signal "done!"
- End the working day with a shower.
- Turn on the answering machine or voice mail.
- Go for a walk.
- Make a cup of coffee.

I have a sign on my bulletin board that says CAN'T WAIT TO SEE WHAT I CREATE TOMORROW! It's a fun kick in the creative pants. I cheer myself on sometimes because I'm often swamped and so incredibly tired I need all the help I can get. Be your own cheering squad. Sounds cheesy, but it really does help.

Remember to make time for the good things in life. Being an independent illustrator should resemble a better quality of life to some degree. Remind yourself to:

- Take time for your family and friends.
- Take time to rest.
- Take time to eat properly.
- Take time to exercise your body and mind.
- Take time to do something new and interesting every day.
- Take time to learn something new every day.

- Take time to do something nice for yourself, your family and your community.

When I was starting out, I used to work nonstop. It was almost like I was afraid to miss something. Eventually, it became necessary to make myself stop because I wasn't doing anything else. Having kids quickly changed that philosophy. Do I get to do as much work as I would like to? No. There are some things I have to put off because I just cannot take on any more work. I have to be realistic about my time. Having kids has taught me a very important thing—live for the moment. That's what my girls do. They don't care about next week or that it's going to rain later on in the day. They're happy right now, and that's all that matters.

CHAPTER 3
SHOW AND TELL

"I made this!"

—TEN THIRTEEN PRODUCTIONS

Whenever I used to watch the television show *The X-Files*, I couldn't wait to hear the company tagline that played at the end. Ten Thirteen Productions' tagline was "I made this!" said proudly by a young boy as the sound of a movie projector played in the background. The line always caught my attention. It was an innocent but appreciative sound-off that reminded me why I like being an illustrator. This statement was very simple but so effective. It reminded me of my childhood when I created without a care and showed my work off to anyone who cared to see it.

This little boy's voice reminded me that after your talent, your promotion plays second fiddle to your business. A great promotion piece grabs the eyes of the beholder and says, "Hey, look what I can do!"

Promotion is a busy process of effort, planning and designing. Once your promotional piece looks amazing, you have to give it to everyone you can think of who could need your services. If your illustration business were an event, promotion would play host by serving up creativity, spotlighting your talent and setting the right mood while taking care of your clients' needs. When it all works out, everyone can have a good time!

Create a theme: This starburst, created early in my career, is a recurring theme in my work.

IDEAS FOR SALE

"I've found that luck is quite predictable. If you want more luck, take more chances. Be more active. Show up more often."

—BRIAN TRACY

Being an illustrator means you're allowed to experiment when it comes to getting yourself out there. Creating your own advertisements is the fun part of this career. Promotion is a great way of getting those untapped concepts into the world. It's also a process of trial and error. Some ideas work, and some don't. Promotion is really a test of your creativity. Make your ads fun. Make them useful. Make your promotions show off what you can do.

The best way to think about promotion is that *you* are now in the spotlight. Instead of solving someone else's visual needs, you must listen to your own needs and give the client what you think they'll want to see. You've got to work hard for *you* now.

Yet why are so many illustrators afraid to sell themselves? There's a lot to think about when we put ourselves into the spotlight. Many creatives don't want to come off as selling something. One way to combat that fear is to explain to your clients the benefits of hiring an illustrator.

As an illustrator, you are providing a creative service in the form of images. Your work is commercial, so you are profit driven. If not, you would be doing this as a hobby. Don't be shy about your objectives. Be honest. You are self-employed and want to make a living from your illustrations. Be confident in your ability to do that. Hiding is not an option.

"I feel a recipe is only a theme which an intelligent cook can play each time with a variation."
—MADAME BENOIT

The possibilities for promotion are endless. Knowing which ideas will get the attention you desire is an ongoing challenge. Originality will get you noticed. Also, always promote with a message. Create a theme. Another good idea is to provide tips or add humor to get your prospective client's attention.

I asked the illustrator and creator of www.illustrationfriday.com, Penelope Dullaghan, what she believes is the best way for an illustrator to promote herself.

Variations on theme: You never know what your audience will like. Try multiple variations.

"I don't think there is one best way to promote. I think it's more like a patchwork blanket where lots of things make up the whole. Word of mouth and referrals are wonderful. But I also send out postcards regularly. And, of course, I keep my website updated with new work and fresh content. No one will know what you're up to unless you tell them. I also think sourcebooks can be good for some people and participating in things online—just being a part of the creative online community. Illustration Friday seems to be helping people get started and published nowadays!"

Selling ourselves is not as easy for some as it is for others. Some are born to network, and others wish that part of the career would just go away. Bragging is never seen as a good thing when we're kids. Tooting your own horn might appear conceited to some. It's not uncommon to be told to tone your promotion down or not to rock the boat. Unfortunately, some get very threatened by someone who has confidence. I see confidence as an attractive personality trait. Just make sure to be yourself.

"Luck, that's when preparation and opportunity meet."
—PIERRE ELLIOTT TRUDEAU

Having the capacity to ask for what you want is another way to describe what promotion is. You are essentially asking potential clients to look at your work, listen to what you want and consider you for future projects. You may be very surprised by what could happen when you do this. In the past year I have asked for many things that were out of character (for example, this very book and a teaching position focusing on the business side of creativity). I decided to just bite the bullet and ask. The funny thing is if someone had told me I would be doing all this six years ago, I would have thought they were crazy. I now apply exploration to my career by being open to all possibilities. I used to be a very shy person. I guess I'm not any more.

It's easy not to be direct enough when seeking assignments. Some people are just plain scared to ask for what they want. If you don't ask, you will miss out on getting to know the people who want to help you. It's in your best interest to be firm and know what you're asking for. In this way, your potential clients feel as though they are participating in your success, and you begin to foster a positive, professional relationship.

YOUR BRAND

"A person is really alive only when he is moving forward to something more."
—**WINFRED RHOADES**

How you describe your business is worth a thousand words. The smallest and quickest statement often makes the biggest impact. Think of branding as your own personal storytelling. Your brand is your professional image.

We have all sorts of ways to describe what we do as illustrators—the hard part is narrowing it down into a quick commercial about who we are. Make it valuable. Make it memorable. This will be one of your biggest assets.

If you could sum up what you do in one quick statement, what would you say? It's not easy, is it? Branding isn't just about promotion, it's about

Use imagery in your branding: My own business icon, and Jeff Andrews', respectively.

building relationships. These connections will be your audience, your clients and your network of peers.

My personal "brand" is "Holly DeWolf Illustrator: A Hand Made Experience." I chose this wording because I believe illustration is a visual experience for many people, especially children. I create my work by hand using gouache. I decided to combine these two things to show my audience what's important for them to know about me.

How do you brand your business? You can do it in many different ways. First, you want to consider the message you're putting out there. This message will help determine the type of clients you get—those who will be attracted to your message through your branding efforts. So, pretending to be something you aren't will probably attract the kind of business that isn't your strength. You are your brand, so be true to yourself.

TIPS FOR BRANDING

1. Talk about your expertise wherever you go.
2. Set up a meeting with a possible client to chat in person or chat online.
3. Write an article.
4. Do a seminar.

All you have to do is watch TV and you'll see glaringly bad brands that do not work. Some branding issues are business statements that don't relate to what a business is all about. Some brands can sound similar to other companies' brands. Another glaring mistake is not being specific enough. These three blunders can cause a lot of confusion, the side effect of which may be not being taken seriously—and that's bad all around!

"Man is happy only as he finds work worth doing—and does it well."
—E. MERRILL ROOT

Things to consider before you begin promoting: Think about what you love, what you're good at and your individual look or image. Determining these things will help you get recognized right away.

A good place to start branding yourself is online. This can be done on your website or your blog. Through your blog, you can write about what you know. Participating in online forums and online groups is another way to get recognized.

Make your website spotlight you and what you do best. Remember to post your very best work with important contact information available. If you have a catchy slogan you use, add it to your site.

Make sure your audience benefits from what you're doing online. This will draw attention to you and your blog. Establishing yourself as an expert in your field lets people know you really love the industry in which you work. You could be seen as an online mentor, teacher and illustration advocate. Getting recognized won't happen right away—it could take anywhere from two months to a year, depending on what you write about and how often. Be persistent and consistent with your postings, and you'll have a better chance of success.

Branding yourself through your business stationery can be done with your business card, logo letterhead, résumé and postcards. The more you send out, the more it will be recognized.

Protect your brand online with a domain-name strategy. Look at possible variations in the spelling of your domain name and purchase the most likely variations: for example, www.widget.com, www.widgets.com, www.mywidget.com, www.mywidget.ca and so on. Make it as easy as possible for prospective clients to find you, even if they misspell your domain. You definitely don't want anyone skimming sites that have similar domain names.

Personalize all your communications, such as your e-mail signature or voice mail. List your phone number, website and slogan. I always add a favorite quote as well. This adds interest to your notes and gets the recipient involved.

Choose an area of expertise and get known for it. Jeff Fisher is best known for his LogoMotives. Ilise Benun is known as the Marketing Mentor. When I hear their slogans, I know exactly who they belong to right away. Their slogans are distinct and unique while making a huge statement.

When branding yourself, be very cautious of social networking sites. Potential clients and businesses are always looking at these sites to see what people in the industry are doing. Be professional and discreet. No need to post your latest party pictures.

DESCRIBE YOURSELF

"At the center of your being you have the answer; you know who you are and you know what you want."
—LAO TZU

Let's face it, it's a lot easier to describe someone we admire than to write about ourselves. We aren't taught to focus on the obvious, and it shows. On too many occasions I see artist biographies and illustrator statements that don't really make a statement.

When creating your illustration biography, it's best to remember to approach it from the client's perspective. The biography should be all about what they want to hear and read. Remember: It's not about you, it's about them. You are writing about yourself for a reason—to attract clients to your business. Over the years I read many illustrator statements; some don't make a statement at all. The usual problems I find are a combination of how many cats one has along with hobbies such as baking and knitting. It's nice to have these, but not in a biography. Poor descriptions leave your audience wondering if you're an illustrator or an astronaut. Mention what you do and where you studied. If you belong to any associations or membership sites, absolutely include those. Make it interesting but avoid using too many tongue-twisting words.

"We are all cups, constantly and quietly being filled. The trick is, knowing how to tip ourselves over and let the beautiful stuff out."
—RAY BRADBURY

You are an illustrator. You are talented and motivated to get work. Let that enthusiasm show in how you write about yourself. Put yourself in the spotlight the best way possible. A good approach is to start a file and fill it with many different descriptions of your work, which will help you with different markets, different promotions, different clients or those chance meetings during which you have to say something quick. The more you write and speak about yourself, the easier it becomes.

Different Statements

- **Long statement:** The longest in your file can be used for your website, a promotional mailer or a media kit. It can be up to two hundred words.

- **Medium statement:** This can be added to promotional mailers, query letters and information your client can put on file. These can be around fifty to one hundred words.

- **Short statement:** This can be your signature statement, which can be put on a postcard or on your e-mail messages and should be around the twenty-word mark.

- **Quick statement:** Sums up what you do in about three to five words. These are good over the phone or at a chance meeting or networking meeting when handing out your business card.

FOCUS ON WHAT YOU NEED THEM TO KNOW ABOUT YOU

1. How you create your work
2. Education

3. Memberships and affiliations

4. Awards

5. Spotlights

6. Creative industries your work can be used in

7. Your agent (if you have one)

8. Interests relevant to the industry (such as blogging, writing, mentoring or teaching)

"To get your ideas across use small words, big ideas, and short sentences."

—JOHN HENRY PATTERSON

The number-one way to turn off your audience is by using words that aren't user-friendly. Big words and technical jargon will not win you brownie points. The idea is to keep the conversation on a human level. Sometimes big words aren't descriptive at all; they can make your audience feel uncomfortable and confused. If someone asks you what you do for a living, describe it the easiest way possible. Big words turn people off. Basically, don't let your propensity for verbosity become egregious. Translation: Don't let your love of language become your worst asset.

"I think big words are funny. It's like your tongue is taking an exam."

—UNKNOWN

Why do people use such confusing language? Some may feel uncomfortable talking about themselves. Some may want to impose their intelligence on you. In other cases, an overblown ego may be getting in the way of communication. The best approach is not to overthink what you say to someone. If you want to make a connection, speak their language. Be confident in yourself and your work. Good body language and an open conversational style say you want to talk. There's no need for

larger-than-life words. Be secure in the knowledge of your ability. Mix in some humor, and you're gold.

HOW TO BORE YOUR AUDIENCE IN SIX EASY STEPS

1. Describe what you do in a preachy tone.
2. Tell your life's history in art all the way back to kindergarten.
3. Describe every course you've ever taken in art school.
4. Give them a crash course in painting and sketching.
5. Talk about your "difficult clients" ad nauseam.
6. Talk endlessly and negatively without any eye contact.

What's best: first- or third-person writing? You should consider your audience and where this information will be used. First person is friendly and is good for public speaking, teaching or if you're using yourself as an example to explain something. Third person sounds more professional and adds credibility to your writing because people are used to seeing that kind of writing in books, on websites and in our illustrator statements. Look at the following example:

First person: "I have always wanted to promote the business of illustration."

Third person: "Holly enjoys painting with gouache."

Your words are worth a lot. When it comes to talking about yourself, make your words count. Talking about yourself is just another form of promotion. Face-to-face conversations are much more effective than a promotional mailer. Think about it: Your client gets to shake your hand, read your body language, listen to you talk and connect with you on a human level. Often we don't get to connect with people because we're too busy working in our studios. Talking to people is one of the best ways to

gain a relationship with a potential client or someone in your creative community. Plus, it's free.

PROMOTION POSSIBILITIES

"To establish oneself in the world, one does all one can to seem established there already."
—FRANÇOIS DE LA ROCHEFOUCAULD

Creativity can often feel like a race against time because we have all sorts of ideas and inspirations during an average day. We cannot realistically work all day and all night to do everything we want to do; some of our assignments don't push our creative buttons. The upside is that we have one thing that can always help us shine: Promotion is one way we can show what we're made of.

There's this misconception that the illustrators who get the most attention are the most talented. Unfortunately, attention is given to those who consistently toot their horns the loudest on a regular basis.

Promotion means using your talents to ask for what you want. You are asking a potential client to take notice of and hire you. By making your promotion memorable, the client may choose to keep it and file it. Another reason to promote is to gain feedback about your work. Get your clients to use you for their projects—and anyone else they might know that could use your expertise. Referrals are gold!

"You've got to ask! Asking is, in my opinion, the world's most powerful—and neglected— secret to success and happiness."
—PERCY ROSS

Often promotional pieces fail to ask for something. I often see promotions that are only an image and contact information thrown into the mailbox in the hope that someone will take notice. This is called wishful promoting. You're assuming your audience knows what you want, even though you haven't said anything in your mailer. It helps if your promotion has a

goal or purpose. Why do we send out promotional materials? So we can get work. How do we get work? Very simply, we need to ask if clients need us. Build a professional relationship by asking a lot of questions. This says you're interested in them and their business.

What makes us avoid being specific about our promotions' purpose? It's easier to be subtle. It's much easier to hint at what we want. Some illustrators assume the potential clients can read minds. Talk to them, ask questions and provide solutions to problems clients didn't even know they had.

Marketing Mentor Ilise Benun says a good approach to self-promotion is to develop strong relationships with clients and potential clients. You can do this by letting them know how you approach business and how you work. Touching base on what you're interested in is a great way to find common ground. Ilise also emphasizes good customer service. When you care about your clients, it shows.

"I just thought I'd spice it up a bit. I mean, why say, 'Hello,' when you can say 'Hellooooooooo'?"
—**MOLLY HUDSON FROM** *ED*

Put yourself in the prospective client's position after having received your promotion. This is a way of working backward to visualize the desired end result. What would you like to see if you were an art director? How would you like to be approached? How would you react to a typo? Putting yourself in their position really puts a different spin on it. Remember that the folks on your potential list are often swamped with mailers every day. The idea here is to get their attention in order to land a job.

STAND OUT FROM THE CROWD

1. Add a personal touch to your mailers, such as a little drawing on the envelope or a sticker that has your contact information on the package.

2. Unique presentations can stand out from the usual. Make your own folder or envelope. Have fun with the shape and size. Just make sure it can be mailed.

3. Great paper that looks good and has a really nice texture is very appealing.

4. Leave your clients something to read—a newsletter, a tip sheet, the press release of a book you illustrated or a great testimonial.

5. Involve your audience. Provide a discount or do something unique to get their attention. For example, children's illustrator Jannie Ho created a promotional coupon offering a discount for clients who hired her during the tough economic times.

6. If your audience is a publisher, create a theme with a series of postcards that tell a story.

7. Tell a joke. Why did the illustrator cross the road? How many illustrators does it take to change a lightbulb? Get your clients to answer it. Better yet, make it a contest. Offer a prize, such as a print or postcard.

8. Put an inspiring quote on your mailers. Everyone loves inspiring messages.

9. Add a quote from yourself. Come up with a clever statement.

Do Your Research

Read what your prospective clients are looking for in an illustrator. Look at their client lists. Look at the types of illustrators they've used in the past. Ask yourself how you might fit in. Could you fit in sometime in the future? Look to see if your clients have submission guide-

lines or if they have a section on their website where you can inquire about work.

The possibilities are virtually endless. You can use the mail or Internet or you can drop off your materials. Consider cost and mailing specifications and their guidelines. Try to always address the mailer to the right person. If you don't know who that is, call and ask.

Another issue is the cost of making promotional pieces. There are many creative ways to get around a tight budget. You can incorporate these money-saving techniques but make sure your pieces still look professional. Digital prints are easy and cost-effective in a creative folder. Postcards are favored as well and are reasonably sized and convenient to send. Another well-liked promotion is the contact sheet. You can have a lot of fun making these because you can include many illustrations but on a smaller scale. You can also promote your work on your website or on an online membership site, such as www.theispot.com.

Create a dream list of potential clients and a handy promotional schedule. Set aside time to research the right people and their proper contact information. Update it often. If there's a holiday coming up, send out a corresponding promo such as a Christmas card (designed by you, of course). If you know you'll be sending out mailers bimonthly, set up a file of materials; that way, you aren't looking for your latest printed samples when it's time to mail. Keep a running record of when you send each mailer. Follow up and write down important feedback, responses and with whom you spoke.

I had a quick chat with Marketing Mentor Ilise Benun (www. marketing-mentor.com) about her take on promotion. I asked her what she feels are promotion dos and don'ts for illustrators. The number-one mistake Ilise sees is "illustrators who do not see themselves as business owners. This mistake generates other mistakes that can make your career difficult." She says being an illustrator is just one part of the business equation.

PROMOTION MISTAKES

1. Overlooking spelling errors

2. Overspending

3. Using one mailer for all your markets

4. Not personalizing the piece enough

5. Not including the right contact person on the envelope

6. Not following through on a promotion

7. Sending your promotional pieces everywhere without a plan

8. Sending your pieces before you contact the intended person to see if they're interested in receiving a mailer or two

9. Bad printing

"Don't ever underestimate the power of commonality and endorsement."

—BILL CATES, AUTHOR OF *GET MORE REFFERALS NOW!*

Word of mouth is an important aspect of promotion. How you approach your clients, your business and deadlines says a lot about you. Word of mouth is also extremely important if you live in a small area. Making a bad impression can get around.

Word-of-Mouth Basics

1. **Be agreeable to some extent:** We cannot always love the opinions of our clients, but we can be diplomatic. Having the ability to talk through issues makes you a great creative manager.

2. **Look the part:** If you don't dress for success, word will get around. Many people consider appearance an important thing.

3. **Respect deadlines:** Missing deadlines on a regular basis can really hurt your reputation as a self-employed illustrator. It not only messes up everyone else's schedules but also just says bad business.

4. **Don't bad-mouth your competition:** Not impressed with another illustrator's work in your community? Keep it to yourself. Think camaraderie, not combat! Try to appreciate your coworker as an illustrator. It's hard to love everyone's work, but you can appreciate the time and effort they put into it.

5. **Don't bad-mouth other clients:** Networking meetings could spread this around. It's a small world, and people talk.

6. **Be prepared:** When you're out and about, be prepared that someone might ask you what you do. It's always a good time to tout yourself—you might accidentally bump into an art director at the mall, the coffee shop or in an elevator.

7. **Be professional at all times:** Carry business cards and promotional materials everywhere you go. Keep a pen and a notebook for those chance meetings. Keep a business-card folder so you can collect important people's information.

Referrals are a great way to get your name spread around with little effort. A referral is a warm contact. The person referring you has confirmed that the prospect needs what you do and wants what you have to offer. By that time, the prospect is ready, willing and able to talk with you.

We are often reluctant to ask for referrals because we don't want it to come off the wrong way, but your clients don't always understand who you might be looking for. Tell them. Be direct. State that you're looking for opportunities in the children's publishing market, for example. Do

they happen to know someone? Be open to suggestions. They may know someone you didn't think of. Just get talking.

Printing

"Tact is, after all, a kind of mind reading."
—SARAH ORNE JEWETT

I could not end this section without writing about professional printers. When you are sending out your designs to get them printed, it's good to have all the right information. Not all printers work the same way, nor do they all use the same software. It would be a lot easier if they did... but I digress.

Things to consider:

- Name all your files in a user-friendly way. Have your name on the file or save it with the embedded information in it.

- Get the printer's exact printing specifications. Do not assume they have Adobe Illustrator because some use CorelDRAW.

- Scan your art in the proper resolution so it looks as it should.

- Make sure you send the file in the right color configuration, either RGB or CMYK. This is important because it will alter the color of your work. This is especially important when it comes to skin tone. There's no need to make faces look orange.

- Send your files the easiest way possible, whether it be on an FTP server, on disk, or as a PDF. Check with the printer to see how they prefer to accept files. Again, don't assume.

- Prepare yourself to deal with printers. Some are all about customer service, and some have their ego up-front and ready to do battle with any creative that walks through the door. When all is said and done, your work needs to get printed. Remember that this is business and

not personal, so make sure you ask lots of questions and be professional at all times.

- Get a proof of your printing so you don't end up paying for something that wasn't prepared correctly or has a typo in it.

- Make sure you get an estimate for the print job (in writing, if possible). No one likes surprises!

- If your print job doesn't turn out well, let the printer know. I once got business cards printed, and because of the humidity, the ink smudged a bit. My printer offered to print them again at half price. Sometimes it isn't their fault. Technology and the weather can work against things like ink and paper.

- Be prepared to throw in a little education about what you do as an illustrator. We are all about image. You need your work to look good—not fuzzy or choppy looking. What looks good to them may look awful to you. You know what your original work looks like; they don't. Proper scanning and making sure it's either RGB or CMYK is what's required to make your work leap off the page. A little education can go a long way.

Online printers like www.moo.com make printing simple and fun. You can even join in and display online what you had printed. They love what they do, and it shows through their online community.

When your printing all works out, your promotions will be a smash. When you find a winning combination of great printing and customer service, your job will be a lot easier. It isn't fun to constantly look for printers. If you've tried and cannot find one, there are options such as online printers that allow you to send out your work and have it delivered to your door. If you try an online printer, make sure you read their specifications and understand them. Always request a proof be sent to your e-mail before you commit to the printing job. And always remember to help them help you look good!

FREE PUBLICITY

"Media publicity can do a lot more for you than feed your ego and enable you to impress strangers on airplanes."
—MARCIA YUDKIN

Anything free should be utilized if it's going to help you on your business way. Always be on the lookout for opportunities. You want to utilize every avenue to get yourself out there.

RECOMMENDED READING

Check out Marcia Yudkin's *6 Steps to Free Publicity.*

Many confuse publicity with advertising. Publicity is a free announcement about what you do and what's going on in your business. Advertising is generally done in trade magazines, online and in newspapers that will spotlight your business for a fee. Both are good to do, but when promotions are free, your business life can be so much easier.

WAYS TO GET PUBLICITY

1. Teach
2. Do seminars, presentations and conventions
3. Network
4. Join associations
5. Look for online opportunities to get spotlighted and interviewed
6. Volunteer
7. Be an advocate
8. Be an expert

> 9. Write magazine articles
>
> 10. Send out press releases

What's your news angle? Are you newsworthy? One way to approach publicity is to tell the public about what's new about your business. You can show them what makes you unique. Do you solve visual problems in your own way or approach things in a different way than other illustrators? Are you doing anything that corresponds to a current trend? There are all sorts of ways to spin it.

For Immediate Release

A press release is an announcement of some event or newsworthy tip you can send out. It can be a great way to highlight a seminar or book about to be released. You're writing about who, what, when, where and why. Make sure your press release is interesting, and make sure you understand all that goes into one. Press releases are very specific in their layout. The first line will have your name and address. The second line will contain your phone number, e-mail address and website. The next line should state *For Immediate Release*, followed by your headline. The body text should begin with the location and date. Finally, you should include all the important information in one to three paragraphs, depending on what you need. Then send it out to trade magazines, blogs, industry links and your local newspapers.

It's a good idea to announce your news in your promotional materials. If you've been mentioned on a great website, announce this to your audience. Another example is creating a promo announcing a book you illustrated. Let the public know what the book is about and when it will be on bookshelves.

List events you'll be participating in and announce them on your website, blog, group blogs and associations. Three things come from this: you

get more traffic to your sites, you become newsworthy and you are seen as an authority in your industry.

Create a media section on your website or blog compiling all your spotlights so visitors to your site can check them out. Post testimonials on your site and in your promotional materials. Always be on the look out for who's promoting you. Another tip is to Google yourself often. You may be surprised where you're mentioned. Being mentioned does more for you than just give you that fuzzy feeling; it also lets you know you're doing a great job and gives you credibility.

Get involved in discussion groups, review boards for associations, guest host on a blog and be a judge for an industry competition. Your involvement can help more than just your career—it can help the industry, too. When you maintain a great relationship with the media, it looks good for the illustration industry as well.

Another great way to be featured is by doing an industry podcast. I really enjoy listening to someone I admire. Hearing their voice makes their work more interesting and puts it on a human level. This is a friendly way to chat about your ideas, experiences and business. I highly recommend doing a podcast and listening to them often.

Podcasts can be created quite easily. Most computers come with a built-in microphone. If you want to get really high-tech, you can always invest in something that can give you more options, such as a microphone, which can be purchased through www.bluemic.com. Along with the mic, you can also throw in software like GarageBand (available through Apple at www.apple.com/ilife/garageband). This software allows you to record, edit and mix sound, along with your voice, exactly the way you want it. You can chop it up and delete what you don't want.

Once you've recorded something you feel is broadcast worthy, you can post it to iTunes by setting up an account. From there you can post it to your blog or website. One example of a site that uses podcasts is www.justonemorebook.com. This site boasts that its podcasts are "about the children's books we love and why we love them—recorded in our fa-

vourite coffee shop." Check out some other podcasts by searching the iTunes Store under "illustration podcasts." A great podcast is the Illustrative Designer Podcast by Von R. Glitschka. He interviews the best of the best in the industry—and it's free to listen!

Let's say you're not comfortable being a publicity hound. Do it often and it will become second nature. Try to think of it as you being your own public relations expert. Remember: You know yourself better than anyone else. The core of business management is to spread information to gain public awareness for your work and services. Assess your victories often because this gives you momentum, especially on those off days when nothing seems to work. Your success is important, so don't be afraid to announce it.

YOUR WEBSITE

"Technology: No Place for Wimps."
—DILBERT

Having an online portfolio is a very important asset to your career. It's much more convenient for someone to look at an online portfolio than it is to have them sit down to look at your book. And if you're tapping into international markets, an online portfolio is a must.

Make your portfolio a sight to see. Illustrator Lori Joy Smith has a really great web presence. "I rely on my website as my main portfolio. I also use Flickr to show people paintings and recent work and ideas. It's less formal. ... My main website is more for illustration work."

An important thing to consider is your domain name. Make it easy for people to find you. If you have a name that often gets misspelled, buy a few backup domains similar to your site. That way potential visitors won't be discouraged by spelling errors.

Make your site easy for people to find it and have it optimized for search engines. You can do this a few ways: You can hire a company to optimize your site; you can consistently add new material to your site, which makes

it stand out more than the dead ones; or you can link your site to a dedicated search-engine optimization site such as www.addme.com.

Having your site optimized for search engines is a handy online way to market yourself if someone is "cold searching" you. This means they're using particular words and phrases to find something specific that may be contained within your site and its text. When you add terms like *illustration* or *New York illustrators* to your copy, your site will be more visible to cold searches. Again, make it easy for people to find you.

Will you be designing your site, or will you be hiring a web designer? If you consider a web designer, make sure you lay out exactly what you want. If you're paying for a site, it had better look good. Be direct and make sure the designer involves you as the site is created. Remember, web designers aren't mind readers. If the site isn't what you envisioned, let the designer know. This is your image to the world.

If you're web savvy, design it yourself. There are many applications you can use, such as Adobe PageMill or Adobe GoLive. You don't need anything elaborate. Remember that you're an illustrator, so spotlight what you do. Images should be the most important part of your site. Make it easy for visitors to see your work, and update your site often.

Get a statistics log for your site. This allows you to see who's checking out your site and where they're coming from. You get to see what countries they're from and what they looked at. Some statistic logs even offer a section that lets you know if anything has been downloaded or hijacked; finding out these statistics also lets you know what images are popular and what might have to be deleted. You can do this by adding meter sites, such as http://sitemeter.com or www.mybloglog.com. There are many to choose from (many of them for free). Try to add the ones that will benefit you and give you the information you need. If you require something better, a web designer may be able to add something more detailed.

Consider your audience when designing a site. One of the biggest turn-offs I hear often is Flash sites. Flash sites can be a huge pain because Flash lowers usability, and it can be a distraction. Image-laden sites that move

and are complicated to navigate could work against you. Flash also excludes older browsers and versions of itself. Do you have time to upgrade your software to see what you're looking for? Neither do the potential clients who just left your site.

Broken links are another problem for your audience. Typos can also look very unprofessional, as can outdated information. But the number-one complaint I hear is that some sites have little to no mention of what the person does. If you're an illustrator, say so. Make sure your contact information is where visitors can find it easily. If they're lost on your site, they'll leave.

Lastly, create a visual experience for the viewer. Involve them and make them want to come back after they've bookmarked your site. This is your little snapshot of the magic that's you. Make it fun and inspiring.

A portfolio on a group site can be another option. There are many good ones you can sign up for on a yearly or monthly basis. The benefits to this are ease of use and an instant community. Many of these sites offer resources and a forum to discuss industry matters.

> "The Internet is like a giant jellyfish. You can't step on it. You can't go around it. You've got to get through it."
> —JOHN EVANS

YOUR BUSINESS CARD

> "Here's my card. It's got my cell number, my pager number, my home number and my other pager number. I never take vacations, I never get sick, and I don't celebrate any major holidays."
> —DWIGHT FROM *THE OFFICE*

I describe my business card as a personal swatch of style—a little snippet of who I am on a small piece of card stock. It's amazing how much information you can put onto such a small space.

Isn't it great to see your name in print? I agree. It's amazing how much you can do with this little piece of paper. Many believe business cards are

useless to illustrators. I disagree. I see them as a convenient memory aid. They're also great to collect. In fact, business-card collectors have their own association, appropriately called the International Business Card Collectors (www.ibccsite.com).

Reasons to Have a Business Card

1. They're excellent for networking and to carry with you to conferences/professional gatherings.

2. They're good to give to friends and family. It's amazing what comes up in conversations, and if your card is handy, all the better.

3. They're great for those chance encounters with interested parties—for example, in the elevator, the park or the mall. You just never know where you'll meet people who are interested in what you do or who know someone who could use your services.

4. You can add them to your promotional mailings, along with mini portfolios, newsletters, tip sheets, etc.

5. Give them to existing clients, who may use your card for referrals to their colleagues.

6. They take up very little space and can be put in a file, folder or tacked on someone's corkboard.

7. They convey your business image.

8. They make great icebreakers. A stunning card can start a conversation and questions or inquiries.

The basic essentials to your card are your name, title, company name, address, phone number(s), e-mail and website. If a potential client ends up wanting to chat with you after your meeting, make it easy for them to be able to. Spice up the card with a favorite illustration or business icon if you

Make it memorable: When it comes to business cards there's no need to be conventional.

can squeeze it in. Then add memberships, industry affiliations, associations, a funny quote, a business tip and your brand motto. Great type can make a card look like a million bucks. Remember, less is more with a card because you're generally using a 2½" x 3" (6cm x 8cm) margin. Make it too cluttered with stuff and you could lose their attention, or worse, it could end up in the trash. Remember you can always utilize the back of the card; you can use the front side for your illustration and the back for the text.

The cost of producing your business card depends on the size and how many colors you'll need printed. Unusually shaped cards will cost a lot more, and unusual materials such as plastic can add up. Keep in mind that unusually sized cards are often misplaced because they don't fit well into business-card holders.

Choose your paper wisely. A business card is also a tangible experience, so let your paper make a statement. If you go with glossy paper, make sure it doesn't mark easy if handled a lot. This could alter the look of your card.

Be on top of how many cards you have on hand so you don't run out, which is especially important before a convention or networking meeting. Don't be caught empty-handed.

There are a few problems that can come up with business cards. A weak layout can make your card look like any old card. Often there isn't enough information on the card, or it's too busy. Some clients prefer digital cards and don't want a stack of cards in a Rolodex.

Not sure what do with your old business cards that are outdated and collecting dust? They make great tags and labels. Another fun example for what to do with old business cards is the site www.gapingvoid.com, where you get to see "cartoons drawn on the back of business cards." Hugh MacLeod has created a wonderfully inspirational site spotlighting his creations. It's worth a look because it puts a whole different spin on the usual concept of business cards. Just when you thought they were only for business, you see they're fine for doodles, too.

THE NAMES WE CALL OURSELVES

"Kroger, your Delta Tau Chi name is Pinto."

"Why Pinto?"

"Why not?"

—*ANIMAL HOUSE*

Never underestimate the power of a great title. Saying you're an illustrator is one way to describe yourself, but don't forget to be creative. Identify your expertise. Tell the world what you can do.

One way to look at who you are is by the roles you play in this creative industry. I bet you have many titles you may not have thought about. Some of mine are illustrator, writer, teacher and illustration advocate. In addition to those, I am a creative consultant, painter, artist, gouache expert, organizational queen, mentor and a very busy mother, of course. Start a list. You may be very surprised what you come up with.

Great Descriptions

Von R. Glitschka defines himself as an illustrative designer.

"I never refer to myself as a freelancer. That is what I did when I worked full-time for an employer—I freelanced on the side. But I run my own business now, since 2002, and over the past six years my niche has been doing design work with an illustrative approach for larger agencies, in-house art departments and small business. I've noticed over the years that since my work has a lot of illustrative flair to it that other designers almost always refer to me as an illustrator. Then illustrators look at my work and see the design aspects of it and like to label me a designer. So I found myself in this strange creative zone where neither side viewed me correctly. Because of this situation I decided to create my own title to describe what I do, and that is 'illustrative designer.' It accurately defines who I am and what I do."

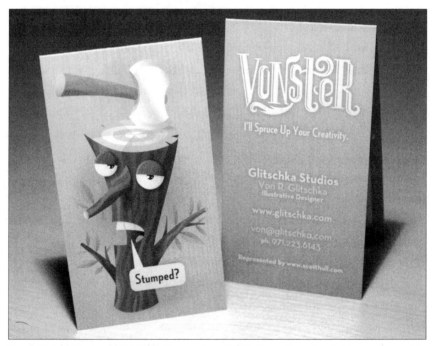

Conveying a message: Glitschka's "concept card" blends quality art and clever copy.

Some other great descriptions:

Jeff Fisher (www.jfisherlogomotives.com) is an "engineer of creative identity." His motto is "Jeff Fisher LogoMotives engineers innovative graphic identity solutions in helping businesses and organizations to get, and stay, on the right track."

Jannie Ho goes by Chickengirl (www.chickengirldesign.com), which does get your attention, mostly because it's a different yet playful way for her to describe herself. It's unconventional, and it works.

The late **Rick Tharp** created a business card that read "THARP DID IT! POODLE GROOMING, REPAIR, TAXIDERMY AND GRAPHIC DESIGN." I will never forget that card ... ever!

Holli Conger (www. holliconger studios.com) is "a girl who creates."

Ilise Benun and **Peleg Top** are the Marketing Mentors (www.marketing-mentor.com).

All these titles work because their owners have a definite reason for such titles. The titles defines their business and their expertise with a catchy, creative title that's hard to forget. Being descriptive about yourself is a great way to make a statement. The more descriptive and visual your statement, the more your audience will take notice. Make it memorable and make it part of your brand.

A great statement can be as brief as two to five words. Try your trusty thesaurus for descriptive words. Browse for buzzwords in magazines and books. Look up jargon that's often used to describe illustration and creativity. Set up a word list and start mixing and matching. Clever word tricks can help you pour on the visual charm.

The definition of *well-rounded* suggests that we have many sides. It's important to look at all that you are. There were many skill sets that came into place long before you started your business. You are more than just an illustrator; you are a big picture of all your experiences and interests.

AN EXERCISE IN PERSISTENCE

"Keep on starting, and finishing will take care of itself."
—NEIL FIORE

If there will be one constant in your career as an illustrator, it will be promotion. Promotion is like a full-time job: If you aren't at it daily, you could lose out on all those career plans you made. Promotion is the nature of the business.

There's one thing I can say about illustrators: We are a determined bunch. It isn't one job we're going after, it's many. Maybe this is why it's hard to get some people to understand what we do. Our work is based on assignments, not a constant job you clock in and out of. We have to remind possible clients that we need them to hire us—no reminder could mean no work or someone else getting the gig you wanted.

"Hey, it's my style. If you can't dazzle, wear 'em down."
—DREW CAREY

Tooting your horn is an art form unto itself—it's a skill that takes practice. A passion to create is what drives us to get our illustrations out there, and this salesmanship will get us paying jobs. We are essentially selling ourselves, our talent and our creative vision of the world—a whole package.

So what does it mean to be persistent? It means to continue or repeat behavior in order to meet a goal. Persistence is determination, continuity and a diligence of vision. You must make your work a routine. Your method will get you work if you know what fuels your creative fire. Use tried-and-true creative tactics to keep yourself moving ahead. You can even take it further by thinking of persistence as being similar to New Year's resolutions (except you must actually follow through on them). Starting is the hardest part. Finishing will take care of itself once you make that initial step.

Persistent Promotion Tips

1. **Be newsworthy:** Start your own hype through online newsletters, press releases, blogging your latest news and announcing when you've updated your website. Make it a habit to advertise your day-to-day projects, however small they may seem.

2. **Choose a different theme every month:** One month, send out postcards. The next month, send out a mini portfolio. Tell a story or make your mailers become a series. Mix it up.

3. **Try to focus on a different market to shake things up:** Set up your postcards on a monthly basis to focus on the editorial market. Then create another for children's publishing. Set up a file so you can easily send out the promotions when you need to.

4. **Develop your list:** This is your list of possibilities. Try to add dream clients to it weekly, if not daily.

5. **Get crafty:** Printing can be expensive, so use what you have or make your promotions. Not only does this say you've added a personal touch to them, it also says you're good at problem solving.

6. **Use what you have:** If you have a bunch of older cards, change them into something else.

Keep yourself in deadline mode even if you aren't consistently getting work. This can be achieved by creating projects for yourself. Pick a weekly theme. Start a new promotion project. Participate in an online illustration group theme, such as Illustration Friday, so your work can be posted for critique. This will keep you working and generating ideas. Don't stop and let the well dry up!

Continually look for clients. Update your list weekly. Pick a day where you have time to just research the Internet and add to your mailing list. Promotion is an ongoing process. Make sure you're constantly looking

for new potentials, as I call them. Try to contact these potential clients at least once a week. I make a list of five to contact each week—that way it isn't too overwhelming. Once again, set aside quiet time to do this so you're comfortable and able to get it done.

So, what should you expect when you send out mailers or e-mail promotions? I have been told there's usually about a 5 to 15 percent response. I agree. It just depends on the market and the type of mailers you're sending out. Keep a record of your promotion successes. This lets you know what's working and what isn't.

Set up a schedule every month. Pick whom you want to target and how you want to go about it. Make a chart that logs response rate to feedback. All of this combined reminds you how well you're working—plus, there won't be any chance of repeating yourself. You don't want to call the same person twice by accident, especially if they have no need for illustration right now. Also, don't forget special occasions such as Christmas, Easter, Hanukkah or Halloween. Holidays are a good excuses to get really creative.

Ask for feedback. This can be accomplished over the phone when you do a follow-up, or you can throw in a feedback card for the client to fill out and pop into the mail. Just make sure you provide postage on the response card.

Remember that promotion can be fun. You're advertising yourself, so look at it as your creative freedom. Calling attention to our talents is sometimes hard. Add some humor to lighten the task. Make your future client laugh. It's a great icebreaker!

PART TWO

GETTING DOWN TO BUSINESS

CHAPTER 4
OPEN FOR BUSINESS

"This ain't no disco. This ain't no party. This ain't no fooling around."

—TALKING HEADS

Believe it or not, business accounts for 50 percent of your time. It would be nice to come up with concepts and make illustrations all day, but you need to get your work out there. Someone has got to do all the promoting and paperwork.

When you focus on the importance of administration and marketing, this will help you feel more like you're running a business. By going beyond traditional business philosophies, you're creating a whole package of skills and experiences to grow your career. Another goal is to add economic value to your creativity, talent and business ideas

When you try unconventional business approaches to find work, they challenge you to go beyond your expectations. Keri Smith once said, "I was surprised to find that some of the things I wanted in the beginning hold no interest for me now. We shift and change and evolve into something different." I agree. We are essentially reinventing ourselves as we go along. I really did not know what to expect when I jumped into the illustration world. But I remained open and ready to try different things and also things out of character for me. I like to surprise myself.

"Creativity can solve almost any problem. The creative act, the defeat of habit by originality, overcomes everything."

—GEORGE LOIS

Don't be afraid of learning as you go in your illustration business. That's just part of being a creative problem solver. We all want to achieve success based on abilities, talent and effort. In other words, we want to get paid to think while making cool stuff!

EMPLOYMENT GROUNDWORK

"We must develop knowledge optimization initiatives to leverage our key learnings."

—DILBERT

You need to be realistic about your ability to get work. Clients aren't necessarily going to come to you. You need to hustle and to foresee where your work will be needed. Make research a habit by looking at magazines, books, making cold calls and searching the web. Success for an illustrator does not happen overnight; success is never an accident, no matter how easy it appears to others.

Your day-to-day routine will always be about accumulating ideas. Some of your research will be planned, and some of it will happen while you're out and about. Start a potentials file. This will be your contact list. Add to it on a regular basis and update it often.

Look at various markets to see if your work will be a good fit. The best place to look is the web—it's convenient, and you can bookmark sites that may interest you. Take a look to see who needs your style of art. Look at different markets and membership sites. Such markets could be children's publishing or the editorial field. On the web you can find submission guidelines on magazine sites and book publishers that tell you specifically what they require you to send. Another option is to use a directory such as the annual books *Children's Writer's & Illustrator's*

Market and *Artist's & Graphic Designer's Market.* These two books are a definite must for your bookshelf. They're great for company information, submission guidelines and updated information.

Another approach is looking for "calls for submissions." You can look for these online on such sites as http://thelittlechimpsociety.com, www.illustrationmundo.com and www.illustrationfriday.com. These sites also post the latest news and spotlight other websites that promote illustration. Looking at these sites daily keeps you informed. Much care is taken to make sure the stuff people post on these sites is legit, and if they aren't, it's often brought to the attention of the website team or made public in the forum section. Many submissions are anything from contributing to books to group shows. This could be a way to exercise your creative muscle.

The library is a great place to check out books and magazines that provide information on who to contact and where. At a library you can find a comfy chair in the corner and spend the time you need to gain as much information as you like about a particular magazine you want to submit to—plus, it's quiet.

Membership directories such as the Society of Children's Book Writers & Illustrators (www.scbwi.org) provide a resource booklet when you join. This booklet details everything from publishers to art agents. The site offers spotlights, awards and grants, news, discussion boards, links and a marketplace section. Another great thing about this site is that it has worldwide regional chapters you automatically become a member of when you join the main group. I'm a member of the society and also a member of the Canada East chapter.

Bookstores are an excellent place to gather information about publishers and magazines. Many bookstores have sections for applied art that can be very useful. Another place to look is the magazine section. They often carry unique magazines from all over the world. This is definitely a great place to add to your list.

Sometimes when I'm looking for a little inspiration, I like to hang out at stationery and gift stores. First of all, they have piles of greeting cards

and cool items that use illustrators. Bring a notebook so you can jot down the card companies and licensing companies.

The site www.etsy.com is quite an inspiring site of everything homemade. It's one of the best places to check out some truly unique work.

Your research materials are going to pile up as you go along. It's important that you file the materials in some way so you can access them easily. I believe combining them into a binder is the best format because you can organize the binder by subject and then easily find what you need.

"The creative mind plays with the object it loves."
 —CARL JUNG

Only research what you're interested in—there's no need to look up medical illustrations if that isn't your strong point. Looking to change markets? Research your new market as much as you can. Research it to death.

YOUR PORTFOLIO

"We need to talk about your flair."
 —*OFFICE SPACE*

Your portfolio holds in one place everything you can do. This portfolio can be online, in a case or in a mini promotion piece you can leave with the client. This is your visual proof of what you do. Make sure it's the best showcase of your talents so it makes a great impression to all who look at it.

I have been told that when you respect yourself and your work, it shows. Why wouldn't

Illustration by Holly DeWolf

you show your best work the best way you can? The bottom line is you want clients to notice you and respect you as well. Be proud of your body of work. You cannot afford to show anything that does not demonstrate the magic that is you!

The Printed Portfolio

It's important to consider placement in your portfolio. How you set up a portfolio adds interest for the viewer. I was taught to do the "fence post" approach: Place three good pieces, make the fourth a super piece and then place three more good ones and so on. Another approach is to make sure the portfolio looks as good backward as it does forward. You cannot always gauge what direction clients are going look at your work. They may want to go back and examine a few earlier pieces and then start flipping through again. Be prepared for all scenarios. The worst approach is to place the images in your portfolio in a descending order. If you start off with a bang, try not to bore clients as they reach the end of your book with work that does not catch their attention.

I always ask the client if they want me to discuss the work as they flip through my portfolio, or not. Some viewers want you to be silent so they can think to themselves. Whatever the style, always be respectful of their time and attention. Believe me, you are not the only talent they will be looking at in the course of a day. Be positive and open to comments and questions. If they do ask questions about your work, be helpful, not defensive or nervous, which will work against you.

Printed portfolios can be sent in the mail or be left behind after a portfolio showing. These do not need to be large. Consider their filing needs and create a folder with about four to five samples. I am a big fan of the contact sheet. This can have five small images, plus your contact information as a quick creative reminder for their files. Smaller still is a postcard, which is the right size to hang on a corkboard but big enough to fit all your important information.

The Online Portfolio

Your website portfolio will be the one you use and advertise the most. When potential clients ask you to send them your URL, it's often because websites offer ease of use and time. After the client becomes interested, they will then contact you to follow up.

I have been told that it takes an average person less than ten seconds to decide whether they want to continue looking at your site. Give them a reason to stay and look awhile by showing only your best work. Make it easy for them to navigate. Avoid filling your site with endless pages of interests and text. Focus on ease of use. Show them what you need them to see so they know what you're all about. Add a biography to introduce yourself. Add some humor and they get to see your personality.

> "Yes, words are useless! Gobble-gobble-gobble-gobble-gobble! Too much of it, darling, too much! That is why I show you my work! That is why you are here!"
> —EDNA MODE FROM *THE INCREDIBLES*

I am a big fan of an introduction page on a website. This is a friendly little welcome that says, "Hi, come on in!" Rule of thumb is to make the introduction page very simple. This is an enticing way to get clients to look at your portfolio. That's when you get to dazzle 'em with your great work.

GREAT MEMBERSHIP SITES ON WHICH TO POST YOUR ONLINE PORTFOLIO

www.creativesource.ca

www.hireanillustrator.com

www.illoz.com

www.creativeshake.com

Membership portfolio sites such as www.childrensillustrators.com and www.theispot.com are a great way to get your portfolio looked at. For a fee you get to add many pieces of work plus have access to the added benefit of resources, forums, contests and spotlights. Many in the industry look for illustrators at sites like these because, in a way, it's one-stop shopping. Just make sure you're updating frequently and joining sites that help you advertise yourself well.

Another style of an online portfolio is an illustrated blog. This can work along with your website. You can showcase your latest projects and concepts and advertise the latest news about yourself. This can allow you to play a bit while including your clients in your life and creative endeavors. A word of caution: Do not use this as a forum to air your dirty laundry, so to speak. Keep it creative, productive and informative.

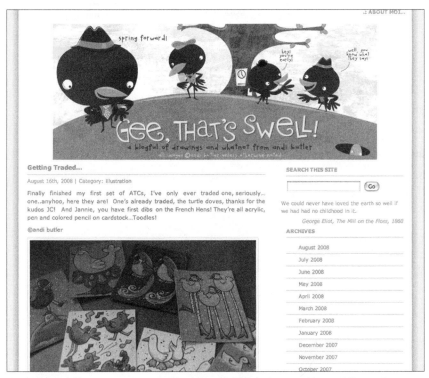

Use a blog to showcase your work: Check out Andi Butler's www.blog.msbillustrations.com

It's good to have more than one type of portfolio if you work in two or more markets. One portfolio can be for children's publishing and the other for editorial work, for example. Another online approach is to have more than one website. The queen of websites is Holli Conger. She is a whiz with the online stuff and has created many sites:

> "I kind of quit counting how many websites I have. I'm a domain-a-holic and have too many ideas floating around. Since I have a web background, I tend to code all my sites (including blogs) by hand and use Adobe GoLive for the tricky image maps."

Jannie Ho likes to have more than one site as well:

> "Currently I only have a portfolio for children's publishing, but I would love to have a separate one for my 'grown up' work for editorial/advertising. I have a website and also advertise in trade books/directories such as Picturebook with my rep's group of artists. My rep also has a presence in many of the online sites. I personally prefer the online sites since they are much more affordable than the trade books."

There's some stiff competition out there, so don't shortchange yourself by not putting yourself in the spotlight the best way possible. Ask for feedback and accept that a portfolio is never complete; you will always be adding and deleting. Always spotlight your background and skills the best way you can. Make it fun and make people want to come back.

YOUR MARKET OPTIONS

> "The artist is nothing without the gift, but the gift is nothing without work."
> **—EMILE ZOLA**

You have so many choices as an illustrator. You can decide to work in one market or many. Research these markets well in order to make your work salable before you begin sending out work.

Markets to Check Out

Children's Book Publishing

This is a rewarding market if it is right for you. Children's book publishing is considered one of the most difficult markets to get into. I asked Roz Fulcher what makes a good children's illustrator: "Tenacity. You really have to want it because it is definitely a hard market to break into and maintain. The market is flooded with great talent, and you have to keep your work current." I asked her about the challenges of working in this industry: "Making everyone happy on a project, including myself. Trusting my instincts. Not comparing myself to others, and accepting who I am as an artist—warts and all."

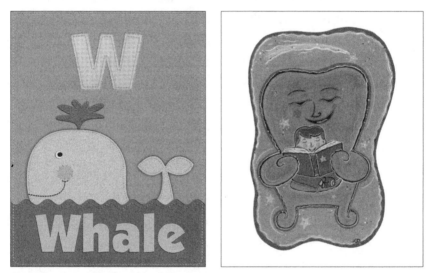

Play time: Illustrating for children's book publishing can be rewarding and fun!

Within this market you have options such as illustrating for trade books, educational books, craft books, coloring books and magazines. This is narrative work. You must be able to come up with images to go with text that inspires young readers. If you can render children and animals really well in various situations, this market may be a good fit.

The children's book industry is about creating images for book covers and also images for the interior of the book. A great cover makes a great

statement and can set the right mood for the book. Books need to stand out when in a store, so the more intriguing the cover, the more attention the book will get. An important thing to remember when illustrating book covers is that you need to read and understand the book in order to make an effective cover. It has to be an image that makes a great impact.

The challenge of this market is that it is a highly competitive one. It has a very specific and special audience: children. However, you must remember that the main buyer is of course the parent. Writing and illustrating children's books seems easy in theory but is really not. Making something creatively simple for a specific age group can be quite a challenge.

Keep in mind that this industry is very narrative based. A complete understanding of the text while creating unique, eye-catching illustrations is a must. The images must mingle well with the text.

My best advice would be to read and look at as many children's books as possible. Define what works for you. Create exercises that get you illustrating text and creating text for existing imagery. This will put the concept of the visual narrative on a different level and help you look at the children's industry with new eyes.

Magazines

Articles need images to make a statement or help explain a point. These can be full-page or spot illustrations. Small icons can be added for quick sections that highlight many different themes. Deadlines for magazines are often tight, so you need to be able to work quickly. Payment is generally set by the magazine publisher and is different for each magazine.

The magazine industry is a challenge because there are tight deadlines and is once again narrative based. If you are about to illustrate an article, you must have a complete understanding of what was written. Also, it is important that your image is understandable.

What makes this industry different is the sheer volume of material needed weekly, monthly or yearly. When pitching ideas to magazines,

you need to think about the material they're going to need in three to six months. Some even look a year in advance. So think about the future needs, such as themes to special occasions (Christmas, for example).

My advice in choosing prospective magazine clients would be to read magazines that interest you on subjects you like or about causes you support. Consider the "voice" of the magazine and the type of work it currently uses. Could your work fit in? Can you handle tight deadlines? If so, this could be a great industry fit for you.

Corporate

Imagery is important for media kits business stationery, business cards and letterheads, as well as a corporate logo.

There are specific challenges for this market: Your work must communicate its message clearly, and your imagery needs to help a company look as good as possible.

Stationery

Creating illustrations for greeting cards, wrapping paper and giftware can be exciting and can add another revenue source from royalties.

The big challenge in this industry is competition—especially when it comes to greeting cards. You must provide imagery for greeting cards well in advance for certain occasions, and you absolutely must make it as eye-catching and memorable as possible. The stationery business is all about the image!

A good way to approach this market is to think about the audience, special occasions and holidays. Look at what other illustrators are doing. If you're a digital illustrator, this market could be a perfect fit due to the sheer volume of imagery needed. Also, if you prefer to work on a smaller scale, this could be the perfect market to dive into.

Look at books that spotlight stationery, such as *The Big Book of Logos* and *The Big Book of New Design Ideas*. Pay attention to how companies advertise themselves. As for greeting cards, hang out at any card shop to see what styles and themes are being sold.

Licensing

As a licensor, you can grant use of your work to a wide range of industries, from textiles to greeting cards. The owner of the illustration work is the licensor. From there, the image becomes licensed property for the recipient, who's the licensee. An agreement must be signed, and a royalty paid to the licensor. This market requires a lot of research. You may want to look for an agent who specializes in this field. It can be a complicated process, and an agent may be able to open doors you were not aware of.

The big challenge for this industry is breaking into it. It's a tough one and can often require you to have that licensing agent. Also, you must be able to understand all the fine print, especially when it comes to your

Send something unique: Personalized stationery can also be used for promoting your work.

image rights and payment. An agent can help protect you and work out the details.

Licensing is unique because you're providing imagery for items that aren't always on paper, such as plates, wallpaper, clothing, posters or other household items. This industry allows you to tap into markets that are unexpected and different, so you will be constantly challenged on a different level than you would creating imagery just for narrative. Licensing also allows you to get decorative with your work.

Research this industry very carefully—there's a lot of information to stay on top of. If you're looking for an agent, find out exactly what they require from you so you can cater your portfolio accordingly.

Websites

Small imagery for web icons and buttons, can add much needed interest to a site, especially if the site is for a designer, advertising agency, clothing company or online art shop. Websites that are visually memorable will keep people's attention a lot more than one with only text. Creating work for websites can be a challenge because you're competing with photography; stock imagery is used quite readily. The upside is that you can provide unique illustrations that will make a website stand out from other sites that rely on stock imagery.

Get to know web designers in your local area and online, and let them know they can use you. Once again, you could be tapping into a market you might not have considered.

Packaging

Images are always needed for food packaging, cosmetics and health products, and can help those products stand out from all the others on the shelf. The next time you're out shopping, take a look around to see what works and what doesn't. Some innovative markets for packaging are natural health, sports equipment, clothing and the coffee industry.

The packaging industry is a very specialized one with the goal of making things visually attractive to prospective buyers. It can be a challenge

to break into. If you're interested in advertising trends and have a good idea of what sells, this market will be perfect for you.

Start looking at how things are packaged and how they visually stand out. Look at what works and what doesn't. Collect packaging you feel is too good for the recycle bin. Another good idea is to look at *HOW* magazine's annual design awards edition. Look at what gets people talking.

Advertising

Imagine your work on a billboard, on the side of a bus or in a magazine advertisement. Commercials that spotlight Flash illustration work are also quite eye-catching. Advertising needs to get people's attention, and illustration is a great way to break out of the norm. It can add a much needed dose of flair—something different than the usual photography.

Advertising is a very busy and demanding industry. Imagery needs to be specific to help sell ideas and products. Image is everything. The industry is highly competitive, but the pay can be good.

Make sure not to compromise your own ethics or beliefs. My best advice is always to work on things you support and believe in. If you don't believe in advertising to children, try a market you might love, such as charities or special causes. Advertising is everywhere! Big companies spend a huge amount of money each year to look good and stand out from the crowd.

On the other side of the coin, we are drowning in advertising daily. So many people are turned off by it and feel like it's too much. Make sure your work stands out as something different. Effective advertising can be memorable; bad advertising just plain annoys people. Once again, look at magazines, on the television and even at the mall. Target potential clients who you find interesting and who you think might benefit from your work.

CD Covers

Some of my favorite CDs have really great work on their covers. Industries that like to use illustrated images are the children's music market and the jazz market.

While some music packaging relies heavily on photography, there are other markets that respond well to illustration. For instance, in the children's music industry, imagery is a must. And companies like the Verve Music Group, that specializes in jazz, often use illustrations for their covers. Alternative rock music also likes to push the boundaries and stand out from the rest. Artists like Radiohead and Kid Koala adorn their CDs with art from one end to the other. These types of CDs are collector's items for some.

Look at the packaging trends for the music you love and support, and go from there. Another option is to approach local musicians in your area who are breaking out and could use imagery on their products. This could be a great way to begin in this industry and build your portfolio.

Theater

Theater groups are always in need of posters, flyers and brochures. If you like to work with text, poster work could be quite rewarding. Plus, it's nice to see your great stuff all over town.

Theater is a niche market that relies heavily on theme. Memorable posters and flyers often contain images that are on the simple side of things. Often the approach of "less is more" works best, as you might be illustrating an emotion or a scene in a poster for a play. Your imagery needs to work well from a distance, plus complement any text. One of my favorite posters is *The Mikado* by Edward Gorey. I have it on the wall in my studio.

Research theater groups in your area and see what types of productions they do. The pay may not be good in the beginning, but it could lead to long-term paying gigs down the road. This could also give you a chance to play with text and perhaps design the whole thing!

Technical and Medical

This is a very specialized industry that requires great skill. If you can render the human body well or draw a car concept, this may be for you. This is a well-paying market that demands strong drawing skills, plus the ability to render someone's ideas to make a final concept.

Attention to detail: Paul Chenard depicts a Formula 1 race at the Solitude, Germany track.

Technical illustration is not often pursued by many illustrators because of the belief that it's too boring to be so accurate in your style of working. It's true that technical illustration is very detailed and needs to represent things in almost photographic fashion, but it's also a very rewarding industry. As mentioned earlier, the pay is very good, and it's not as competitive as some other fields.

Research publishers produce medical, instructional and college books. Look at what could interest you. If you're good at the technical end of things, this could be a lucrative business, especially due to the ongoing need to update textbooks on a regular basis.

Animation

Wouldn't it be great to see your work in motion? A perfect example is illustrator Lauren Child's work for the children's show *Charlie and Lola*, which is a personal favorite of mine. Strong character and ideas are a must if you create something for the public to watch. Another example is a music video. One of my favorites is the "It's a Big World" video by children's musical artists Renee & Jeremy. It's lovely, colorful and inspiring (I play it often for my girls).

Often illustrators who first break into the children's publishing market end up having an easier go at breaking into this market. It's highly com-

petitive like the children's publishing field. If you love children's imagery, color and whimsy, this could be a good fit for you. The nice thing is that television stations such as PBS, Nickelodeon and Noggin often use illustrators for their commercials, videos, websites and packaging.

I'd advise starting in the children's publishing industry first so you can build a portfolio. It isn't an easy market to break into, but your persistence could pay off. Just get your work out there, even if it's something you produce on your own. Animate something and post it to your website, blog or on YouTube. Many newbie animators have been discovered on YouTube.

Lettering

Creating illustrations with a typographic flair is a great way to create unique letter forms. These can do more than just convey a message; they can show information in a playful and emotional way. Good examples are web banners, signage for local coffee shops, posters, fun alphabets for children, and toys or journals for teenagers to write in. Illustrators such as Linzie Hunter and Ray Fenwick are known for their text work in this area. Whenever I see their work, I know it's theirs.

Creative texting: Some great examples of typographic illustration courtesy of Jeff Andrews.

Adding narrative to your work showcases a new level of skill and could open you up to new markets such as advertising, posters, clothing and apparel or even adding fun text to snowboards.

The best way to start is by getting wordy. Add text to your images by using the computer or by adding hand-lettering. I like to illustrate lyrics from music; I often just in throw part of the text for interest. Playing with text could help you end up creating a signature "font" that can be yours and yours alone.

Cartoons and Comics

Cartooning has always been loved and collected by many people. You could create comics for the paper or start a new series. A great comic illustrator is Bonnie Timmons, whose work was added to the sitcom *Caroline in the City*. Her work is really fun and whimsical. Another style is more technical, such as Todd McFarlane's *Spawn* comic book.

McFarlane's is a unique example of another approach to getting published; alternative comics are quite popular and, once again, can open up another market for you. Some alternative comics have been adapted into animated shows and into movies. You just never know.

Do some research. See what's going on in the underground of comics, either online or at a favorite comic store. The figurative quality of your work is very important, so practice style. Make your stuff unique. A good approach is self-publishing and posting work to either a blog or website. This will help you develop a loyal fan base, which could lead to bigger things once you get known.

Information and Maps

Some magazines add mini maps to help describe the must-see events and places of interest to travelers. Another example can be posters for children. The idea is to keep things imaginative and decorative. There's no need to be technical with this market. Add your own flair!

Tourism boards always need maps and guides. Magazines often use whimsical maps to point out where to find places to visit or shop. A good

example is *Country Living* magazine. They use small fun maps to show the latest antiques fair or best B and B.

Contact your local tourism boards, magazines that specialize in travel or even the hotel industry. Keep in mind that these places do need to convey directions, so don't play with scale and text.

UNCONVENTIONAL MARKETS

"A discovery is said to be an accident meeting a prepared mind."
—ALBERT SZENT-GYÖRGYI

Illustrators today need to be very innovative and creative to find steady, rewarding work. The goals for many illustrators are constant assignments that lead to a successful career. No one wants a dry spell.

Why do so many illustrators gravitate to the obvious marketing routes, not stopping to take the time to discover and pursue unconventional markets? While it's great to work for designers and publishers, there are some hidden opportunities that may interest you. Your creative business will benefit from opportunities that could be right under your nose. All you have to do is look around.

You would still be creative regardless of who liked your work or who paid you for it. Your talent comes naturally. Making a business out of your illustrations helps when you take the concept of marketability up a notch. Using any and all experiences and interests to help your business grow will be an asset. Realizing all the markets that can use your illustrations will save you from dry spells in any one of them.

Looking at the unique things other illustrators are doing is one way to come up with a list of markets. Illustrator Gary Baseman has a line of collector vinyl toys. He also creates paintings and sells posters, lunch boxes and T-shirts on his website. Keri Smith describes herself as an illustrator, author and guerrilla artist. She has a collection of books that focus on creativity, such as *Living Out Loud* and *Wreck This Journal*. Claudine Hellmuth creates custom artwork that combines photos, paint, paper

and pen into fun collages. Claudine also does workshops and has been published, and she has been on such TV shows as *The Martha Stewart Show* and *I Want That!*

Another great example is Tony Dusko's efforts with creative problem solving through animation. He creates animations for his fifth-grade students as a way to teach. It all started with the challenge to get his students ready for lunch: A talking grilled-cheese sandwich did the trick. He now has created many animations, such as *Homework Hero, Some Facts About Owls* and *How to Take Care of a Pet.* His efforts were rewarded for an animation called *What Is a Friend?*—he received Best of Festival at the Mobifest Toronto film festival in 2007 for it. He now has created a site called www.notebookbabies.com that showcases all his work. Tony saw a need and filled it with a little bit of silliness, funny characters and a whole lot of creativity.

Income Streams

We all could use more income—who couldn't? More income has many benefits, such as flexibility to pursue your favorite pastimes, travel, more education and most likely an overall better quality of life. By treating your illustration career as an enjoyable task instead of a job, it no longer feels like work. An illustration career in essence is living the creative life. Making a good living at it makes your life all the sweeter.

There are obvious businesses that need our creative expertise, and then there are hidden gems we may not be focusing on. We get busy with our daily routines by focusing on what we always do. Looking around every corner for more publicity is a good career move. Consider publicity a side project. Recognize a need for your work and fill it. The results of this could be more income, variety, creativity and fans.

Variety is the spice of the creative life. If we don't add some variety from time to time, we could stagnate and get bored by the usual routines. It's hard to feel creative when you're frustrated by projects that don't inspire

you. We all want to have work that's exciting instead of taking on any old assignment that comes our way. We need to nurture our creative spirit daily, and a good way to do that is by adding new ideas, concepts and possible new projects to tickle your big, innovative brain. Taking on the unusual makes easier our tedious tasks.

Variety helps you find a diverse group of admirers of your work, which can create more work for you as well. An admirer of your work will be on the lookout to see what you're creating by Googling you, reading your blog and linking to your website. They will buy your work, prints and other goodies. They will spread your name around, and you could then get spotlighted on various sites on the Internet. Your admirers could become your very own creative community. What does all this have to do with unconventional markets? Unconventional markets become another avenue to promote yourself to people who would like nothing better than to see you succeed. Your fans will, in essence, promote you.

Remember the 20/80 rule. Take a good look at your business, where the money is coming from and focus on that.

Big Thinking

"Creativity involves breaking out of established patterns in order to look at things in a different way."
—EDWARD DE BONO

Being an illustrator in business means living the experimental life. Targeting unconventional markets is a way of giving future clients what they didn't know they needed. You're creating work for clients you didn't know needed you. Talking about your career to those who don't understand what illustration is all about is a great way to educate a possible client. Expecting a potential business client to understand immediately is often shortsighted. A little explanation could go a long way.

Some Unconventional Markets

Art Galleries

Many illustrators consider themselves artists as well. There are many benefits to creating art for art galleries; it might a break from your usual style of work.

Unique Stationery

Stay-at-home moms or dads may want something to hand out to other parents for playdates or parties, such as calling cards. Calling cards are simple but can be designed with style. Greeting cards can be sold at art shops, galleries and gift shops and can be handmade or professionally printed. This could lead to a side business.

Postage Stamps

Illustrating stamps would definitely get your work seen. It would be seen all over the world!

Selling Prints

There are many online print companies, such as www.thumbtackpress.com, that showcase unique illustrated prints. Another way is to sell them on your website.

T-Shirts

Creating work for T-shirts for online companies like www.threadless.com could attract attention to you and your work. Once again, you could also sell them on your website.

Licensing Your Work

You can work with a licensing company or agent by lending your art to things like wallpaper, toys, giftware, games, children's clothing, snowboards, skateboards, fabric, household goods—the list goes on. In many cases licensed work is paid in the form of royalties or a flat fee. Not a bad gig, if you can get it.

Architecture Firms

If you like the technical side of illustration, architects may be able to use you for concepts. You may be able to show a building, living space or home addition from a different perspective.

Real Estate Brokers

Real estate brokers may need your talents to help sell a house. Many home-owners hire companies that offer home staging, which dolls up a house to make it more visually appealing. The concept here is that an empty house is a hard sell, but an inspiring house is more attractive. Showcasing some of your work could help.

Interior Decorators

Your work could be used in a children's space or an office in need of something unique. You may be able to sell paintings, prints or paint images or text to be used right on the walls.

Universities and Colleges

Higher education needs posters, billboards, banners, brochure illustrations and website illustrations on an ongoing basis.

Dance Clubs

Dance clubs may need posters, postcards or stickers to showcase their unique style, deejays and groups they may be promoting.

Pet Portraiture

People take their pets very seriously. They want their pets to have great stuff, too, and are willing to pay for something a little different than the usual photograph. Pet portraiture could be another option if you're into the furry-friend variety.

Charities

If there's a cause you believe in and support, you may be able to contribute work for brochures and auctions as well as images for their website. You're giving your time by lending your work and creativity.

Call for Submissions

Always be on the lookout for magazines, book publishers, illustrator showcases and galleries looking for illustrators to show work. Look for legitimate needs listed on sites such as www.illustrationmundo.com, http://drawn.ca and http://thelittlechimpsociety.com.

Website Designers

Colorful banners, moving Flash illustrations and link buttons can really add visual punch to any site. Spot illustrations can really make a website come alive and stand out from the usual text and photographs.

Coffee Shops

Many caffeine-fueled businesses like to have creative signs, stationery and art on the walls. The shops sell not only a great cup of joe but also a great atmosphere.

Handmade Items

Online shops, such as www.etsy.com, can help you sell great collectibles such as prints, T-shirts, toys and other items you love to make.

Get Published

Writing and illustrating children's books, writing about a technique or writing about the business of illustration not only establishes you as an illustrator but can open up many doors.

Teaching

If you like mentoring, take it to the classroom. There are many art institutions that really should teach illustration and don't. Could you create a world-class illustration department at a local art school? Too many illustrators are training themselves but could use classes on creative business. There's a huge need for this.

Propose an Idea

If you see a business or industry you feel could use illustrations, throw yourself out there. You never know what might happen if you open their

minds to another way of doing things. It could lead to a job or, better yet, steady gig.

Small Business
Many small businesses need logos or business icons as well as promotional stationery such as mailers, business cards and letterhead.

Become an Illustration Advocate
If you love illustration and want to see it succeed, write about it, talk about it and blog about it. We need more people promoting this industry. This not only gets you attention but will establish you as an expert in your field because you'll be letting people know what you're passionate about. Illustration is important. Spread the word.

Start a Campaign
Your city or town needs more illustration! Advertise your industry. Doing so will put illustration out there while you enjoy the benefit of advertising yourself.

Growth

"If I create from the heart, almost everything works; if from the head, almost nothing."
—MARC CHAGALL

There's an expression that says a finished person is a boring person. I say never feel finished. Always keep your eyes open for new challenges. Illustration careers are evolved through many actions and strategies. Sometimes a few mistakes can happen along the way. Look at your challenges as part of the process to reach your goals. How you visualize your ideal professional career will help you achieve it. It *is* possible. Remember, whether you think you can or can't, you're right!

We all want to achieve success based on abilities, talent and effort. We want to get paid for our time and expertise. Constantly being aware of the

economic value of your work will help you create the career you want and make the illustration industry stronger. Then you're in business!

CREATE YOUR OWN JOB OPPORTUNITY

"Those who create are rare; those who cannot are numerous. Therefore, the latter are stronger."
—COCO CHANEL

So you may have a work dilemma: You have hit a dry spell, or worse, no one will hire you. What do you do? This is the time to consider creating your own opportunity. This concept confuses some illustrators because we're so client based. Job seeking almost always brings the customer to mind. If you're client deprived, you're really going to have to try another approach.

It's time to sit down with a notebook and come up with new ways to make jobs. Create a resource file of ways to make money from your talent. Check out local businesses, your art community and troll online.

Get Published

There are plenty of markets that could use your expertise and imagination. Trade magazines are always looking for tips, advice and industry-related news. You could try writing and illustrating a children's book. How about a gift book spotlighting illustrations, accompanied by some poetry? The ideas are endless.

Build It and They Will Come

Ever think of making what you do the product? Set up a shop on your own site. The benefits from this are establishing variety, creating a fan base, gathering extra revenue and adding another service you can provide. Instead of posting your shop on a group site and losing out on commission, do it yourself.

Another approach is creating custom work. This is a wise approach that can open many possibilities, such as children's room art or framed prints for a baby's room. Kids are big business these days. Some folks are quite willing to pay big bucks to create a unique room or playroom for their kids.

Jump Into the Art Market

Nowadays, the line separating illustration and art is often blurred. This can be an opportunity for you. One approach is to resell your work to another market. Be careful that the work you attempt to sell to the art market isn't part of one of your clients' business identity. Art galleries are always looking to feature local talent. You may be given the opportunity to have a solo

Illustration by Holly DeWolf

show or be asked to contribute to a group show. Propose a great theme to a gallery owner, and this could spark interest in what you can display.

Local art shops like to sell work from regional artists and artisans. Local art collectives have annual art weeks or "art in the park" events, which could be a great way to sell prints, greeting cards, postcards and other handmade items.

Coffee shops and restaurants like to bring art into the atmosphere, which is nice way to propose a theme—such as a series of coffee cups painted in various styles—to percolate the right audience.

Local competitions can spark other people's interest in your various talents, but make sure the contests are legitimate and professional. Often the contests have a traveling show to go along with the winning work.

Exhibitions that raise money for a good cause are another way to bring attention to what you do. I once painted a banner for a local art community where all the banners were to be auctioned off. The proceeds of the money went to local art groups that taught art to children. I was all for that.

Bartering for services you need could help as well. When bartering services, you're trading your time for someone else's specialized time. Your friend may need an image for a business card, and you need them to fix your plumbing. Some cities actually have bartering associations you can join. They not only provide bartering opportunities but also keep things very professional.

Teach illustration or creative business at a local school. You not only get to help aspiring illustrators, but you'll be seen as an expert in your field.

We all love to get paid for innovation and problem solving, and you may achieve this by looking at what you can offer to various markets or to your community or by coming up with your own projects. Don't be afraid to cross the boundaries every once in a while; doing so opens new doors and allows you to find new contacts. The more networking you do, the more opportunities you'll create for yourself. There are opportunities everywhere.

PASSIVE INCOME

"... Every joy is gain, and gain is gain, however small."
—ROBERT BROWNING

Having passive income is a way of letting your work do the work for you while you're doing something else. You are in essence producing images for such things as products or books, which then adds to your earnings. Royalties are a great addition to your business, but they require some negotiating on your part. If you aren't good at that sort of thing, you can always hire an agent or a lawyer.

Books

Children's illustrators and writers are generally paid royalties based on their book sales. Make sure you know the difference between advances and royalties. An advance on a book is an up-front payment to you, usually made at the time the contract is signed. An advance is almost always credited against future royalties, unless the agreement states otherwise. An advance isn't normally refundable to the publisher, provided the author/illustrator fulfills his part of the contract.

Many often prefer royalties to a "flat fee" type of payment because you benefit by receiving a percentage of the ongoing sales of a book.

Advertising and Affiliate Programs

You can generate additional income by adding advertising to your website or blog or by participating in affiliate programs. Which is to say that online stores (such as www.amazon.com and www.bookcloseouts .com) offer programs in which you can refer your visitors to their site to learn more about a book or product. On your site you can spotlight specific books you recommend, such as industry books (or advertise your own!). You can make up to 20 percent of referred sales. Make sure ads are placed tastefully to the side and not in the way of the true purpose of your site.

Be aware that clients may not appreciate a lot of advertising popping up all over your site.

THINGS TO CONSIDER WHEN ADDING ADVERTISING

1. You may lose readership because your potential clients may not believe in your advertising choices. Many people already feel swamped by advertising.

2. Only advertise things you believe in, use and support.

> 3. Make sure your information stands out more than the advertising. Avoid pop-up windows that try to sell something.

Make sure the advertising isn't a deterrent for those who frequent your site. If it does become a bother, consider removing the ads or set up another blog that isn't business based, such as a one about books or hobbies. You may even develop a whole new audience.

Licensing

When you license your artwork, you retain copyright over your work while someone makes and sells your illustration on merchandise such as toys or wallpaper. In return for granting the license, you receive a royalty payment determined by the company that's hired you. You'll receive a continuing payment based upon a percentage of the income from sales of the item featuring the licensed artwork.

Online Marketplace

Online sites such as www.etsy.com allow you to sell handmade items such as greeting cards and prints. Their purpose is to unite buyers with sellers of unique handmade items. With Etsy, there's a 3.5 percent sales fee when someone purchases your work, plus a small fee for listing your items. Their motto is "Your place to buy & sell all things handmade."

Your Own Online Shop

Some of us want to control the earnings and how much we want to sell. If so, you might want to set up a shop on your own website. A PayPal account can be used to keep everything safe. Plus, you can add a personal touch when you mail your item.

We all want to achieve financial independence and have a greater freedom of choice. The thing to consider when adding licensing, advertising and sales to our already busy careers is that these things will take some time to set up and maintain. Make sure it's worth the time and effort.

YOUR BUSINESS PHILOSOPHY

"There's a difference between a philosophy and a bumper sticker."
—CHARLES M. SCHULZ

We all have beliefs and ethics we stand behind. Your philosophy explains your approach to work, and others know what to expect from you when you stand by your beliefs. Your clients will have confidence working with you.

Your beliefs cannot stand on a weak foundation. Try to remember that when you offer the best, you're working on your future successes down the road. Philosophies are useful when you think about morals, rights and wrongs. What do you think can help grow your business? Define what's important to you. There are some jobs we won't take or places we won't post our work by choice. If you don't believe in a market that wants your work, you have to ask yourself if it's worth compromising your convictions just for a paying job.

Are there things you would never do, types of markets you would never work in? Things to consider are unethical companies or companies that have bad reputations. It helps when you believe in the people you're doing work for. Remember, you're looking for good, positive and professional working relationships. If you feel you cannot trust a possible client, move on.

What's your mission statement? We all see them, especially on résumés. Think of it as your personal statement. Sum up your strengths in one quick sentence. A perfect example is Jeff Fisher's statement, "LogoMotives engineers innovative graphic identity solutions in helping businesses and organizations to get, and stay, on the right track." There you go!

How do you approach your business? I often tell myself to "run if the job and the client aren't any fun!" I follow my gut. I take on work only if I believe in it and if it seems like a sound career move for me. Now that I'm more settled into my career, I feel I can be more choosy. I have also learned from experience that when you get a bad feeling, it doesn't go away. I took a job once that I ended up resenting. I felt miserable while working on it, and when I got paid I almost didn't want the money. It was a huge learning experience I never care to repeat.

Taking the money and running isn't a great way to approach a long-term business. Doing work for companies that "don't pay but will give you free advertising" is questionable as well. Unfortunately, these sites, magazines and companies are taking advantage of many aspiring illustrators who may not realize this is unethical. It also makes the illustration industry look bad when uninformed illustrators agree to do this. Many industry leaders have worked very hard to establish ethical guidelines to help improve the industry, but many young guns are taking the approach that they can do whatever they want to do. Some aren't interested in being involved in the industry community and are doing a disservice to themselves as well as the industry as a whole. It's unfortunate.

So, who put the "free" in freelance? Free isn't part of my working philosophy unless I'm doing work for a charity. It's a recognized term (hence the book title), but not one I personally prefer. It was a buzzword in the eighties and nineties and now sounds dated to me. To me *freelance* sounds temporary, like the line "Here today, gone tomorrow." I prefer to call myself a business or a self-employed illustrator. I'm here for the long haul.

A good rule of thumb is to be up front about your beliefs. This lets your audience know you're in control and are confident in your business. Being direct means you're secure about what you do and who you are. When you're wishy-washy, people fill in their own blanks and could categorize you in a way that doesn't describe you best. Never let them guess.

COPYRIGHT AND OTHER ISSUES

"Common courtesy ... isn't."

—ANONYMOUS

Copyright is in the media a lot these days, from music to art; it's getting confusing for many of us. Just when you have it all sorted out, someone changes the rules on you. My best advice is never to assume a copyright symbol is enough.

Stay informed and read everything, no matter how technical. Remember: This is your work, your future and your ideas that need protecting. Every country has its own approach to copyright. Make sure you know where your country stands on the issue, but also be informed about other countries. Know your rights.

Another rule is to read the fine print when posting work to free online communities. Some sites have terms and conditions that essentially take over whatever's posted on their site. After that, it's fair game to use your writing or images and do what they want with it. They could create a library of stock imagery; they could sell, alter, publicly display and distribute it anywhere or to anyone. You may have the original, but the online world has its own rules. The unfortunate thing is some companies bank on people not reading the fine print. Don't let anyone hijack your images. Read everything before you post. If the company doesn't have any "fine print" listed, write them a note asking them what the terms and conditions are. You have the right to be online. Just make sure you protect yourself and your work.

I asked Jannie Ho what she does to protect herself online. "I do have concerns about my work being online and try to add my name and web address on most images."

Consider adding watermarks to your work. Many illustrators do this, but don't be surprised if potential clients don't like it. Many see it as a distraction. Another solution often used is to add text right on the image. Again, make sure your audience can see the work. Always have

your name in clear sight, plus a copyright symbol. Keep your images at a low resolution, like seventy-two dpi. If possible, make sure you personally sign your work. Many illustrators add a note on their websites to discourage theft, such as "Stealing is not cool," or "Please enjoy but do not copy my work." There are many ways to add your own personal spin but still get the point across.

When situations arise that involve stolen work many different reactions may occur. Some are angered, some post it all over the Internet to drive attention to the plagiarizer in question, some see it as free publicity and others take legal action. One thing's for certain: Illustrators do not like it when someone is unethical with their work. Illustrators are a tight-knit bunch that want their industry to be great. No one likes it when someone messes with their industry and their right to make a living from their work. Get involved. When you speak up, it makes the industry stronger.

ACCOUNT FOR EVERYTHING

"So much crap they had to start a second pile."
—MIMI BOBEK FROM *THE DREW CAREY SHOW*

Organization is the anal-retentive part of our careers. Not many of us can hire an office assistant, so we have to make do and wrestle with all that paper ourselves. We aren't born organizers; it takes practice and good planning. I believe in buckets, baskets, filing cabinets and folders. If these ingredients weren't part of my office, I would be swimming in paper.

Is it just me, or does paper seem to multiply on its own? I am amazed at the state of my office when I get busy—it looks like some entity walked in and took over. I make it a habit to exorcise the paper demons on a regular basis. Your office is your control center, so make sure you don't lose your mind trying to find stuff.

Keys to Organization

Your Filing Cabinet

This system allows you to store information you may not be looking at regularly, such as tax files and bank statements. Organize them well so when, or if, you need them, you aren't left tearing your poor office apart.

Your Desk File Holder

This handy-dandy desk system is good for paperwork you need all the time. Set up files for receipts, spotlights, submission guidelines, invoices, time sheets, membership information and password lists, bills, expenses and a promotion schedule file.

Baskets, Buckets and Containers

These catchalls are great when you have no time to organize. One bin can be for mail and another can be for invoices pending. If you have a mishmash of paper, throw it into a basket to be dealt with later.

Your Recycling Bin

Creatives go through a lot of paper in the course of a year. We need a recycle bin conveniently placed near a paper shredder. No need to add to the landfill. Recycle what you can. Shred your old mail and old bills you may not need anymore.

Your Home Safe

These handy containers protect your valuable work, disks, photos, passports, contracts and other important documents from fire, theft and water. You can choose a small home safe or one the size of your TV. No space for one? Mount one on or in the wall.

File Storage System

File storage systems are good to have as a backup system for your computer. Instead of throwing everything onto a disk, try an external hard drive to store important projects, work, photos and other documents. Their small size makes it easy to take with you if you travel.

Shelving and More Shelving

Shelving is essential for books, trade magazines, paper, envelopes, your promotional materials and extra supplies. Shelves can also be a great place to stuff those baskets to get them out of the way.

CREATIVE MANAGEMENT

"The power of the oak is in the acorn."
—JOSEPH CAMPBELL

When we become established in our illustration business, we have the option of hiring help. A professional agent can provide this help. First you need to establish why you might need an agent. An agent can open doors for you into new markets. Steady work is another good reason to seek assistance. You may be at a point in your career where you just want to create without all the marketing and business stuff taking up your time.

Illustrator Susan Mitchell says an agent has given her more freedom. "For me, it made a huge difference. It's a big weight off my shoulders to know that the agency will deal with all the contracts and paperwork and will push to get the best budget that they can for me. For an agent to consider signing you, they need to see a strong and consistent body of work. If you want to work in children's illustration, they want to see good samples of kids in different situations and varied compositions, as well as pieces that tell stories. If you have ever had work published professionally, I think it really helps, even if it is a piece in a magazine."

An agent relationship can be described like a good marriage: When two great minds come together, great things can happen, but it has to work for both parties involved. It's a business relationship in which you are hiring someone to market you, and you need to keep your work marketable for them. An agent needs to be confident that you can follow through on a project, respect deadlines and deliver great work.

"Opportunity is missed by most people because it is dressed in overalls and it looks like work."

—THOMAS EDISON

The illustration agent Anna Goodson (www.agoodson.com) describes her business this way: "We handle all aspects of business development, marketing of the artists, promoting the artists, do public relations, accounts payable and receivables among many other things that we do for free. We also pay a percentage of our artist's participation in all contests that they choose to partake in. We offer expertise in setting up our artist's portfolios and work with them to best present their work."

The best place to look for agents is on the Internet because you get to read up on what the agents do and why they represent the illustrators they represent. Doing an inventory of who they take on can give you an indication whether your work could fit or not. You can also look up their submission guidelines to see if they're still accepting new clients. As a rule, it's good to submit and contact agents the way they describe in their guidelines. Never assume you can always call or send a PDF promotion through e-mail. Every agency is different. Some prefer a link to your website, and others want something for their files. Follow up if doing so is requested in their guidelines. Some agencies indicate they'll contact you only if they're interested. Keep in mind that they receive many contacts in a week.

When shopping around, ask yourself how you might fit the various agencies you see. Look to see if they prefer variety or want all the talent to be a certain style. Look at their client and project list. See how many illustrators they represent. Too many illustrators could mean your work might be overlooked. Too few illustrators could be a red flag that the agency isn't professional enough. Remember that an agent needs to be working in your best interest.

Some agencies offer free portfolio reviews and good advice for aspiring illustrators. If an agent asks for a portfolio review fee, just make sure the

agency is legitimate and that it's worth the expense. This isn't the usual approach, so be careful before sending any money.

THINGS TO CONSIDER WHEN SEEKING AN AGENT

1. How willing are they to give advice and critiques?
2. Ask them how involved they are in the industry and in online groups.
3. Ask where they advertise the illustrators they represent.
4. What ways do they promote their talent—mailers, sourcebooks, online, newsletters, websites?

Some agents represent illustrators who write. Some like to focus on specific markets, such as children's publishing or licensing. If your work is very specific, such as children's art, an agent may be the perfect fit.

I asked Holli Conger how an agent has helped her career.

"My agent is awesome, and I tell everyone I can that she is. She is very attentive and has really allowed me to step away from wheeling and dealing with clients and trying to get them to pay. Having her for my business has allowed me to just create and not worry about the administrative things. She does get me a good bit of work, but I think I am as successful as I am because I have two cheerleaders out there for me. Her and myself. She never wants me to shortchange myself even though she would benefit from it (taking her percentage of the fee).

"I never really thought about getting a rep when I first started illustrating. I didn't know how they worked, and I thought an illustrator had to be superexperienced to sign with an agent. When my goal of giving myself a year to be a full-time illustrator and stay-at-home mom was coming to the twelve-month point, I decided to e-mail some agents specializing in children's illustration, and I found my current agent that way."

The underlining thing to consider is flexibility. You are hiring help, not a dictator. If you need to pursue other types of work, you'll have to address that up front. Remember to ask as many questions as possible and get as much information as you can before signing anything.

As you go along, you may realize you don't need an agent at all. *Should* you be represented? Anna Goodson had this to say: "Not all illustrators should be represented, only the ones that really want to be. If an illustrator has the time to do all that a rep or agent does, then when do they find the time to illustrate? At [Anna Goodson Management], there are four women working full-time, about one hundred sixty hours a week. They handle all the business development, marketing, promoting, advertising, public relations, preparing of quotes, negotiating billing, etc. All this for a 25 percent commission of the business that they bring in. If any illustrator doesn't see the advantage in having a great rep, then they shouldn't have one."

Susan Mitchell believes hiring an agent was the right choice for her. "It's hard, however, to say if an agent is for everyone. I tried for a couple of years on my own, but in the end signing with a rep was the right choice for me. You do have to accept that 25 percent of your fee goes to the agency, [but] since a good rep is more adept at making sure you are paid the most possible for each job, it should come out even in the end. Working without an agent, I would have to negotiate contracts by myself, and that can be time-consuming and stressful sometimes when there are items you disagree with. Here, an agent is usually much more experienced and makes sure that any agreement is fair."

I have been told that when an illustrator doesn't need an agent is generally when the agent needs us. I think what this statement means is that when we are established, experienced and confident in our ability, we are seen as a good fit. I can appreciate the risk an agent might feel when taking on talent. Agents need to feel confident that you're worth the time, money and effort. This doesn't mean agents never take on newbies. They're looking for a whole package of skills, including talent, professionalism and character. If you can produce what they're looking for, you could be asked to join their creative team.

CHAPTER 5
AT YOUR SERVICE

"Nature gave us one tongue and two ears
so we could hear twice as much as we speak."
—EPICTETUS

One of the most important aspects of your career is taking care of your clients. Your clients are your customers. You're providing a creative customer service they need. Treat your clients well and strive to understand what they want. Always remember to mingle your own creative needs with the needs of the client—it's a package deal.

Your service is images. Your clients hire you because they don't have your skill. You and your clients are therefore looking at a project from two different perspectives: The clients are the business side, and you are the creative side. If you're working for a book publisher, you need to keep the publisher and story writer in mind so you can interpret the text the best way possible. You must follow instructions, suggestions, deadlines and the voice of the book, for instance.

Remember that clients have just as much on the line as you do. When projects don't work out, they have a lot of explaining to do to *their* clients, too. Missed deadlines and miscommunication can delay projects—or the project could be terminated altogether. No one wins. When everything

works out, your clients get a pat on the back, which in turn gets you a pat on the back. Getting paid for a job well done is your reward. This builds trust and can lead to more work down the road.

"Empathy is one of the best indicators of maturity."
—SAM HORN, AUTHOR OF TONGUE FU

A good approach when dealing with clients is to use common sense. Provide the type of service you would expect to get. Be open. Be friendly. Above all, be flexible. Problem solving will help you come up with ideas. View customer service as problem solving as well. Your number-one job when working with a client is to listen to them.

How to Be a Better Listener

- **Practice active listening:** This involves asking a question and then repeating your client's response to give your client confidence that you're really participating in the conversation. For example, "What I heard you say is you need the illustration to have a dreamlike quality to it. Is that correct?"

- **Remain open:** We all have the bad habit of drifting off during a conversation. We go into our creative minds and fill in the blanks without even realizing it. Be aware of what shuts down your listening. Avoid evaluating and making judgments as the client talks. Save that for later when you're mulling over the conversation while getting down to work.

- **Pay attention:** Can you tell when someone is really listening to you? Recognize any bad habits and take stock to see if you're doing any of them yourself. If you're meeting in person, always look at the client while they speak. While on the phone, say things like "ah-ha" or "mmm"—that way, the client knows you're following along and understanding their ideas. Complete silence on the phone can give the impression you're asleep.

- **Be patient:** Get all the information before you respond. Our brains can think up more words than what we can physically speak. This means when your client is quiet between sentences, they might be trying to figure out a way to say what they're thinking. Avoid filling that quiet time with your own information. Stay focused on them until they're completely finished.

- **Be empathetic:** This involves imagination, so it will be an easy task for any illustrator. Empathy means respecting and understanding where your client is coming from. Take a walk in their shoes. This involves understanding and accepting their feelings and opinions. Your client needs to be reassured that you're hearing them out.

- **Body language:** Be watchful of the client's nonverbal cues. It's said that body language accounts for 75 percent of all communication. Look for clues. How is their posture? Do they seem nervous? Are they avoiding eye contact? Actively listening may help them feel more at ease. Being cool, calm and collected can be contagious.

- **Remove distractions:** Create an environment that allows you to hear well. Turn down the music. Shut the door if the kids are screaming. Better yet, if it's noisy, set up a better time to talk when you know it will be quiet. You need to be motivated to listen. You also need to be available to listen. It's important for both sides to be heard and understood.

Illustration requires that you visualize what your client needs, which means you need a mix of intuition, communication and sometimes mind reading (well, maybe not mind reading, but it can certainly feel that way sometimes). Let's call it trial and error while coming up with ideas. Some concepts work, and some don't. That's why we call it problem solving.

"I speak BASIC to clients, 1-2-3 to management, and mumble to myself."
—UNKNOWN

Good customer service goes beyond the studio. Be professional on the phone and online. Your blog shouldn't be your own personal complaint department—file that stuff under "confidential" rather than for public viewing. Professionalism involves online networking groups, too. Some sites have a "what are you doing right now" section you can post on. If you've just had it out with your girlfriend or had a bad day, this isn't the place to complain. Think ahead—you just never know who might be a fan. You never know who might be reading your thoughts!

DEFINE YOUR DREAM CLIENT

"I don't build in order to have clients. I have clients in order to build."
—AYN RAND

There are clients, and then there are dream clients. Why send your work just anywhere when you could send it to someone who could give you work that goes beyond your dreams? There is no rule saying you have to start small.

Illustrator and designer Jeff Andrews thinks on a large scale. "Since the beginning of my career I've wanted to design something on a national or even global scale. As a young design student I had dreams of designing something as recognizable as the Coca-Cola logo. In the grand scheme, I'm a small fish in a huge pond, but a guy's got to dream, right?"

Something to consider when poking around for clients is familiarizing yourself with their company. What do they value? Who are their competitors? Get a big picture of what illustrators they've used in the past. Do they follow trends? What kinds of products or services do they promote? Ask yourself where you could fit in.

"No one is going to pay you just so you can pay your bills. They want to know what kind of job you'll do and why they should hire you in particular."
—KATE MCATEER

Another big question to ask yourself is why should they hire you? Your work needs to be marketable, especially if you're targeting a specific company, such as a children's publisher, that relies heavily on imagery to sell books. Make sure you know the best way to get their attention. Just sending a postcard with your contact information will not make you stand out from the competition. You need to give them a reason to buy what you're selling. Tell them what you're good at, such as illustrating children interacting or images that focus on a particular theme. List your accomplishments, such as creating a series of illustrations for a pet store that involved packaging, signage and their corporate identity. Let them know how this increased sales and made your client stand out from other pet stores. Show them how your work can benefit them. Do they need an illustrator who can represent the human form well? Do they need an illustrator who can hand-render type? Show them what you can do. Potential clients don't have time to guess.

Closely examine your strengths and weaknesses. This is sort of like doing inventory of your work. Ask colleagues, friends or family questions about your work. Ask them if your images would be better suited for children's publishing instead of trade publishing. Ask them if they see what you see in your work. Ask them to be honest about what's good and what needs to be improved. Think of this as your very own focus group. Feedback is crucial.

"There is only one way ... to get anybody to do anything. And that is by making the other person want to do it."
—DALE CARNEGIE

You would never buy a product if its packaging or commercials didn't tell you its benefits. A statement such as "The best cup of coffee outside a café" sounds better than "Try our coffee. It's good." One of my favorite things in life is a good cup of joe, and the latter statement would never get my attention. This is how potential clients look at illustrators who send them promotional materials. The competition is huge in illustration.

Define what makes you unique and what services separate you from the crowd. There's room for you at the top, but you must have a reason for being up there.

I have a lengthy dream-client list I've been building since I graduated from art school. A list like this is good for two reasons: It keeps me motivated, and it keeps me open to future opportunities that could be around the corner. Have you always wanted to illustrate a cover for *The New Yorker* magazine? Put it on the list. Ask yourself how could this happen. What steps do you need to take to accomplish this goal? What do they look for in an illustrator?

Your list can be divided into different markets, products and locations. Next to each company I'm interested in, I always add notes, including the reason I'd love to do work for them, their website and contact information, the date I listed them and an estimate of when I plan to contact them for work. I set aside a time to keep my list up-to-date. I make notes of what types of work they're looking for so I can cater my promotions to fit their needs. I make notes on why they need my work and how they would benefit from my talent. When I send out promotional materials, I add the time I contacted the client, their response and what types of promotions I sent. This system keeps me on my toes. I don't always get feedback, but when I do, it allows me to reinvent myself to achieve my goals of being a successful illustrator.

Andi Butler has a great list of dream clients she would love to do work for. "I have worked with some great folks already, but I'd love to work with, say, Cranium, or do all the art and signage for a holiday campaign for a large retailer," she says. "I already have work with Klutz, which is wonderful, and I'd like to work more with Scholastic on activity books and such. I love fun spot illustrations mixed with photography. My big dream job though would be to develop new characters for Children's Television Workshop or a PBS ad campaign—I would *love* that!"

Another way to think about your dream client would be to think up the ideal situation and imagine everything falling into place as it should.

Susan Mitchell's description is the ideal arrangement I believe we're all looking for. "My dream client first brings me a really exciting project that I am dying to illustrate," she says. "They are decisive [and] communicating regularly by phone and e-mail, so I know clearly in advance exactly what they are looking for. They provide a realistic amount of time to complete the project and extend their deadline whenever they delay the process themselves. My dream client offers a competitive advance and a good royalty, of course, and makes sure their accountant sends out the check in a timely fashion. And, finally, my dream client sends along a generous number of samples!"

Visualizing your ideal dream client can make the concept more real for you. It can give you something creatively concrete to work with. Often illustrators are told to just send their work to anyone anywhere. This can seem like a blind approach. Sitting and really thinking about what we want from a client and the types of projects we'd love to be a part of will help narrow the search. There are clients everywhere: Wouldn't it be helpful to know what you'd like in a client before taking on any old project? Clients who insist on tight deadlines may not work for you (if, for example, you have a second job). Another issue could be payment. If your client is late to pay you, the business arrangement may not be the right fit. It all comes down to needs and boundaries. This is where research pays off. If you feel some sort of connection to a prospective client, either by the type of work they do or by their creative personality, this is a great starting point. Dig deeper, ask questions and never let a client walk all over you.

YOUR ASSIGNMENT

"Let the commencing beginulate!"
—PROFESSOR FRINK FROM *THE SIMPSONS*

You got an illustration gig. Now what? Well, before you pinch yourself, you have a lot of things to sort out and questions to ask. Some questions you may want to ask yourself before you sign the contract are:

1. How do you feel about this job?
2. Will you enjoy working on this project?
3. How much should you charge?
4. How long will it take to complete? What's the deadline?
5. Do you understand what this job is about? Did the client clearly explain what's needed?
6. Is the client trustworthy?
7. Does any of this project sound too good to be true?

If these questions have made you question the assignment, you may need more information. If you answered no to numbers 2, 5, 6 and 7, this assignment may not be worth your time. If you get a bad vibe, ask yourself why. You may need more information from the client. Get all the information up front and then go with your gut.

It's never a good idea to accept an assignment before you get all the important information. If you're too spontaneous and accept an assignment you're unsure about, you may regret it later. The project may not be of any interest to you, or you may not get paid for your time.

There are many questions to ask the client to help you get a clear picture of what needs to be done. What's the purpose of the job? Make sure you understand the nature of the assignment and where your illustration will be used. Guessing isn't a method. Both sides need to communicate effectively in order for the assignment to be a success.

Three very important aspects of any job are deadlines, payment and the usage of your work. Discuss these things up front. Make sure the deadlines are reasonable with regard to other projects you're working on. Start talking about numbers and find out what they feel their budget is. Discuss any extra expenses that may be part of the whole process. All this jump-starts the negotiation process. Negotiation is a lot of give-and-take and requires patience. It's a learned skill that becomes easier the more you do it. I always look at it as a business chat; that way, it keeps my mind casual and open to suggestions as well as the needs of my client.

If you feel you need time to mull the assignment over, tell them. You can very politely mention that you will contact them in a couple of days once you have thought it over. If they need an answer right away, tell them to give you an hour, for instance. Once again, it's wise not to commit to anything before you feel ready. Never feel you're obligated to answer right away. Pressure tactics to answer immediately should send you a red flag to step away. In some cases—when it's a huge red flag—run!

YOUR ILLUSTRATION PROCESS

"The creative process is not controlled by a switch you can simply turn on or off; it's with you all the time."

—ALVIN AILEY

Our illustrating process usually becomes automatic over time. Often we don't even think about how we break down a project. Other illustrators and clients may be interested in how you work at creating your images. I'm not telling you to spill your creative secrets, but share your process.

If someone asks about your process, how would you describe it? Break it down by how you come up with ideas, how you sketch out ideas and how you create your work. Describe what steps you take to get inspired.

I asked Penelope Dullaghan how she catches ideas. Here's what she says:

"I write a lot. I take notes when I'm out and about. I get a lot of ideas while driving. I look for connections between things. I talk about the problem with my husband. With an illustration assignment, I'll often read the story and make notes as I

Illustration by Penelope Dullaghan

read. Then I'll write a list of any words I associate with the topic ... just let my brain list as much as it can as fast as possible. Something usually falls out of that. I also try to keep in mind that, like with Illustration Friday, there are never just one or two ideas that will solve a problem. There are countless options. And my job is just to pluck one or two. Reframing it like that helps it seem much easier."

I'm big on researching and mulling over ideas. I often find that walking, doodling or having a coffee break helps. I look at books and magazines or just start by making notes. Doodling in my sketchbook comes next. When the lightbulb goes off, I focus on one main idea. This doodle can take many forms, such as little details, text and layout. I start revising my idea on tracing paper; if I need to copy some detail off a previous rough, the tracing paper makes it easier. I often cut up and rearrange ideas to play with the layout a bit. Once I like the final image, I create a good rough on tracing paper that can be transferred onto illustration board. This is the time I show the preliminary idea to the client. Changes can easily be made at this point. When we have a layout everyone agrees on, I get to painting and finish the illustration. I scan it into the computer and whisk off the finished concept to the client to make sure it's fine to use. If they believe it needs tweaking, I can go back and change what needs to be changed. I rescan, send the image and voilà.

Andi Butler describes how she approaches a project this way:

"Whether the project is self-initiated or an assignment, I always start at the beginning. That is, I need something to get the creativity beetles crawling around. That's usually a trip to a little boutique or gift shop, even a little florist or the bookstore (with kiddies in tow, of course)! I kind of look around and keep my mind open. Once the ideas start coming, I get them down in Illustrator on my laptop. I am, however, trying to get back to doodling in a sketchbook; I find I lose some ideas and spontaneity when I stifle myself until I get home. [What I jot down in Illustrator as a first draft is often] quite close to final. I'm able to give the client

a rough, and there are no real surprises when I go to final—it's what they were expecting. I get very few changes because of this. However, I think the [quick, jotted-down] drawings lose something, and I'm working on making things a little less mechanical-looking. I try really hard to keep the bounce in my finished piece. Textures help tremendously!"

Illustration by Andi Butler

You can use Andi's information. Good places to record your process are your website, your blog or on a promotional series. Remember earlier when I mentioned that giving prospective clients a little education about what you do can go a long way? Well, describing your process is also a way to let your clients into your creative world. Describing your creative process allows your public to understand how you tick, so to speak. This can also help establish you as an expert in your field.

Digital illustrator Kimberly Schwede's process is quite detailed:

"Some of my illustrations are created straight on the computer digitally with the mouse, and others I draw beforehand [and] then scan. If I'm drawing a certain object, I Google it first for visual inspiration. I create line art by hand with pencil [and] then trace it with black pen, scan, clean up in Photoshop, save as a black-and-white BMP file [and then] place [it] in Illustrator and color in. I redraw the empty spaces with color and place the shapes behind the outline for an organic look. I personally prefer the hand-drawn look. My logo, for example, was created this way."

Break it down for your audience. Many do not understand what an illustrator does. For example, they may think your work is digital, not re-

alizing you actually use paint. I have had that happen quite a few times and found myself surprising people because they were certain my work was created on the computer. This made my work even more interesting to them because it added another dimension.

Creative illustrator Jim Bradshaw has many dimensions to his work that are quite interesting:

"My process varies greatly. I'm the kind of personality that can't stay in one place doing the same thing over and over. I have this childlike need to keep exploring, always wanting to know what is over the next hill. Much of my stuff has been digital for the last ten to fifteen years. Many times, I will scan my final sketch and work up color in Photoshop and [Corel] Painter.

Illustration by Jim Bradshaw

I have a nice digital camera, and I'm always on the lookout for cool textures to shoot so I can incorporate them into my art. Anything old, decaying or rusted up is great to shoot. I also like to create characters in Illustrator and then bring the vector art into Photoshop to add texture and further elements. Lately, I have gone back to traditional media. Right now I mostly work in acrylics and pencil on varying surfaces such as old weathered wood, Masonite, cardboard and various papers. I love found objects, and that gave me the idea to take old, useless floppy and Zip disks and paint on them. They take acrylic surprisingly well, and it is an all-out blast. There is no end to how to do it and what to do it on, and I love it that way."

Your creative habits can be useful to others. Very often illustrators new to the industry read up on other illustrators to see how they work. Explaining your process also lets the buying market know what they're paying for

if they hire you; this can be very handy if the client wants custom work and therefore a deeper insight into you before they decide to hire.

A great example of an illustrator who creates custom work is Claudine Hellmuth:

"A large part of my business is creating custom work for people who send me their photos. This is a great supplement to the illustration work that I do and also keeps me in the flow of creating work to a specific topic. When I create work for a client, it's the same as when I do an illustration job [for a company or art director]. They let me know the theme for the work and what colors and overall feel [they want and] then I create the work to a draft stage where they can review it and make adjustments. Then, once that is approved, I go ahead and finish it!"

Illustration by Claudine Hellmuth

KEEP THE CLIENT INVOLVED

"A client is to me a mere unit, a factor in a problem."
—**ARTHUR CONAN DOYLE SR.**

If you have a client, keep them involved in the process of any project you're working on. Be a creative team player. Remember, you're providing a service, so make sure you let your client know what you're doing. Make it a creative partnership by asking a lot of questions, presenting ideas, sending a final concept and listening to their suggestions. They're hiring you for a reason. You're adding a visual perspective only you can provide.

Always remember that clients do not like surprises. The final illustration should resemble the final concept that you presented to them. If your client did not like the color orange in an earlier concept, avoid using it for the final. It all sounds like common sense, but mistakes can happen when we get busy.

Both sides are investing time and effort into a project. If it all works according to plan, you're creating imagery, and they're communicating their needs while giving you feedback. When one side of the equation is off balance, the assignment may not be a successful one. Be incredibly easy to work with—I cannot stress that enough. When you show your client how excited you are to be part of a particular project, it becomes contagious. You can be professional and fun at the same time. Help them love the process as much as you do.

How much should you include clients in your work? Sending e-mails, phone calls and proofs of your progress may not be enough. If your clients want to be involved, make it easy for them to see your process. We need to let clients into our creative worlds more, and that can be done easily—through an illustrated blog, for instance. A blog is a great place to post concepts, ideas and different stages of your work. Blogs can be used like a sketchbook. This helps clients understand how you work and what steps it took to come up with a final concept. It shows them that illustrations don't magically appear out of nowhere.

"Quality questions create a quality life. Successful people ask better questions, and as a result, they get better answers."
—ANTHONY ROBBINS

Never feel that you're ever asking too many questions while working with a client. Always find out the best ways to contact them. Always make sure your software is compatible so that when you send important information, it arrives the way it should. Don't let technology become a communication barrier. Color is also always an important detail to discuss, as is the size of the image. Nail down a concrete deadline and don't be afraid

to discuss money. When you're both communicating what you need, you ensure that everyone involved is on the same page. This makes your job so much easier.

Involve clients in more than just your assignments. Stay in touch by e-mail, new additions to your blog or promotional mailers. E-zines are a great way to let clients know where you've been spotlighted. A gallery installation you're about to participate in can also make a great promotion piece. Send clients a note if you've updated your website. Big news is worth broadcasting: Getting published? Has an agent taken you on? Branching out into a new market? Let your clients know.

Other things to add are any hobbies related to illustration or art that may interest your network. If you have a public speaking engagement or presentation coming up, invite your clients to come. All this shows them you're doing more than just working in your studio. Networking talks, class visits, school visits and industry events—all show a broad range of what you're interested in; these activities say you want to be involved in the industry as a whole. The result of all of this is a sense of connection and compatibility. Become an essential partner your clients cannot live without.

Last but not least, don't forget to talk to your clients. It's the cheapest and most personal way to market yourself, allowing you to reassure and confirm any questions or concerns on a much friendlier level than, say, an e-mail.

THE COMPLICATED CLIENT

"In the middle of difficulty lies opportunity."
—ALBERT EINSTEIN

Ever had a difficult client? Got one now? We've all been there; it's part of the package when dealing with business, money, deadlines and egos. There are times when you and your client are not going to see eye to eye. There are also times when your client might be downright frustrated. Let

them be frustrated. Listen to their concerns. Try to come up with a solution everyone can live with. If by chance this conversation gets heated, try to keep your cool. Silence can be used to diffuse a tense situation. If you let yourself become frustrated in turn, nothing will be resolved.

"Silence is one of the hardest arguments to refute."

—ANONYMOUS

Never underestimate the power of silence. Being quiet allows the client to talk about what they need you to know. If you jump in, you may interrupt or miss an important detail. You need to really listen to what they are and aren't saying. Get it? Being quiet lets them get it all out; then you come in with either a solution or a resolution. If they're on the attack, let them finish. Then, when they're done, confirm what they just said. From there you can give your professional opinion and a professional solution. The idea is to give them the confidence that they're being heard. If you mindlessly strike back at them, will anything be resolved? Absolutely not!

When there doesn't seem to be a resolution, you need to make a decision to keep working ahead or decline the job. There aren't any laws stating that you must always agree with your clients. Never allow a client to get in the way of other projects you're working on. Keep everyone separate.

Take stock of the situation. If you've analyzed all the possible solutions and know the project truly will not work out, you need to make a decision. When you feel you aren't at fault and cannot see any other solution, try to leave gracefully while remaining respectful of your client. Keep your chin up. We can't win them all, but we can always be professional when the chips are down.

It's okay to agree to disagree. It's hard not to personalize bad attitudes, egos or just plain bad days. Remember that your client is human after all. Just as you answer to them as far as the assignments go, they often answer to someone else as well. I always remind myself that the client and I both have deadlines. If I miss a deadline, they, too, could miss their deadline.

"Tact is the art of making a point without making an enemy."
—ANONYMOUS

Can you throw a little education your client's way to keep everything on track? If you can deal with the assignment and it's worth your time, complete the project and then move ahead. Never let difficult situations get the better of you—chalk it up to a learning experience. Staying professional says a lot about your character and can help you maintain a good reputation.

Now, on the other side of the coin is your role as the illustrator. Have you ever been told you're hard to work with? How's your body language? Are you open to suggestions or criticism? Do you want to know the secrets to annoying your client?

- Always be defensive about your work.
- Make sure the final is always final! No revisions, period!
- Make it hard for clients to get in touch with you.
- Avoid deadlines at all cost.
- Don't be open to suggestions.
- Don't see it from the client's perspective—only your own.
- Avoid any explanation about what you do and how you do it.
- Avoid speaking up.
- Most importantly, overpromise but underdeliver every time.

Be fair when billing your client. Always discuss numbers before committing to anything, and that includes revisions. Do you have a client who won't pay? Send a friendly note to remind them about payment. Then follow up to see when the check will be mailed. No payment yet? Send another reminder, plus a request to speak to the billing department if they have one. If the bill is past due, you may want to consider getting creative or getting legal if you can afford it.

The worst client I ever had wanted me to create whimsical maps. What made the project go sour was that this particular client wanted me to directly copy another illustrator's work. The idea was that I would make a

series of maps with a few added touches. I could not help but question his professionalism while trying not to laugh at his total misunderstanding of the illustration industry. When I did question the ethics of his request, I was told I must be stupid not to want to be considered for such an easy project. After all, it was a big-paying job! It was at that point that I told this client that good illustrators do not plagiarize other illustrators' work. I then told him to have a great day, and I left. What makes it all very ironic is that this happened at a tourism office. The lesson I learned was to expect the unexpected. Even though this was a professional office, their conduct was completely the opposite! In the end I billed them for my time and stated that it would be in their interest to pay, considering how fast word of mouth traveled. A learning experience indeed!

Working with clients can also be a joy. A creative meeting of the minds can lead to a great working relationship. It helps when we try to find something in common with our clients. Being agreeable and open to all suggestions is not something we're all born with. When they say patience is a virtue, they aren't kidding. If you've mastered this trait, your relations with your clients will go so much smoother.

Roz Fulcher has been lucky to have good relations with her clients. "I have been fortunate that I haven't had to work with a very difficult client … knock on wood. There have been challenges, sure, but not anything major. I have had to decline work before, and it was painful to do. Learning to say no is hard when there isn't a guarantee that another job is around the corner. But I'm learning that listening to your gut can save everyone involved from a lot of headaches."

SPECULATIVE WORK

"No way! I have scruples."

—MARTIN BLANK FROM *GROSSE POINTE BLANK*

You've been asked to create work for a new client who won't pay you unless they like your finished product. What do you do? If you think this

may be a good career move, there are some things you should know about speculative work.

Speculative work is doing work for free without the guarantee of compensation. The client basically says, "I'll tell you if I like it when I see it." Payment usually never happens when you venture into this type of an arrangement.

Speculative work is like gambling. There are no guarantees that you will ever get paid for your time and your talent. You could lose rights to your work. It could be used without your permission. The client could basically steal it. They could also take credit for your work or your ideas and reap the rewards.

The NO!SPEC campaign is a great website that addresses the dangers of taking on speculative work: www.no-spec.com.

Unfortunately, spec work can be found everywhere; there's no shortage of illustrators and designers doing it. It's like a virus. What does it say about an illustrator who chooses to do spec work? It says they may be inexperienced and don't have a full understanding of this industry. It also says they could be desperate and quite willing to do any work at any cost. And, worst of all, it only encourages more speculative work.

What does it say about the person requesting speculative work? It says they do not understand the industry and the needs of illustrators. It shows little respect for illustrators and business in general. They aren't looking at the big picture and the best possible outcome. The end result will be a bad reputation and unprofessional work.

"Men are respectable only as they respect."
—RALPH WALDO EMERSON

Demand respect. You're investing time and talent into your work. Why compromise your future? Your work isn't disposable. You're creating custom work, and you need to be paid for your expertise and time. This isn't a cookie-cutter business. If you've committed yourself to being an illustrator in business, make a professional commitment to protect your work as well.

I have ethics, and I'm not afraid to use them. I will not take a job that compromises my beliefs and the industry standards that so many other illustrators and designers have worked hard to maintain and promote. It's just plain bad for business. When in doubt, ask. If you aren't sure about a project, ask someone who can offer you advice. Always go with your gut. If the job seems confusing, questionable and does not require a contract, ask yourself if it's worth it.

Illustrators need to get on the same page. When speculative work is seen as an acceptable source of work, this creates negative competition practices. Know your industry and promote it the best way possible by being professional. Take it up a notch and become an advocate.

"He who wants the rose must respect the thorn."
—PERSIAN PROVERB

Always remember that the promise of "free exposure" almost always means no exposure at all. Bad promises can leave us vulnerable. No sense having your work out there if you aren't getting any credit for it. Be leery of contests that say if your image is picked it will be a good promotion for you. Are they reputable? Stick with the professionals and choose the jobs that will point you in the right direction. Your success depends on it. You owe it to yourself and to your portfolio.

PROPOSE AN IDEA

"The universe conspires to give you what you want."
—GAIL CARR FELDMAN, PHD

Letters are a friendly way to introduce yourself or to propose a reason your audience needs your illustrations. The idea is to get prospective clients familiar with your work. Down the road, when you follow up from your note and samples, you'll be able to jog their memory more easily.

Friendly notes are another way to ask for what you want. This could be a dream client you've always wanted to pursue. You may need to find

out if they hire illustrators and if they'd be interested in samples of your work for their files. If you're looking for an agent, this is a good way to find out how you might go about submitting your work.

A cover letter is a great way to introduce yourself and your illustration. Think of it as your very own "call to action," summed up in a few paragraphs. Tell them who you are and why you're sending this letter and promotion pieces. You can give a brief description of your style, your experience, your professional affiliations and education.

QUERY LETTER BASICS

The hook: Make a statement to entice the reader to take interest in what you have to say.

The pitch: Ask for what you want or propose an idea.

The body: Elaborate on what you need them to know.

The credentials: Tell them who you are, what you do, where you studied and your client list, if you have one.

The close: Always thank them for their time and attention. Mention that you'll be in touch by either phone or e-mail.

As I mentioned earlier, asking for what you want puts a different spin on what clients never knew they needed. They may really need your illustrations. Introduce that idea to a potential client and you may land an assignment out of it.

You know what's even friendlier than a letter? A phone call. This can work to your advantage if you're trying to explain an idea to which words on a page don't do justice. This is how I got a teaching job. I just threw an idea out there, and they bought it! (Well, I had to work at it

and explain the benefits that students would get from taking my class, of course.)

Reasons to Call

You might be new in town. Using a phone call to introduce yourself to someone who could potentially need your work is a good first step. You might ask a local publisher if he ever thought about using custom illustrations in his magazine. You could introduce yourself to a local designer who might need your work down the road. Ask people if you could add them to your mailing list. As a nice bonus, they might know people who could use your style and give you that information over the phone.

Warm up to cold calls. Imagine them as research calls to help you gain information and give information. Again, phone calls are a personal way to make contact. They can also have a good ripple effect if you find common ground with the client on the other end. When I moved back to Nova Scotia, I called a few local businesses, only to find out that one particular person was from the city I had just moved from. It was a good icebreaker and allowed me to toot my horn a little more comfortably. It may be faster to e-mail, but it does not always result in a connection. Use all your resources and find what works best for your audience.

RESPECT DEADLINES

"Fashionably late is an oxymoron."
—MISS MANNERS

One of the most important aspects of any job is the deadline. Deadlines can drive us crazy. The clock can sound louder, and the days can seem shorter. Our calendar keeps reminding us our deadline is closer than we think. Instead of waking up in the middle of the night in a cold sweat, get organized.

Have a good relationship with time. Deadlines need a system. When negotiating a deadline, expect the unexpected. If you know it will take two weeks to complete an assignment, add three days to make sure you're covering your butt. Think of it as creative breathing space.

Break the project into chunks. Divide it into different sections such as research, notes, ideas, roughs, final concept and the final layout. Avoid jumping all over the map; plan the project so you know what to expect. You can divide and conquer what needs to be done. Remember, slow and steady wins the race.

As stated earlier, I always underpromise and overdeliver. My time is tight, so I need to make sure I'm not promising something I can't do. I know now how long certain types of projects take. I also factor in my kids and other work I have to do. I'm not comfortable saying I can get a project done in two days. Life happens, so I need to remind myself that if something *could* interrupt me, it probably will. I try to look at the big picture of my life and how demanding my responsibilities are.

"Don't make excuses—make good."
—ELBERT HUBBARD

The worst possible scenario is a missed deadline. It's an awful feeling to break a promise, but don't despair. The first thing you want to take care of is a little damage control. Call your client immediately. Don't make excuses. If they ask what happened, be honest. If you got into a car accident, tell them. You aren't seeking sympathy here, just an understanding. We get sick, we get into accidents or our computers conveniently act up just as you're about to finish your project. Life is like that.

Find a solution to help preserve the client's confidence in you or the project. Make it up to them. One solution could be adding a little extra to the project. Then, when the project is finished, add it to your list of experiences and move on. But first make it right with your client so they know you're the true professional they hired.

GET THAT IN WRITING

"Just get it down on paper, and then we'll see what to do with it."
—MAXWELL PERKINS

Contracts are an essential part of your business and the best way to guarantee that everyone is on the same page when it comes to your deadline and payment. Think of the contract as a security clause. Without one, the whole project is up in the air. Protect yourself.

Contracts are parts of our daily lives. We sign contracts to buy a cell phone and rent an apartment. The biggest contract my husband and I ever had to sign was when we hired a mover last year for our relocation to Nova Scotia (it was a huge document—they left no stone unturned with that paperwork!).

RECOMMENDED READING

Check out Tad Crawford's *Business and Legal Forms for Illustrators.*

The contract is based on the Latin phrase *pacta sunt servanda.* This means "agreements must be kept." There are two types of contracts—written and spoken (we agree to pay our restaurant bill after a meal, which is a type of spoken contract). By creating and defining the obligations between you and your client on paper, you are entering into an agreement. Always insist on using a contract.

Contracts sound very formal and legalistic for many of us. Another way to look at all this paperwork is by calling it "a letter of agreement." This sounds friendlier and is a lot less formal than a standard contract. You can custom tailor your paperwork for your individual needs, depending on the type of project you're about to take on.

My philosophy is no agreement, no deal! Even a request for a small project that takes only two hours to complete needs to be in some sort of writing. Ask yourself how important it is to get paid. Dumb question, right? It's amazing how some illustrators feel they're putting clients out when they make them sign a piece of paper. Break it down: It's only a couple pages of text. Make your terms clear and easy to understand. Once everyone agrees, it's signed, and both parties receive a copy. If you do come across a client who feels you don't need any paperwork, remind them that an agreement protects both of you.

Consider your specific needs to complete a project. If you have an international client who requires you to courier certain items, you'll need to factor the cost of shipping into your bill. Got a client who needs to see you personally two times a week? That consultation time could cost you valuable working time; you may want to factor that into your price. If you have an extremely cautious or nervous client, insist that you bill in sections. It's okay to ask for a third of the final payment at the beginning of the project. Many illustrators do this when they're dealing with a new client or they're getting the vibe to stay cautious. The feeling of the unknown can make us want to ask for money up front before we complete the whole assignment.

Your Terms

There are many things to consider when you come up with an agreement. Depending on the type of job and client, you can custom design it to fit your needs: Small assignments may need only a few items, while a large-paying assignment may require a lot more detail. A good thing to consider when laying out your agreement is to make it easy for clients to follow.

"Sure, I lie, but it's more like tinting. It's all just negotiating theatrics."
—IRVING AZOFF, MANAGER OF THE EAGLES

Negotiation is part of the agreement process. When in the negotiation stage, try to remember to document everything. Define your responsibili-

ties for the project. Your paperwork is never ironclad—there needs to be flexibility due to changes and revisions. Remember, this is an agreement for illustrations. You aren't signing away your soul.

Once it's all finished and agreed upon, make sure you file the final document. Always keep your agreements in a safe place. I keep mine in a security safe that's waterproof and fireproof. It's an important document, so protect it.

Your biggest challenge is getting everyone involved to agree and sign on the dotted line. After that, you get to focus on all the good stuff you do best.

REVISIONS AND FIX-ITS

"The tiger can't change his spots. No, wait, he did! Good for him!"
—JACK HANDEY

Sometimes the finished piece isn't quite a finished piece at all. Remember that this situation is part of the job. It's hard not to take it personally when you've worked on something and the client says it needs a little tweaking. They aren't asking you to change; they want you to change the image. As illustrators we often personalize any suggestions made about our work. It's hard not to—our work is such a huge part of who we are.

These revisions are where a little creative management comes into to play. Altering an image takes time, costs money and can alter your schedule. Instead of getting frustrated, get to work. I come to expect revisions (within reason, of course).

So what happens when your client asks you to change the image too many times? You may want to consider asking them why the image isn't working. Rule of thumb: If your client has asked you to alter the image more than two times, you're going to have to account for that time and effort. Could there have been a misunderstanding? Ask lots of questions and review your notes. At this point you should set up a meeting to discuss some solutions. Remember that if you have other projects on the go,

you must organize your time according to what needs to get done. This is a business, and you need to get paid for your time and expertise.

Always discuss any added price before taking on more than one revision. Explain that your time is valuable. You are providing a service like any other professional, just like a mechanic or a plumber. Everyone knows that the original estimate for a car repair is almost never what the bill comes to. We pay it and move on. That's life.

If you don't mind revising something more than once, tell your client you'll factor that into the price and then send them a revised update of the contract, if needed. In fact, state in all your contracts that revisions after the final are subject to an extra charge. Once this detail is in there, it makes your job a little easier.

The worst-case scenario would be terminating the project if you can't see eye to eye. If you and the client are both not getting what you need, parting may be the only solution at that time. It happens to the best of us. Remember to stay professional—remind them you'll have to bill them for the time you put into the project. Some jobs just aren't meant to be, and it can be frustrating, especially when you're new to the industry. Keep in mind that there will be another assignment on the horizon. In time, moving on becomes a little easier because you have experience on your side. Don't let it get you down.

CHAPTER 6
LET'S TALK NUMBERS

"Formal education will make you a living;
self-education will make you a fortune."
—JIM ROHN

Knowing what to charge for your illustrations is one of the biggest challenges we face when we start getting work. In fact, it downright frustrates most illustrators because there isn't one price system to fit every type of project. If I could install a decoder ring with this book, I would!

The image we have of ourselves is based heavily on our talent and work. We can often forget the commercial purpose of our illustrations and our creative problem-solving skills when we're in the flow of creativity. Remember, if you aren't minding your business, no one is. You are not a charity. Illustrators deserve to be paid like any other business. We often need to remind ourselves that clients are paying for creative value. The quality of your work, combined with its presentation, unique ideas and your customer service, make a valuable contribution to this industry.

One of the biggest factors to consider when coming up with a yearly salary goal is your lifestyle. (For me, this includes kids, travel, bills, supplies, debts, mortgage and food and lots of coffee!) On the other side of the equation, you need to think about the lowest amount of money you

can live on, i.e., being able to pay for your main necessities, such as bills and groceries, while making sure you still have a roof over your head and a cup of coffee in your hand. I bring up this point because you won't get a steady paycheck as an illustrator. There will be peak moments in your bank account, as well as dips that keep you awake at 3 A.M.

I prepare myself for all sorts of different money scenarios. Being self-employed with an unpredictable income has made me quite savvy. This includes how I shop, how I cook and how I run my household. As unpredictable as my budget can sometimes be, I manage never to do without. I have never subscribed to the starving artist lifestyle. On the other hand, I choose to live quite simply. I don't need a mansion or a fancy car. I need to be an illustrator in business, I need my family and, most importantly, I need to be happy. Oh, yeah, and don't forget about the coffee!

WHAT'S YOUR TIME WORTH?

> "Money never starts an idea. It is always the idea that starts the money."
> —OWEN LAUGHLIN

As illustrators, we put a lot of time into our work and business every single day. That effort needs to mingle nicely with our earning potential. If you're going to work that hard at creating a certain style and a body of work, shouldn't you get paid for it? That's the focus of this section.

QUESTIONS TO ASK YOURSELF

- What are other illustrators charging?

- What markets do you want to work in?

- How many years of experience do you have?

- How will the image(s) be used?

- How much time will it take to complete the project?

- What are your skills? List them.

- What is your demographic of work? Are you working locally or globally? Both?

- Who are your clients or possible clients?

- What is your bottom line? How little will you work for?

- How high is your reach—what is the highest price you're actually comfortable standing behind?

Illustrators are a fee-for-creative-service business. How much you could earn is based on how much you value your time. Some illustrators fall into a bad of pattern of underearning. This could be a learned behavior. Developing a good relationship with money isn't something most people are born with. You usually have to screw up a lot in order to take stock of your financial situation. It all comes down to motivation. Your motivation could very easily move you closer to easy street. You just need to change your thinking about money.

"Win some dough, some serious dough!"

—*UNCLE BUCK*

Money makes people uncomfortable. Running a business is a mix of selling and taking risks. To get to your earning potential, you need to be able to negotiate and communicate to your clients that you're valuable to them. The best way to do this is to focus on your pricing daily and connect with like-minded people who understand money. You can find good online sources such as entrepreneurial groups and self-employment resource sites. Another approach is to connect with associations within

your community, such as your local chapter of the chamber of commerce and other small-business networking groups.

"If you pay peanuts, you get monkeys."
—JAMES GOLDSMITH

You control your paycheck. When you become unproductive, distracted, sick or unmotivated to work at your peak, you will pay the price. We all waste time. We all need to take breaks and vacations. It's only human. When we *can* be productive, that's the time to get moving. Our type of work requires a lot of time, energy and action. How much of that do you actually get paid for? The value of your time is based on money earned combined with how many hours you've worked to get it. This combination makes up a base number you can work with.

Break It All Down

Illustration-work time: concepts, roughs, beginning and finishing a piece, meeting and chatting with clients

Business-management time: promotion, networking, marketing, research

Everything-else time: home life, vacations, weekends, breaks, the kids, family, friends, running errands, "me"

Add up how much time you spend on all three of the above. Take a look at how much you actually get paid for. You will notice that a lot of what you do in a day isn't actually earning money.

PRICING BREAKDOWN

"If only God would give me some clear sign! Like making a large deposit in my name in a Swiss bank."
—WOODY ALLEN

Pricing is really an exercise in patience and flexibility. I asked Andi Butler if she had any tips to share. Here's what she had to say:

"I usually let the client determine that by their budget. Then I either think it's fair, or, if not, we negotiate. If the price is low, I tell them they'll get two roughs instead of three or four or one rough only, and they can make all their changes at one time, or ask them for a later deadline. The latter works quite a bit. So many clients want their work 'yesterday,' but why should another client, who's paying better, get bumped? I know you can add rush fees and whatever, but I find subtracting works better for me than adding! Half the time they don't really need it that soon anyway. Many times I've experienced 'hurry up and wait.'"

Let's think large for a moment and say you want to make $100,000 a year. That's a fine number. Let's work backward:

Earning $100,000 per year comes to about $9,100 a month for eleven months (because you'd like to have some time off). If you're working forty hours a week, that's $56 an hour. If you're scheduling only twenty hours a week of "work time," you'd better charge $112 an hour.

Or working forward without a specific income in mind:

Lets say you need $3,000 a month to live comfortably. You plan to get six projects a month. That's an average of $500 a project. Then add 40 percent to your fee to factor in income tax and clear approximately the $3,000 you'd like to keep. Your fee per project would be approximately $700. So now you know what kind of client you would need to target your advertising to—one who can afford $700-plus per project.

The point of all of the above is this: When you break down the numbers in a series of steps, it doesn't seem so far-fetched, does it? Typically what we fantasize about is a number we'd like to make per year, but then we cannot imagine how that could possibly happen. The negative self-talk kicks in, and you forget all the little steps that can help your brain grasp the possibility of it all.

When you come up with a number, you'll have to go after the types of clients who can give that amount a month. If you're taking on a lot of small jobs, this could kill your chances of reaching your big earning goal. You also need to take into account your expenses.

EXPENSES TO CONSIDER

- Promotion: postcards, business cards, mailers, postage, website

- Printing: promotion, invoices, newsletters, portfolio

- Communication: cell phone, home phone, Internet

- Equipment: computer, software, Wacom Tablet, printer, scanner, storage

- Supplies: paper, illustration board, paint, brushes, pens, disks

- Travel: client visits, errands, parking, bus

- Memberships and associations: Society of Children's Book Writers & Illustrators, Hire an Illustrator, theispot.com, Society of Illustrators

- Industry conventions: HOW conference

- Bank charges: monthly fees

- Tax: accountant

When pricing a project that requires a quote, you need to take into account the average hourly rate you've come up with. This rate will have to be combined with materials, courier, phone calls (if long distance) and any specific research materials that will be required. Then you can give the client the project's estimated price.

Some clients prefer you to give them a bill at the end of the project if you agree on an hourly rate. In this case, your invoice will need to break

down how you came up with your magic number. Itemize the specifics it took to complete the project. Don't just send a bill with your address and an amount that's due in thirty days.

Both methods must stay flexible. Some clients budget only for certain amounts. If you feel they can afford it, go bigger. Remember the value of your work. You are highly skilled, and your time is important. Don't be cheap with your rates. It's amazing how people can rationalize the price for something if they really want it.

DISCUSSING MONEY DOS AND DON'TS

THE DOS:

1. Always research industry standards for pricing from such places as the Association of Illustrators (www.theaoi.com), Creative Latitude (http://creativelatitude.com) and *Graphic Artists Guild Handbook: Pricing and Ethical Guidelines* (http://gag.org).

2. Always work out a quote before discussing money with a client. This gives you something to refer to if your mind goes blank or if you need to justify your project's fees.

3. Always ask the client what their budget is.

4. Always be up front about additional fees. Clients do not like surprises.

5. Always be realistic about your time. Adjust your fee to work along with how much something will realistically take to do. Plan for mistakes or bad days and throw in a little extra time to cover your bases.

6. Always explain how you came up with your price, if asked. For example, is that the fee for one illustration or all five of them?

THE DON'TS:

1. Don't be shy about your fees. Discuss them up front.

2. Don't ever argue over the price. Discuss it.

3. Don't try to get the price just right beforehand if you aren't sure about it. Ask for help from like-minded illustrators, online forums and resource books. Do your research.

4. Don't throw unreasonable extra expenses into your quote. Use common sense.

5. Don't quote an hourly rate when explaining money. Clients need a concrete number to work with. Remember: They may have a client who's also part of this process and needs to know what the final price will be.

6. Lastly, don't surprise your client with a new price out of left field for a project when you send an invoice. Clients really, really do not like that. Be nice with your numbers!

There's industry-standard pricing for certain types of illustration projects. Let's call these variables. If you've been asked to create a logo, you may want to work for around $500 to $5,000. This is a big gap, but again it depends on the project and what the client is willing to pay. Moving illustrations on a big website could go for an estimated $1,000 to $4,000. Book illustrations could be $250 to $1,500. All these need to correspond with what you want to make and what your client is willing to pay.

Variables

You will notice once you start to ask around about that there are huge gaps between price ranges. The following are just examples to show you some of the differences. Remember that pricing is relative depending on

usage, demographic, royalties, time and market-standard pricing. This is why people in the industry are constantly scratching our heads and asking, "Huh?"

- Magazine interior spread: $500 to $1,500
- Web spot illustrations: $200 to $1,000
- Moving illustrations: $1,000 to $3,000
- Logos: $500 to $5,000

Remember that clients will want to simplify your project's pricing by using an hourly rate or suggesting a quote. They will try to go after the lowest bid. All in all, inflation, demographics and the laws of economics alter pricing. Some illustrators will get paid more because they have many years of experience behind them, but inexperienced illustrators need to get paid, too. Believe it or not, confidence sells. The more comfortable you get with chatting about numbers and pricing, the more you'll come off as a very self-assured illustrator.

Hourly Rate or Per Project?

Per Project

Getting paid per project is based on how many hours you feel something will take to complete. You come up with an average price that can include materials, time and other expenses to present to a client. The downside can be revisions. Factor in some cautious optimism when doing an estimate. Most likely, there will to be adjusting, and you should get paid for your effort to get a project completed.

Per Hour

Getting paid per hour is normally based on a general fee you feel is fair to charge, based on a running tally of your time. It helps if you can give the client an estimate of how long a project will take to complete. As you move forward in your career, you'll get better at estimating work time. Clients usually prefer a total to work with. Having them hanging on to

an hourly rate is an uncomfortable thing for many clients because no one wants to be surprised when you present them with an invoice. Try not shock your client. My best advice is to come up with an estimate of how much you realistically need to earn a day while considering your clients' needs.

THINGS TO CONSIDER

"Carpe per diem—seize the check."

—ROBIN WILLIAMS

Your earning potential is influenced by how your projects turn out, which is influenced by so many factors. Every project has a life of its own, whether the project is through a client or a self-promotional piece. You may be in situations where you don't have much influence about what you could be paid for a project. Situations like this come up with publishers, for instance. Children's publishing, book publishers and magazines typically have a payment scheme already in place. If you've been hired to illustrate a book cover, you could be paid a set price with no flexibility for negotiation.

Also there are predetermined royalties for certain industries. Once again, royalties are most often set in stone by some markets; some are the royalties that come with providing images for a licensing agency or a greeting-card company. This is all typically laid out in your work contract. Read it carefully and make sure you understand all the details about how you will get paid.

Some projects will be determined by your client's budget. This will require the often-dreaded negotiation dance. A code I always live by is to ask the client first what number they have in mind before I get serious with my own number slinging. This is the best way to gauge what they can realistically offer you. It also helps you avoid throwing out a number that could potentially shock them or convince them to hire someone else.

If you have an agent, you should take into account that a percentage of your paycheck goes to them. When you sign on the dotted line to join

forces with an agent, make sure you understand any and all expenses. Some agents take a percentage plus fees for promotion, printing and advertising. Throw that into the budget well beforehand so you won't forget and end up being disappointed down the road.

Many common mistakes can happen when you're juggling money and budgets. A big one is that you try to sell to the wrong prospects. Take the path of least resistance. Don't waste your time and energy on a market that may not want your services right now. They might change their mind later, so don't scratch them off the list completely. Follow what works.

Another big blunder is spending too much money. There are business essentials that all illustrators can't live without, but be kind to your budget and be extra nice to your credit cards. I once knew someone who blew her entire small-business budget on printing alone. She went overboard getting everything printed, including personalized stickers. Long story short, she ended up declaring personal bankruptcy.

Then there's the opposite problem of not spending enough. If your computer is fit for the vintage museum, let it go and budget for a new one. It's imperative to have technology that works when you need it to. If you're out of the office a lot, invest in a cell phone. Another big expense is good printing. There's no need to break the bank like my friend did, but you'll need the basics like business cards, postcards and promotional sheets. Printing yourself isn't always the best choice—some printers are better than others for home-office use, and if the ink is running out, your invoice will stand out like a sore thumb when you send it to your client. Printing the basics doesn't always have to cost a lot.

THE KILL FEE

"I've learned to pick my battles. I ask myself, 'Will this matter a year from now? A month? A week? A day?'"
—VALORIE JACKSON

A kill fee is a nonrefundable fee that covers your billable time and any expenses incurred so far in a project. The kill fee can also be called a cancellation fee or a rejection fee, depending on the reason for termination. It's insurance that you'll get paid for the work you've done to that point before the project got axed.

There are many reasons why a project can be terminated. Your client could cancel for reasons such as budget modifications or a complete change of plans. Missed deadlines or a difficult working relationship could result in the project's end as well. Whatever the reason, make sure you have it in your signed letter of agreement that you are to be paid a kill fee or a rejection fee. Always!

A little explanation can go a long way. Some clients you ask to pay the kill fee don't always get to see the final illustration and can often feel you didn't do much to warrant a fee. On the contrary: They need to take into consideration the hours of research, thinking and mulling over ideas that jump-started the project in the first place. If you have a client who really objects to this business practice, you've made the right decision to have a kill fee. You are in fact protecting yourself from the very type of client this is designed for.

If a kill fee is instituted, you'll need to specify in your contract that you're to have all materials sent back to you. This includes original artwork, printed samples, disks, CDs and digital files. At this point you must advise your client that they cannot use the image or images from the canceled project without your consent and that, if they do, legal action could result.

The general percentage for a kill fee is 50 percent of the final fee. This should be paid within thirty days of notification. Some illustrators charge 100 percent of the total bill even though the assignment was canceled but all the work was completed. Percentage depends on the nature of the project and why it ended.

"Mistakes are the portals of discovery."

—JAMES JOYCE

Another type of fee is the rejection fee. This is paid when the illustration work doesn't meet the initial requirements. This is different than a kill fee; generally the kill fee can happen when the image is completed and the client decides not to use it. In the case of the rejection fee, the client isn't satisfied with how a project may be moving along.

There are several reasons why a project may get rejected. Perhaps you didn't follow the specific guidelines for the project originally agreed upon, or maybe you used a style or color that wasn't specified. Maybe you did something different from your original layout. Other times it can simply be a bad working relationship. These things happen more often than you think.

The percentage charged for a rejection fee can be in the range of 25 percent to 100 percent, depending on the client, the nature of the rejection and the amount of work done.

"Here's the thing, you just have to drive a lot faster, and if you don't get there, we're both fired."
—BILL MURRAY

There are some things to consider about situations like this. Remember, you still own the copyright of your work. Contracts should state from the very beginning that in the event that your project is terminated the client loses the original agreed-upon rights. The client cannot use your image. Period. If you don't have a kill or rejection fee in the contract, there are no guarantees that either will be paid to you. Cover all your bases.

DEFEND YOUR FEES

"Don't be apologetic about your fees. You are a professional and should be paid like a professional."
—LEE SILBER, AUTHOR OF *MONEY MANAGEMENT FOR THE CREATIVE PERSON*

It isn't always easy to convince your clients that your fees are normal and not from another planet. On top of that, you have to convince them

you deserve to be paid. I wish I could tell you no one will ever protest or question you. They will. It happens to the best of us. Penny-pinchers are among us in many markets. Try not to take it personally.

A good way to pump yourself up about your fees is to define why you deserve to be paid. Make a list. Coming up with reasons will help when you discuss it with your clients. Being put on the spot can be an uncomfortable feeling. Prepare yourself and be confident.

WHY ASK FOR WHAT YOU WANT?

- Number one, you are a business.

- You are combining knowledge, skill and experience to create one-of-a-kind imagery.

- Illustrators make things beautiful, which goes beyond just decoration.

- There's no better way to establish mood for text, book covers and children's books.

- Illustrators' work helps carry the message forward in ways that words simply cannot.

- You're selling an emotional visual experience like no other.

ASK FOR WHAT YOU WANT

"So what'cha, what'cha, what'cha want?"
 —THE BEASTIE BOYS

I talk a lot about asking in this book because it's a really important action to take when it comes to getting clients, jobs and also getting paid what you deserve. Sitting back and letting everyone control how much you make

as an illustrator isn't something I advise you do. Your income depends heavily on how you approach money and how you approach negotiation. As motivated as you are to create the style you promote, money needs to be a motivation as well in order for you to move forward in your career.

A good example is when you ask for service. When was the last time you went to the hairdresser and said that you will pay *X* amount of dollars for a particular service? Most likely, the hairdresser will say she has set prices in place that she cannot alter.

My husband can relate to this negotiation dance because of his personal-training business. Surprisingly, when it comes to physical health, many feel they should not have to pay much in order to get in shape. Fitness professionals like my husband who promote health management have many barriers and stereotypes to get past when coming up with fees for their clients. Once again, like illustration, there is no set fee that fits all. Fees are based heavily on demographics, additional services (such as a food plans) and the type of package a client decides to purchase. Only the very serious see results.

All this brings me to my point: Payment for illustration has been viewed heavily on a sliding-scale approach. Many illustrators charge too low, and some too high; many in the industry have known this for quite some time. Fees are all over the map. So, as a professional in business, what do you do? Ask for what you feel you deserve! The more you practice asking, the better you can gauge what will work for you.

To get to that point in your business, you need to address the issues when you ask for what you want. First, you need to eliminate the barriers to why you aren't getting paid what you want. Second, you need to learn how to ask effectively.

"Don't give the store away because of any insecurities you may have."
—LEE SILBER

First of all, what's the harm in asking? Asking is a form of motivation on your part. If they say no, try to negotiate a number everyone can live

with. If they can't live with it, you can move on or take what they offer. Just make sure you're okay with that number.

So, what are the usual problems we face when we throw numbers around? We fear our numbers are out of whack. We fear the client will respond with a number we think ridiculous, or worse, we fear they respond by saying they would never pay our number in a million years. The fact is if you ask too little, they may not believe you're professional enough, and if you ask too much, they might decide you're too expensive and move on to another illustrator. This is definitely not what any of us want!

Some of us fear that we'll be considered weak if we ask for something. My philosophy: There are no stupid questions. Asking questions means you're interested, proactive and seeking knowledge about something.

You need to be confident when you ask for what you want. Believe in your work and believe you can get paid to make it. The bottom line is that confidence is sexy. No, this isn't a sex talk for illustrators! The point here is confidence will get you where you want to go. Be confident, be clear and tell them what you want. Strong minds like to work with strong and confident people.

THE GREAT REWARD

"A happy person is not a person in a certain set of circumstances, but rather a person with a certain set of attitudes."
—HUGH DOWNS

Making a living at your work gives you a sense of self-worth. The rewards can be small or huge, depending on the person, and there will be frustrating moments that may require you to stand back and look at the big picture. Remember that convenient commute? Remember that you now have more time for friends and family? A huge plus is having your own career you make possible every day, whatever the size of your paycheck.

The theory of "like attracts like" is the law of attraction summed up in three words. I could get all psychological, but basically it's all about

perception. If you're like me, you can see success in even the simplest of moments that involve your career and your life. Perception is a funny thing. What we see as a big reward may not seem like much to someone else. It's a matter of opinion, really.

Those tiny moments can lead to very big things. When great events happen, they become a huge motivator to go out and look for more great events. This creative motivation will help you onto the next step while enforcing the positive value of what you do.

We have primary rewards, which are money to help pay bills and buy groceries. Then we have secondary rewards, which can be the little perks such as recognition for a job well done or a spotlight on an industry website. Another kind of secondary reward might be a nice gift to yourself and your office, like a new a computer you've been putting off buying.

You can even break down rewards into many different sections like end-of-the-project rewards, end-of-the-day rewards and end-of-the-year rewards. I take a certain percentage after a project and treat myself for a job well done. The reward doesn't have to be a lot but just enough to say, "You worked hard—you deserve it."

CHAPTER 7
DIFFERENT STROKES
FOR CREATIVE FOLKS

"Some people march to a different drummer—and some people polka."
—LOS ANGELES TIMES SYNDICATE

An illustrator's choice of medium(s) can be a very personal thing. We like what we like! Oftentimes illustrators choose what they feel works best after many years of experimenting. You could follow a trend, but why bother if it doesn't seem right for you? My advice: Use what comes naturally—that way, you can make the work you really want to make. I have asked six illustrators about the materials they use to create their amazing work. I've thrown in a little blurb about my own choice as well.

Holli Conger
"I have three different illustration styles: painterly/digital, 3-D clay sculpture and 3-D found-object collage. I really don't prefer one medium over the other, but for fast-turnaround projects, I prefer my painterly/digital style. My found-object style is the most fun for me to do, and my clay work seems the more relaxing to do of the three."

Andi Butler
"I started with traditional media—I used to use gouache, Prismacolor pencils and pen and ink, but when I worked for two major retailers in their

Illustration by Andi Butler

art departments, I was required to use digital for speed, easy adjustments, sizing and color accuracy. When I began learning how to create digitally—with Aldus Free-Hand and Adobe Photoshop in the early 1990s—I would still sketch with pen and scan. As of now, I am primarily sketching digitally and then going to final in Adobe Illustrator. I'm getting back to my roots, though, because I do feel traditional methods can be more spontaneous for me, personally. Sometimes digital is too easy, and I use 'undo' far too often. I should be able to make mistakes and keep them!"

Irisz Agocs

"I'm mainly using watercolor for painting. I really like the freshness of this medium. Sometimes I draw the lines with pencil before I paint; some other times I use quill to do the outlines, after painting or between the

Illustrations by Irisz Agocs

different painted layers. I think watercolor is very good for dashing style painting. I work very fast, and I feel this is why I choose this medium. I use light, very sensitive and faded colors. Watercolor is also great for forming my very own palette."

Roz Fulcher

"I create my illustrations with felt, fabric and a variety of embellishments. I have always loved creating crafts (my mum is a craft designer), and after minimal success illustrating with traditional media, I decided to see if my felt work would translate well in [2-D]. I literally felt like I had found my niche."

Susan Mitchell

"Most of my work is rendered in either water-color or acrylic. I think my style has changed over the years. I used to outline everything in black ink before painting, and now I use pencil or just paint, so my work is a lot softer. I have also been experimenting with collage, which I really enjoy."

Illustration by Susan Mitchell

And Now for My Choices

The majority of my work is created in gouache. I have to make a confession: I absolutely could not stand painting with this type of medium when I was in art school. It used to frustrate me so much I decided to master it, and now I don't really paint with anything else. At first, it seemed it dried too fast, but I soon realized that can be a good thing. It's a very versatile paint and can be reworked. It's

Illustration by Holly DeWolf

also great as a flat color but can be watered down nicely. I often use pen and watercolor pencil to add extra color or texture with the occasional use of collage. I use a lot of black lines, dots and squiggly lines, which is now part of my style. My work isn't completely traditional—I do have to scan it into the computer. From there, I often add text and clean up any flaws that show. If something doesn't quite fit, I can cut it out or move it around. I am slowly embracing letting go of the original image if it needs a little tweaking.

IMAGINATION CAN BE FUNNY

"The world is but a canvas to the imagination."
—HENRY DAVID THOREAU

When we're kids we're told not to let our minds wander, but as an illustrator, I feel that's part of my job. Getting lost in thought can be a skill. Drifting can be used to your advantage. Spontaneous thought and mental images can create usable ideas by surprise. It's a healthy part of an illustrator's day to just disappear somewhere. Often this happens and has nothing to do with the task at hand. It's like your brain has officially left the building. (Just make sure you don't do this while driving!)

I was told that everything has been "illustrated" and that there are no new ideas. This could be technically right. When it comes to illustration, it's about the message and feeling an image evokes. The image could be someone using

Claudean Hellmuth creates custom images for her clients.

a watering can to "grow" money, but it all comes down to how original you can make that theme. It all also comes down to feeling. If you can make the image feel different, it will be truly original.

There has always been a fine line between inspiration and imitation. Illustrators are visual sponges—your "mental recorder" is always on and filing everything in the storage tank of your brain. The world is so interesting to an illustrator. There's so much to learn. With all that information, you can sometimes imitate an idea. It's hard not to. If you aren't sure about something that's popped into your brain, check your sources. The best way is to Google it. Go over your notes or any books that brought that idea in the first place. No sense letting your ideas get you into trouble.

When it comes to ideas, I believe it's okay to use the same ingredients as another illustrator—it just depends on how much you use and how you mix it together. Just flip open a copy of *HOW* magazine, and you'll see all sorts of interesting and inspiring ideas. It has to do with perception.

"Ownership is by signature now."
—DAVID BOWIE

THREE QUESTIONS TO ASK YOURSELF ABOUT YOUR IDEA

1. Is it new to you?
2. Is it new to your client?
3. Does it look like someone else's idea?

"What is now proved was once only imagined."
—WILLIAM BLAKE

Some illustrators fear putting their ideas out there, for fear they will be copied or not taken seriously. Risk is part of the job. I say get your ideas out there; the art world totally makes room for more ideas. Don't take the

usual route. Not sure if your idea is marketable? You'd be surprised what the world wants to see. New ideas scare some and excite others. When your idea comes from left field, you've officially given rise to something rare and remarkable!

THE IMPORTANCE OF STYLE

"Style is primarily a matter of instinct."

—BILL BLASS

If there's one thing illustrators worry about the most, it's style. Your personal style is your own visual voice. It's your distinctive identifying manner on all your work that says *you made that.*

I asked digital illustrator David Sones about his personal working style. "I have always just drawn in the way that is most natural for me and let my style develop from there. That way I feel have a stronger connection with each drawing, and I hope that the audience will have a stronger connection with my work as well. I

Illustration by David Sones

have only one illustration style, [and] I call [it] Pickledog. Overall, Pickledog doesn't change, but I am always experimenting with different ideas or techniques to add to it. That way my style has consistency, and I can keep it looking fresh."

There are a few schools of thought on style. Some believe you should have only one distinctive style. Others feel you should be flexible. Lastly, some feel you should have a few different styles to keep yourself open to as many markets as possible. To some, having one style isn't enough. To others it can be an obsession. Why obsess? It may have something to do

with the enormous amount of illustrators in the market. Another reason could be that some illustrators have art directors or agents who encourage a certain trend.

Illustrators with recognizable styles are Bob Staake, Anita Kunz, Gary Basemen, Ray Fenwick, Linzie Hunter and Lane Smith, to name a handful. There are more. One illustrator who stands out right away for me is Irisz Agocs, who's from Hungary. Her style is quite unique, and whenever I see it online I know it's her work right away. She uses rich brown watercolor tones with color subtly mixed in. It's very charming, whimsical and has a feeling of smart humor. I am a true fan.

You can learn a whole lot from looking at your own illustration heroes; think of it as learning by looking. Many illustrators have something to teach us as mentors in the tools of the trade. It can be the way the illustrator adds color to her work or the way she represents certain images. A couple of my personal favorite illustrators are Lane Smith and Ludwig Bemelmans.

I have loved Lane Smith's work since I was in art school. He has this nice way of combining collage, color, interesting techniques and found elements that's delightful. Following convention is not his forte. Lane definitely beats to the rhythm of a creative drum. He is willing to experiment with style and composition, which in turn taught me to let go and try different ways to create images. I must confess I buy his books to look at the pictures.

I love the work Ludwig Bemelmans did for the *Madeline* book series. His beautiful, subtle illustration style is charming, painterly and linear. Certain subjects are left almost obscure, and other subjects, such as buildings, feature a very whimsical style but with more detail. His work seems very light to the touch and almost effortless. This has always intrigued me and got me thinking about how easy it is to overthink a subject and overdo it. It's hard to believe Ludwig's first attempt to get the series published was rejected. It was finally published in 1939 by Simon & Schuster.

Another style that intrigues me is vintage illustration produced for advertising, books, toys, records and magazines between the forties and sixties. This was a very stylized period in illustration that I find incredibly interesting and just plain cool. My interest has led to a very large collection of vintage books, packaging and records. I refer to these little gems often as inspiration and creative stimulation when I'm in an idea slump and need a mental pickup. It works like a charm every time.

Illustrator Paul Chenard has a more technical style that's very different from my own. He has a very specialized theme of work he combines with something he truly loves. He illustrates cars and racing history as he sees it. "For a long time, I've had a passion for the history of motor racing and

Illustration by Paul Chenard

the cars and people that made it happen. I am now creating art related to this passion."

Style is, in essence, your creative hook. If it gets attention and gets noticed, it can be marketable if promoted and utilized by the right buyers. Try to remember that there is truly more to your work than style. Style is a function. Remember that the heart of your work is the message and the meaning combined with skill and technique.

Do we choose a style, or does it choose us? I believe the more work you produce, the more you'll get into a groove you feel comfortable with. Your style will grow out of that. There will be influences along the way, of course. What we start off with after art school or during our early days of experimentation could be completely different years later. Just because you have a current style doesn't mean it will never change as you continue to grow and evolve as an artist.

Reasons for a style switch could be that your style is becoming trendy, and imitators are swallowing up your work. You may want to change

markets from magazine editorial work to children's publishing. You could get bored or finished with the redundancy of a style you've mastered over a ten-year period, for instance.

When changing your style, let it progress naturally. Don't fake it, or it will show. Be honest with your head, hands and eyes. If it feels right, go forth and create.

THE ILLUSTRATOR'S TOOLBOX

"Everything is there, if you use the tool box and the systems
that are in place."
—DAVE ELLIS

If somebody asked what you needed to use to be an illustrator, what would you say? There are essentials many of us cannot live without. The big one, of course, is a computer and great software. A desk is pretty important as well, as is paint, paper, a Wacom Tablet and a good scanner. What about those things that help you create images in a really unique way? There are unconventional tools that help us create all the magic we call our illustrations. This is essentially our own personal formula.

There are also unorthodox ways to make an image. A good example is Holli Conger's Junk A Doodles. She combines illustration and found objects to make extremely whimsical and fun work. Holli has a very good understanding of 3-D illustrations that really work. She isn't afraid to play. Another great example is Linda Solovic. She combines collage, pattern, shape and design to create work that's like a tapestry. She says her work has a "sophisticated, primitive look." Although some teachers in high school and college did not always appreciate her work, she managed to get encouragement from one teacher who told her she should "make her art in the way she saw the world, not with the accepted standards of perspective, shading and realism."

Von R. Glitschka created a book titled *Crumble Crackle Burn* that promotes texture as a way to alter your designs and illustrations. The one

hundred twenty textures are from organic sources that will help you add another dimension to your work. It's a completely unique idea for a book that Von describes as "a timeless resource of real-world surfaces along with corresponding examples of how they can be artistically applied in design and illustration projects."

<div style="border:1px solid #ccc;padding:1em;">

RECOMMENDED READING

Von R. Glitschka's *Crumble Crackle Burn: 120 Stunning Textures for Design and Illustration*

http://texturebook.com

</div>

Your illustration toolbox doesn't need to be an actual box; it can be a metaphor for how you do things; it can be a system you follow to create your work; it can also be all the necessary tools you need to create your illustrations and run your business. This "box" can contain things such as your ethics, values, interests, boundaries, philosophies, likes and dislikes. It can even be what you turn to for motivation and inspiration. Kind of deep, huh?

Here are some tools I find useful:

- Creating shapes on my work with things like bottle caps dipped in paint
- Creating great backgrounds with sponges and toothbrushes
- Collaging with cut text

I often create unique work by making collaged shapes I end up tracing to create an illustration. Not only can this be random placement, it also helps me let go of the idea that everything needs to be just right. I know of illustrators who paint with tea and coffee. It makes a good background wash, plus I'm sure it ends up smelling quite good!

Your toolbox can also include how you live your life. Jannie Ho's work is very vibrant and fun. I asked her if it was similar to how she lives her life and to her personality in general.

"My life as an illustrator might not be superglamorous, but I can say that I am never bored! There are always things I find strange and quirky. I think I am young at heart with a strange sense of humor, and everything ultimately comes through in my art. My apartment looks like one big playhouse, although I've been trying to be more 'adult-like.' Its hard not to bring home another funny knick-knack or colorful thing for inspiration. I feel like I'm always in play mode."

Illustration by Jannie Ho

I can relate. Essentially, my house is a jungle gym. There are toys, books, paper and crayons in practically every room. Kids do that to you. There's a method to all the madness, and that method is "fun." Color, interesting collections and unusual things are used to decorate the rooms. The way I see it, I live here. I create here. I also raise my children here, so why make it sterile, stuffy and boring? Have fun with your space. Let it work for you. Make your own rules.

Jannie Ho brings up an important tool I think we all could use more of, and that's weirdness. I had a teacher in art school who gave me this parting advice when I graduated: "Don't trust anyone who does not wear jeans!" First, I thought he was drunk, but then I figured there must be something to it because he was allowed to teach! Only once I started getting out there and growing up while having to deal with people did I realize what he meant. Basically, don't let someone else impose their stuffiness on you. Stay creative; look for the weird and

interesting things that make this world fun. Of course the "jeans" are just a metaphor for commonality. Let's face it, we all wear jeans. We all need to be weird from time to time. As Mike Myers puts it, "Silly is you in a natural state, and serious is something you have to do until you can get silly again."

I cannot finish this section without mentioning the importance of humor. Humor can be a very useful and motivating tool, especially on the days when things aren't going as planned. I apply this to everything—from whatever I'm doing with my kids to chatting online. Humor helped me write this book. There were moments when my brain would stop cooperating and the best way I found to move through it was by joking around. Wit is an art form in itself. I look for interesting ways people describe things and how they comment on things. I think humor is also a very attractive quality to have. However, with that said, you also need to appreciate that not everyone is going to appreciate your sense of humor. Connect with those who get you. Humor means you're willing to let go while stopping to look at things at a different angle. An added perk are all those "happy" chemicals that help you back on the road to creativity. So stop and play with your words every once in a while because you never know what great things doing so may lead to. If anything, it will make you laugh, and that is always good creative medicine.

DOING IT ALL

"Doing easily what others find difficult is talent; doing what is impossible for others is genius."
—HENRI-FRÉDÉRIC AMIEL

There have always been Jacks and Jills of many skills. There are also many who are multitalented and very well-rounded. Illustrators are generally good at a lot of things. Skill and talent just seem to naturally breed more expertise. Many have a broad educational background with an array of skills that match an equally interesting lifestyle.

A person who's creative often also has a fierce interest in things. Holli Conger is a great example of a well-rounded creative. She essentially does it all: illustration, web design and art, all the while being a very busy mom. Penelope Dullaghan used to be an art director before she became an illustrator. Her love of creativity and community inspired her to start the website Illustration Friday. Von R. Glitschka teaches illustration along with his illustration and design work. I teach a class on the business side of creativity. Many of us mentor and do public speaking, and many of us are advocates for the industry.

The concept of a well-rounded creative means a person who has a variety of desired skills. This carefully composed way of being is all about covering all the necessary areas for a creative life. The big skills are planning, problem solving, the capacity for lifelong learning and making sure you're challenging yourself. But, wait, there's more! Reinvention and improvement are a huge part of this skill set. What about those hidden talents you don't always get to chat about?

Hidden talents are essentially buried gems. We can often surprise people by all the secret things we do. You may be labeled an illustrator, but your exceptional skill for cooking could wow the pants off many at a gallery opening. Illustrator Claire Robertson has a unique flair for creating delightful handmade creatures she calls Softies. Keri Smith is an exceptional wordsmith. Both Claire and Keri have been blogging while sharing their creative thoughts and creations on the web for quite some time. In fact, Claire has been spotlighted in *WIRED* magazine and *The Wall Street Journal*. Keri has created many books, such as *The Guerilla Art Kit* and *Tear Up This Book!*

Hidden skills can work their way into your business in the form of things such as unique handmade promotions. A hidden skill of mine is origami. My flare for origami helps me create some very interesting packaging for promotions. I love paper, and I make sure I have plenty on hand so I can fold, chop, even sew with it!

"There is no such thing as a great talent without great will power."

—HONORÉ DE BALZAC

I asked the creator of www.sugarfrostedgoodness.com, Jeff Andrews, if it's a challenge to juggle his many skills. "A challenge? Not really. I've always found the creative process for design and illustration to complement each other, and I think it's imperative that anyone working in either field to have at least a basic knowledge of the other. A good designer needs to know how to draw, plain and simple. A logo, for instance, should always start from the basic conceptualizing stage of a good old drawing pad and pencil. And an illustrator without a basic knowledge of the building blocks of good design (i.e., concept, color theory, working within a grid, visual hierarchy, etc.) will ultimately fail."

There really is no limit to the illustrative mind. Creativity combined with many skills give you an unlimited advantage to marketing yourself. Somewhere along the line we lose the fear of trying and doing it all. These mad skills enable us to do amazing and unexpected things. Creativity is fun. Everyone should be so lucky.

THE COMPARISON HABIT

"Be yourself. The world worships an original."

—INGRID BERGMAN

If there's one surefire way to suck the life out of your creative enthusiasm, it's comparing your work to another illustrator's. It's good to look at another's work from time to time. Look at what they're doing and look at their client list. Draw inspiration from them and enjoy their work, but keep the focus on yourself and what you need to do. Comparing yourself to other illustrators could make you lose momentum and bring your creativity to a screeching halt.

We're taught at an early age to compare and contrast things. As an adult, we can compare so much that we lose our perspective. As a result

we become harsh critics of our own work. Often our judgments of our illustrations and ourselves are far worse than what our audience feels about what we produce.

I asked the creator of the popular site Illustration Friday, Penelope Dullaghan, if she ever compares herself to other illustrators. "For me, 'comparing' my work to others' is always a bad thing because there are always others who are 'better' or 'worse' than myself. And if I'm in comparison mode, I am just looking for that lift of 'Hey, I'm not so bad' or that kick of 'I suck compared to them.' It's an ego thing. So I think it's better to not compare at all and just be where you are. However, I find that looking at other people's work for inspiration, without comparing, is a better way to go for myself. But I have to ask myself why I'm looking in the first place ... really understand before I open a website or a book if I'm prepared to be inspired or to compare. If I hear myself say, 'compare,' I try to walk away. Not always easy. It feels like sometimes we actually want to make ourselves feel worthless."

"Comparison is what kills most artists."
—JULIA CAMERON, AUTHOR OF *THE ARTIST'S WAY*

Looking at another illustrator's work can be a form of research, a way of gathering ideas or an education of sorts. It's good to keep up on the trends and what everyone is working on. Rule of thumb: Never copy another illustrator's style. It isn't you, and it will show because you won't produce work that comes naturally to you. Do you want to follow a trend or create your own unique style that will set you apart from all the rest? Again, be inspired by trends and use parts of the trends to keep your work marketable, but make sure that in the end your work is identifiable as your own.

There are many reasons we do this comparison dance. Reasons such as rejection, lack of confidence or just plain inexperience can lead a person to look around. Rejection can have you questioning your style and marketability. Often we find ourselves wondering why "they" are getting

work or an agent and not us, for instance. Lack of confidence or inexperience usually creates a lot of research and digging that can stop you from getting out there. That "I am never quite ready enough" holding pattern can be made worse when you're busy beating yourself up over someone else's successes.

On the road to making great images, every illustrator has a different story to tell. True freedom means just doing the work while leaving the worry behind. A friend of mine recently sent me a note with that old faithful quote, "Don't sweat the small stuff. It's all small stuff." It was a nice reminder that worrying and comparing take a lot of energy and time. When you stop worrying about what others will think and what others are doing, this frees you up to do the really important stuff.

Doing "different" and creating "different" are refreshing. The difference you make with your work is a true gift to yourself and to your audience. Go beyond comparison and compete with yourself!

YOUR CREATIVE FORTE

> "We don't choose our passions. They choose us. We have to pay attention to them so they can tell us who we are."
> —JACK BUTLER

According to American psychologist Howard Gardner, every individual demonstrates many different levels of intelligence. In his book *Frames of Mind: The Theory of Multiple Intelligences,* he describes the theory of visual-spatial intelligence as someone who possesses a strong visual memory and is able to visualize and mentally manipulate objects while possessing excellent hand-eye coordination. I think this pretty much sums up every illustrator I know, including myself. I do believe as creatives we are tapping into skills not everyone has.

You've heard of the myth that the average person uses only 10 percent of their brain. Well, this is one of those misunderstood factoids that's still thrown around. I'm pretty confident in saying illustrators definitely

possess the ability to think more than 10 percent. Why? Our brains are like sponges we continuously fill with ideas while pouring them back out into our work on a daily basis. We have, in a sense, trained ourselves to think a lot. We naturally become fiercely interested in things some may not notice or care about. It's a skill to see, feel and create the way we do. We spend a lot of time getting to know how we think about things. One thing's for sure, we creative folks are generally in touch with ourselves and feel passionately about what we do for a living.

An inner freedom allows illustrators to create what comes naturally. Creating takes courage, and this courage allows us to try other creative endeavors. This is probably why you often hear talented people being told they're artsy or crafty; one skill generally leads to many. Once we lose the fear of getting our ideas and skills out there, we realize the extent of what we can do.

I have often heard from many friends who didn't pursue art or design that they are unable to draw or be creative. My response is always, "Can you write?" They answer with the obvious yes. To me, writing is a form of drawing. As Paul Klee stated, "A line is a dot taking a walk."

I asked Penelope Dullaghan why she chooses to paint and if anyone has ever told her she should create digitally instead of traditionally.

"No one has told me how to do my work, thankfully. I have transitioned on my own to a mix of paint and digital for my illustration work just because it's much faster and more efficient to complete an assignment. I also like the flexibility of doing it that way. You can change colors or fix up a boo-boo without having to repaint an entire piece. There are no rules on how to create your art, so I just do it however I enjoy it the most."

As illustrators, we focus on so many things, but how often do you focus on what you're good at? Knowing your strengths allows you to be able to sell yourself in a much different way. Every illustrator offers something different. Make a list. Do you mix paint well? Do you know twelve differ-

ent types of software? Can you create your own fonts and text? You'd be surprised what will make it to your list. Coming up with a list like this boosts the ego as well as helps you get to fully know your creative self.

CONCEPTUALLY SPEAKING

"An open mind loves a blank page."
—UNKNOWN

Conceptualization sounds big and mysterious to some. But to illustrators it can come easily. Essentially, we are sponges of information we twist and alter to solve creative problems. This cognitive approach is a process of independent creative thinking for new ideas and solutions.

"An open mind leaves a chance for someone to drop a worthwhile thought in it."
—UNKNOWN

Lateral thinking is basically thinking that changes concepts and perceptions. It's all about reasoning. A perfect example is the concept of the "thinking outside the box" philosophy, which means omitting or putting aside common accepted beliefs or constraints. I believe that when we fall into the box, we basically enter a state of mind; once inside, your view of things and the world becomes narrow and blurry. It's all about fear and uncertainty. Being in the box can stop progress.

When it comes to making your illustrations conceptual, what does that mean? It means the idea or concept is the most important aspect of the work. There's much planning mixed with decisions before the image comes to light. The execution of the image is then a careful and detailed process.

Conceptual thinking is about linking things together. As a creative, I'm constantly connecting things that sometimes seem out of place or completely unrelated at first. Brainstorming allows me to mold the idea together with something that could potentially work. This takes time and

practice. Mix in a little experimentation, exploration and word association, and you have a great recipe for ideas.

A good place to see great examples of conceptual illustration is *The New Yorker*. In fact, make it a habit to look for good examples of work. If you're going to look at other illustrators' work, try to learn something about how it works and why you like it. You will take yourself beyond the initial first impression—that it just "looks great." Go deeper. Look at the color, placement of objects and any symbolism. Does it seem to have a narrative feel? Imagine the many markets it could fit into. My point is this: Really look at what you find interesting. Doing so speaks volumes about how you think, feel and perceive the imagery around you.

Remember that the purpose of all this illustration business is visual communication. Develop your skills first and then create a style that eventually develops into concepts. That's when you start to make meaning out of your work. You must find your creative niche and the proper markets that go with it.

REDEFINE SUCCESS

"Success has a simple formula: do your best and people may like it."
—SAM EWING

What does success mean to you? Does it mean a BMW sitting in the driveway, or could it be conquering a fear of cold-calling for work? Success is relative. What may be important to someone else may not ever make it to your list. Success could be something huge, like landing your first assignment, or a series of small steps that lead to something bigger.

A great link to participate in is My Life List: www.mylifelist.tv. Create a life list, act on your goals and celebrate your accomplishments by sharing stories and photos. This is a huge motivator, especially on those frustrating days. Also, it allows you to take stock of your accomplishments and successes.

I asked Penelope Dullaghan how she defines success for herself.

"Answering the question 'Are you happy?' with a resounding yes. That seems like such a simple answer, I guess. But if you are happy, you have what you need ... why push beyond that?"

I believe success is a state of mind. Keep your success real for you. We normally respond to this subject by saying success means getting steady assignments while making lots of money. For many illustrators we gauge success by getting our work viewed by the public and by being spotlighted in anything big or small. Recognition plays a huge part in this career. If the public doesn't know who we are, we feel this alters the success meter.

What is your success meter based on? Is it based on your ideas or comparing yourself to another illustrator? Once again, it comes down to what's important to you as a self-employed illustrator. Are you out to be a creative superstar? Do you want to change the world one image at a time?

"Success is getting what you want. Happiness is wanting what you get."
—DALE CARNEGIE

Success can be unexpected; often what we plan for takes a different turn. And sometimes success is as easy as doing what you set out to do in the first place. Reaching your goals requires motivation and action on your part. The old expression of "success breeds success" means hard work and taking stock of any and all progress.

"There is one success—to be able to spend your life in your own way."
—CHRISTOPHER MORLEY

Making ourselves accountable helps us follow through on our goals, which can only lead to success. All this needs to mingle nicely with discipline. When I started out, I focused on baby steps. I was always too afraid to leap too far, so I found a happy medium I felt comfortable with. These little steps added up and actually got me further than I ever could have imagined. Every tiny moment was a miniscule pat on the

back that helped me gain more confidence and that now allows me to take more risks.

"Success is a journey, not a destination."
—ARTHUR ROBERT ASHE JR.

Want to surprise yourself? Start a success journal. Then read it at the end of the year. It's very interesting to read about all the moments that accumulated in a twelve-month period. It's also a huge motivator and ego boost. Not a bad way to start the New Year!

CHAPTER 8
HANDLING PROBLEMS THE CREATIVE WAY

"Creativity can solve almost any problem. The creative act,
the defeat of habit by originality, overcomes everything."

—GEORGE LOIS

No matter what you do in your career, there will be many bumps along the way. Call them hiccups or Hindenburgs. Either way, these disruptions can leave many of us scrambling for a solution. Don't panic. You are not alone. No one is handed a magic wand for all the little disruptions that can come with this business. Time to get problem solving fast!

What doesn't break you and knock you down can only make you creatively stronger. Resilience is being able to rebound from a difficult situation. How well you return to your normal creative self after rejection, illness and adversity says a lot about your creative nature. The good news is that falling down half a dozen times will help you handle anything this career throws your way. Don't get rattled. Instead, try another approach.

"See problems as holes in the ground. You can dig deeper, or you
can break new ground."

—ANONYMOUS

Von R. Glitschka turned around a potentially bad situation in February 2002 after he got fired.

"I went into work about an hour early to catch up on stuff, and my boxes were packed, and they handed me a check. Getting the boot wasn't fun, mainly because I [had] a wife and kids that depended on me and a mortgage to pay. But in hindsight it was the best career move for me. Forced me to leave a comfort zone that frankly was holding me back and has equipped me to pursue many things I otherwise would never have been able to do if I was working for someone else. My personality and drive [are] perfect for the flexibility of being my own boss, so it's worked out great, and I get to spend more time with my family, too.

"The first six months were hard. I actually went on two interviews, but both stated, 'You're overqualified.' My wife suggested I start my own business, and that proved to be the best advice anyone gave me. At the end of the first year, I was floored when we did our tax return, and I saw for the first time in a very pragmatic way how well I had done. Every year since, my business has grown, and new creative opportunities have presented themselves, and for that I am really thankful."

You will have lots of practice with frustrating moments. The illustration road can be bumpy, just like any other small business. The way you handle it makes all the difference. Don't question yourself. Most importantly, make sure you get back up after you've been knocked down.

BURNOUT

"It's like, 'Whoa, what the hell happened there? I am retreating within myself.'"

—MITCH HEDBERG

Burnout can strike at the worst possible time when we aren't feeling our best; it's a progression that can leave you uninspired, bored and com-

pletely drained of any useful energy. Burnout is a red alert. It is your mind and body telling you to stop. When you're too stressed, too tired and done with the same old, all bets are off.

Bad signs are a lack of interest to create and a lack of care whether you create or not. This could have disastrous effects if you forge ahead even though you know better. Missed deadlines and upset clients, mixed with much frustration, cannot be good for any illustration career. This will add to that awful feeling that something is wrong and that you do not feel like your normal self.

"My candle burns at both ends; it will not last the night."
—EDNA ST. VINCENT MILLAY

YOU KNOW YOU ARE BURNED OUT WHEN

• Nothing you do feels good or looks good.

• Your work isn't inspiring you to create.

• You lose sight of what's really important.

• You're distracted and feel like doing nothing because your brain is feeling nothing.

• All you want to do is sleep.

• You feel cranky, frustrated and drained.

• You stop caring about the important things going on, such as deadlines, networking and all those normal things that used to get your attention.

If every little thing is stressing you out, you have to know something is off. Being easily angered and feeling lost are signs of a larger problem that needs to be addressed stat! What should you do? Do something different.

Do something out of character. Do something for yourself. Burnout often is a signal that a holiday is badly needed.

Vacations should be the ultimate getaway, but oftentimes we take work along for the ride. We book vacations that may be too labor-intensive. The result can be coming home even more tired than you were before you left. Do your research. Make sure your vacation interests you. Better yet, if your brain is completely drained of any useful function, book a vacation to do nothing.

So you can't take that much time off, for whatever reason—try a mini vacation. Good sources for this are a visit to an art gallery, concert or day course; attending a get-together; going on a day trip; reading a good book or spending a lazy couple hours at your favorite coffee shop. Do what works. Do something that's going to distract you for an hour, a day or even a whole weekend. Imagine the possibilities! Having only a limited amount of time has a funny way of making us get creative with the clock.

Need a nudge? Throw on your iPod. Or go outside, close your eyes and just listen. Try to reinvent what you're hearing. Here's a goofy thought: If you catch part of a conversation, try to imagine the parts you missed. Fill in the blanks and create a new scenario. It's sort of like creative commentary to everyday normal things—like watching an episode of *Mystery Science Theater 3000*.

Want a true escape? Try a mental holiday at home and do nothing. Sounds kind of Zen-like, but it works and can be a new spin on a short bout of boredom. Daydreaming and drifting off are art forms unto themselves. There's a real importance to just shutting off. Think of it as a type of mental refocusing—it allows you to imagine anything and everything. You're giving your constantly busy brain permission to stop. Empty time works well without any sensory stimulation and can become a great creative asset with practice.

From time to time, our brains need to go into a pattern of thought called "the default network." Unconscious thought falls into this category when we're reading, doing the dishes or driving. These tasks become auto-

matic even when we tune out. This internal brain soup helps you discover new ideas. Connections are made to things you might have overlooked. Unrelated thoughts can mingle nicely to create new relationships. It's a win-win creative tune-out.

A big philosophy I live by is this: The good stuff happens during silence. Believe it or not, but silence is good for you. There's silence. and then there's effective silence. This basically means you're actively being quiet to gain something or open yourself up to new ideas, solutions and creative tinkering. I believe this quote from C. Krosky sums it up well: "Most of us know how to say nothing; few of us know when to let our silence speak louder."

PROCRASTINATION

> "We will not know unless we begin."
> —PETER NIVIO ZARLENGA

Procrastination is generally that missing link between productivity and being in a coma. It is completely-slacking-off time. You know you have work to do. You know you have a deadline coming. But your mind wanders off somewhere else. Everything becomes a distraction. All of a sudden an unorganized sock drawer ends up being the most important thing in the world. Next to come is the TV, and then you end up zoned out for three hours. If there's one definite thing we all have in common, it's procrastination.

Procrastination comes from the Latin word *pro*, which means "forward," and *crastinus*, which means "tomorrow." It basically leads to leaving action and tasks for another time. Some see procrastination as a coping skill against the stress and anxiety of starting or finishing a job or making an important decision. This loss of productivity often creates a huge amount of guilt associated with avoiding responsibility.

Fear can be a trigger. Who doesn't get cold feet when dealing with the unknown? As you know, we usually avoid the things we fear. Feeling un-

organized or unprepared can bring on this uneasy feeling. Sometimes the wires get crossed when we're dealing with differences between urgency and priority. The next wrong move can be a distraction that takes you away from what needs to be done right now. As in the case of writer's block, lack of inspiration or creativity can be the culprit. After that, you could start avoiding the project due to lack of interest because you're spending so much time overthinking it.

Lumping everything together and wanting it all done *now* is a form of perfectionism. We often want things to go just right. It's hard not to want to control every aspect of a project. Let go! This release can open the mind and allow it to be easy and free. I think we can all agree that in order to kick creative block in the butt, we must find some sort of release.

A useful strategy is what I call "chunking," or breaking the task into small, manageable steps. This could be a really good time to throw in some "free" creative thought to mix things up. Another approach can be stopping for the day and returning tomorrow with fresh eyes and a fresh brain. Lastly, try visualizing the final outcome.

The good news? Creative blocks can mean a change in direction and a fresh beginning toward something new and exciting. What you started out with might be the opposite of where you thought you needed to be. You never know—you might like the results.

REJECTION

"Pick yourself up, dust yourself off. Start all over again."
—PEGGY LEE

Rejection is one of the biggest momentum killers I can think of. Let's face it, it feels rotten but is one of the unfortunate bumps along the illustration path. You can pretty much count on rejection (like bills or aging). No matter how many times you hear the phrase "Your work does not suit our needs right now," rejection can make even the most positive person wonder what they're doing wrong.

Most often you aren't doing anything wrong. You may be targeting a market that doesn't need your particular talents at this time. It could also mean they don't fully understand what you do. Or maybe they're looking for a particular style of illustration that isn't yours.

A great site that lets you submit rejected work is The Designers Recovery Magazine (http://floggedmagazine.com). Their motto is "We celebrate good designs that have been flogged in a monthly magazine."

> "You're like some kind of superhero that can ward off success at every turn."
> —THE DREW CAREY SHOW

Too often we question our work, our marketing style and worst of all our personalities! Keep in mind that even the best of the best get rejected. We can get too down on ourselves when we're kicked to the creative curb. We are talented. How could they not want what we do? How is it they don't see what we see in our work? Why don't they realize how hard we've worked to get to this point?

We ask all sorts of "why" questions when we feel dejected and bummed out. So, what are they really saying when they throw your efforts a curveball? Number one, they are not rejecting you, they are rejecting the services or the style you provide. Sometimes they are rejecting all illustration services because they don't need work at the time or it isn't in the budget. Remember that this industry is based on many factors, and rejection need not be forever. Ask them to put you on file. Ask them for a critique. Ask for a little advice to see what they need from a potential illustrator. And, lastly, ask them if you can follow up in the future.

> "I reject your reality and substitute my own."
> —MYTHBUSTERS

Reject your rejection. Don't let it take away your creative power. Find another way. Find another audience. Stay true to your style, your creative voice and your goals.

DEALING WITH THE INNER CRITIC

"You're like a pop-up book from hell!"
—*GILMORE GIRLS*

I often think we're all born with a little critic deep inside each of us. We don't need this critic's opinions, negativity and nagging little voice. You can always count on it to rear its head when your work gets rejected or when you get tired and frustrated. The little critic can rule your creative brain if you let it.

"Experience is the toughest teacher because she gives the test first, and then the lesson."
—*UNKNOWN*

I asked Jeff Andrews to describe how he handles that little critic inside. "I'm easily my own worst critic. Too often I agonize over the most insignificant little things in regard to a current project. Ralph Waldo Emerson said, 'We [become] what we think about all day long.' If my clients knew the amount of work I actually put into a job, they'd be amazed. I tend to become a bit obsessed during the early stages of the creative process. A favorite catchphrase of mine is 'Eat. Sleep. Design.' The way I usually get around this, however, is by taking a systematic approach to the job, exploring and working through the task at hand in an almost militaristic fashion. And I like to bounce stuff off of my family and colleagues for critique as well. Feedback can be invaluable."

"That's it, mister! You just lost your brain privileges!"
—*PLANKTON FROM SPONGEBOB SQUAREPANTS*

When that "voice" strikes, do you know how to talk over it to silence it? How much of it do you believe? The inner critic is basically a really bad dialogue within yourself. It can come from anywhere—from naysayers from the past, from mistakes and from past misunderstandings. Try to remind yourself that this voice is a completely separate entity from yourself. It comes from you, but it isn't the true you.

Try to reprogram this inner chatter in the most creative ways you can. I often challenge my inner critic with silly rebuttals. It sounds odd, but I refuse to let negative script get to me. There is a time to create and a time to evaluate. There is also a time to look for real perspective. Others can never verify self-worth; you can only do that for yourself.

PERFECTLY IMPERFECT

"Practice makes great!"

—HOLLY DEWOLF

I know what you're thinking. You're thinking, *The saying above is "Practice makes perfect."* I have always preferred things to be great over perfect. The word *great* just sounds wide open to possibilities. As an artist, you can do a lot of creative things that can lead to many great things down the road.

Mistakes can also find their way into that great category, too. Mistakes aren't as bad as we think. We focus on errors and blunders so intensely that we lose sight of all the good things mistakes can teach us. Mistakes allow you to reinvent the idea from a different angle. As I am well seasoned in the mistake category, I am willing to admit my goofs and boneheaded moments. My philosophy is if I can laugh at it, I can live with it and learn from it. I try to use that energy for good. Sounds like superhero thinking, but it's better to use mistakes than to waste time wallowing in them.

Perfection is an illusion—it's only an idea, not a human truth. Illustrators are in the business to solve creative problems in a visual way. Trying to be perfect only creates more problems on top of what we have time to fix.

Perfection is also a surefire route to Crazy Town. It can only lead to stress and unhappiness. A happy illustrator is a creative and productive illustrator. Why waste time on negative energy when you can be doing what's really important? Perfectionism means only one option, too many rules and inflexible thinking; this leads to hair pulling—mainly your own.

Basically, perfectionism is all-or-nothing thinking. Perfectionists believe it is best or worst and black and white.

I like to go the route that says, "Mistakes happen. Have fun anyway!" The level of creativity you require as an illustrator is pretty big. There are endless possibilities, decisions, mistakes and experimentations. Perfectionism requires too much energy that can otherwise be better spent on the fun part of your life and illustration work. When you're worrying about things being "just right," you lose that element of surprise many illustrators require in order to come up with new ideas. The wrong energy spent on the wrong things can lead to missed opportunities, and these missed moments could increase that unrealistic need to get things "just right" the next time—or else.

As illustrators, we are in a constant state of reinvention, and reinvention pretty much cancels out any concept of perfectionism. At some point you will have to break your own rules. No sense being rigid as a stick. Remember that your illustration career "ideal" is only a creative guidepost to work toward. It also helps to add some flexibility because there will always be deviations from your original career path. Focus on the benefits that led you to this career in the first place.

The Antiperfection Checklist

- **Step away:** Leave an idea or an illustration you may be feeling critical about. Instead, look for inspiration. Something unrelated that can distract you long enough to refresh your brain. Fresh eyes add a new perspective. It's also wise to avoid looking at other illustrators' work at this time because this can halt your productivity even more.

- **Shelve it:** If it's the wrong time or the wrong kind of energy or it just feels wrong all around, shelve it. Sit back and relax. You know where it is and that you can revisit it later. If you're going to exert that much energy on a project, make sure you're enjoying it. This simple act can let you love that idea again.

- **Get organized:** It's definitely beneficial to create some sort of order for yourself if deadlines are looming. Order can add a sense of control at those moments when you feel like you're going to pop your disordered head. Mess has this funny way of agitating people. Mess can also be very distracting.

- **Define what's really important right now:** What's the number-one thing you need to focus on? Making yourself do things on a regular basis even though you aren't into it isn't a good push in the right creative direction. Nagging yourself to do it all, do it right and do it exactly as planned can work against you.

- **Practice letting go:** Do you really need to control every little thing, idea and illustration project? Sometimes the uncontrollable and unchangeable career issues can be quite liberating. I find these moments to be surprisingly refreshing.

- **Make a deliberate mistake:** Do something imperfect, messy and really out of character. Create blindly without a plan, blueprint or notes. Break the rules (but make sure you break your own rules).

- **Distraction:** Set up diversions for yourself. Distraction can be a wonderful thing, especially when it's something really different, interesting or a bit odd. Moments like this help your brain wrap itself around things.

- **Embrace the concept of "good enough":** Accept that you need to be done. If you're tired of looking at something, it's a sure sign to call it finished. The project can be good enough right now. Down the road you can revisit it, change it or realize you love it.

- **Reward yourself:** Hard work in creative thinking and illustrating needs to be appreciated from time to time. Take moments when it isn't so busy to do something good for your creative ego. Do what you need to do. Need what you need. Want what you want.

- **Joke:** Nothing stimulates my mind quicker than, humorous banter. Humor—especially self-deprecating humor—works really well. If the person you're talking to or watching can laugh at her mishaps and oddities, you can too. Humor is a great fix and in many cases it's free. It's cheap medicine!

Essentially, you're letting go of the over-responsibility role that can be numbing your illustrious mind. We can exert too much of that all-important energy to perform great things in exacting specifications. Not only does this make life harder, it can also alienate important people such as friends, family and your clients. Being seen as someone who does not creatively play well with others isn't going to help your career. Allowing yourself to be less obligated for your work to be done "exactly as planned at this very moment" kicks perfectionism to the curb. All that's required of you is to admit the truth that you're a creative illustrator, and perfectionism has no business poking around *your* business.

Wabi-sabi, a Japanese philosophy of aesthetics based on the transient nature of things, focuses on three simple realities: nothing lasts, nothing is finished and nothing is perfect. This philosophy has a very nice simplicity to it and I think sums up life in a very down-to-earth, common-sense way. *Wabi-sabi* focuses on the concepts of being imperfect, impermanent and incomplete. When we stop forcing things to be something they aren't, we develop new eyes and a much simpler way to live life. I believe that only when we let go of those things holding us back do we actually become our true, authentic creative self. It is then that your illustration career really benefits. It is then that you take your illustration career to the next level.

RELOCATION

"I'm taking down the office now!"
—*GROSSE POINT BLANK*

Moving always has a fine way of turning your work life upside down—it's a stressful and tiring thing to dismantle your work space. There are so many things to sort through, organize and box up. And you either need to finish up projects or put them on temporary hold. Moving leaves your business basically up in the air and in the back of a moving van.

Just showing your house can be a pain, especially if you work at home, and the realtor requires you to leave. You have to stop working on whatever you're supposed to be doing, tidy up and vacate the premises. Depending on how many people are looking at your home in a week, you could be leaving a lot. It's frustrating and tiring.

I haven't stopped moving since 1988; it has been approximately fourteen times total so far. I'd like to say that I will be staying put for a while, but life sometimes has other plans. Being in home-and-office limbo can really put your life up in the air. There's a lot of waiting that goes on, such as waiting to get your house sold, waiting before you move out, waiting for Internet and phone hookup and waiting to set up your space again.

I asked Roz Fulcher about her many moves across the country and if it altered her career at all. "With our frequent moves, I have found freelancing ideal. The beauty is I can take my job with me. The main difficulty, though, is switching e-mail accounts and contact information for each location. This has been a little easier now that I have an agent."

What helped me in past moves was having a type of office on wheels. I have a large plastic storage cabinet I can move from room to room and place my mess into in a hurry. It fits nicely under a table so it doesn't have to stick out like a bull's-eye. A laptop computer helps so I can actually leave or go outside and still be able to do work.

Not having access to all your much-needed technology is one of the largest pains to deal with. It's really hard to pack up the computer, which is your networking lifeline and promotion-controlling machine. My advice: Let all your clients know you're moving beforehand. Have an alternate e-mail account you can access at a friend's house. Your cell phone will have to be your much-needed lifeline. If you have a blog and participate in on-

line sites, post something that announces you're in the process of moving and gives an estimated time when you'll be gracing the web once again.

When you're about to set up shop in your new digs, send mailers of your new address. This keeps you motivated, plus it's a nice distraction while you're in office limbo. This also makes a great excuse to send out a new promotional series.

Lori Joy Smith just recently moved from the west coast of Canada to Prince Edward Island. "Moving to PEI has changed my life in every way. We have a house and a yard, as opposed to all being cooped up in a tiny apartment. The lower cost of living here allows us to afford full-time day care for my daughter, giving me more time to work. It is generally much less hectic and stressful in Charlottetown than at the corner of Main Street and Broadway in Vancouver. Life feels much simpler.

"I spent a great deal of time in Vancouver doing custom paintings and selling paintings to stores. It was never my intention to get into this market; it just sort of happened. It was nice to have a way to make money in between illustration jobs, but there was always a little voice in the back of my head telling me that it was taking me away from what I really should be doing. I found it hard to turn down a job—how often do you have people willing to pay you money to paint? Moving to PEI has pretty much stopped all of my custom work; I am finding myself with much more time to concentrate on all the big projects I have been dreaming about for so long. I wouldn't say I have lost any opportunities, they have just shifted."

Susan Mitchell took a longer trip from Scotland to where she now calls home in Quebec. "Because of the Internet, I don't think where you live restricts your illustration opportunities anymore. For example, most of my clients are in the United States, and nearly all of the communication and sketching is done via e-mail. The final artwork is couriered to the company, and it usually works very smoothly. In an ideal world, it would be lovely to meet with clients face-to-face to go over ideas, but I have had quite a few chats over the phone trying to fine-tune projects, and that can work just as well."

One other thing to consider when you're about to leave your old space for a new one is the possibility of damages. This could involve hard drives, monitors and other very vital office equipment. Things get bumped, dropped and roughed up in the moving van. Your best bet is to get moving insurance. I highly recommend it. Often when you move these things in your own vehicle, some insurance companies won't cover you. Another thing to consider could be renovations. Your office and home may not be quite ready for you yet. Lastly, rest up because you will be doing some serious unpacking. After that you can spend time getting used to a new working space and getting back into the swing of things.

THOSE UNTHINKABLE EVENTS

"Man is so made that when anything fires his soul, impossibilities vanish."
—JEAN DE LA FONTAINE

A month before I moved back to Nova Scotia, I was attacked by my neighbor's dog. As I fought to remove my right hand from his teeth, my illustration career literally flashed before my eyes. I thought to myself, *That's it, folks. My illustration career is officially over.* I then went to the emergency room, bloody and bruised, and was immediately moved to the front of the line. Apparently, dog bites are very serious business at hospitals. I was cleaned up and bandaged and told that a public-health official would be stopping by my house to get more information. That was it, or so I thought.

That very bad day ended up becoming six months of recovery, physiotherapy and missed work. I couldn't even hold a pencil. During this ten-second bite, the dog had nearly ripped off my right index finger. On top of that, the dog had shaken my finger and wrist out of joint a half dozen times while trying to pull me over the fence. Needless to say, this had not been a warning bite. He'd wanted me for lunch!

What became very apparent was that the index finger is very important for even the simplest of tasks. Basic things like changing my daughter's diapers or doing the dishes were extremely difficult. I will admit I'd taken that wee little finger for granted. Not anymore.

Kathy Weller is no stranger to overcoming an injury. "Early in my professional career, I started experiencing hand and wrist issues. I was scared. At one point, my problems were so severe that I actually was looking into pursuing other career paths. This was completely depressing—I couldn't bear the thought of giving up my art career! As a last-ditch effort, I went to see an independent 'alternative' physical therapist. This person's work was not covered by my health insurance, but I was willing to try anything. Seeing him was a smart and lucky move—the treatments not only helped me gain back mobility and strength but I learned that regular physical conditioning is integral to overcoming these types of ongoing, chronic injuries. He introduced me to a set of unique exercises that my orthopedic surgeon had never even touched upon. These exercises and the overall knowledge I gleaned from this person helped me eventually gain back control over my art career and my life."

In the course of a day, how often do you think about your hands, eyesight, hearing and your overall health? We are often so busy with our lives, illustration assignments and promoting ourselves we focus on everything else but our health. Remember: Without those amazing hands, eyes, ears and overall healthy selves, we do not have an illustration career.

My hand is about 90 percent better. There are scars as a reminder. It feels tight when cool weather kicks in. All very minor things, considering it could have been much worse. I'm just glad I can bend my finger and that it's still part of my very important hand. As a side note, I am a huge lover of dogs, and this did not sway my belief that dogs make awesome companions. To me, this was a random, isolated incident. My only fault was getting in the way of his very large mouth. Needless to say, it could have happened to anyone.

GO TO PLAN B

"Being challenged in life is inevitable, being defeated is optional."
—ROGER CRAWFORD

Everyone should have some sort of backup plan. Call it plan B or a disaster plan—just make sure you have one. Getting munched on by a dog helped me devise a blueprint for disaster. What I learned from my hand injury was that I needed to reevaluate the importance of what I do and how I do it. I'd never given much thought to the concept of a game plan before that. Worst-case scenarios often have a funny way of forcing your hand, so to speak.

The first thing I looked into was insurance. I'd had no idea there was such a thing as dismemberment insurance for artists. Who knew? It only makes sense, if you really think about it. The concept of dismemberment is pretty gruesome, and it doesn't just happen to zombies in movies. I have come to expect the unexpected because, as it turns out, life is funny like that.

We tend to have insurance for our computers, cars and houses. These three things can be replaced if they happen to blow up or fall apart. Fingers, hands, legs and eyes do not grow back. The reality is we can have accidents and can run into man-eating dogs from time to time. Protect your assets.

So, say you get sidelined. Can you find some sort of additional income? What other creative assets do you have on the table? If you don't know, you'd better get thinking. If you do, start coming up with plans. This book came about after that lovely pooch bit me. It was a concept I had shelved five years ago. I'd had to think fast to find some kind of income while my hand healed, so I took a chance, and the rest is history as they say. The funny thing is I have not ever classified myself as a writer. I mostly went with "idea generator." Either way, this was a good move in the right direction.

A good plan is to make sure you have some backup funds set aside for any temporary setback in your assignments. And don't go it alone. Set up a support system of friends, family and a really good babysitter.

PART THREE

GETTING INVOLVED IN THE COMMUNITY

CHAPTER 9
BRING YOUR TALENTS TO THE TABLE

"Take what you're passionate about, do it well—
then commit yourself to making it better."
—FRED CONNORS

Ever notice how many words rhyme with *illustration*? To name a few: participation, cooperation, foundation, relation, affiliation, organization, association and collaboration. I could go on, but I think you get my point. This career just screams community!

The big difference with illustrators today is the concept of community and what we do with it. Instead of always working in the deep recesses of our studios, hidden away, we're opting for a creative connection among people. The web allows us to connect on levels never seen before. Because we can all use a little help from our friends from time to time, the Internet provides that in spades. Online groups, blogs and forums make this connection so much easier. We get to discuss ideas, issues and business with ease on levels that can only improve this industry for the better.

Small changes happen from small moments. Communication can be as simple as starting a blog or updating your website. Offering advice and online mentoring help us all connect on a deeper profes-

sional level. Support happens when we add links to our webpages of illustrators we love and illustration sites we support and contribute to. Sending someone a link she may find interesting can create more attention for something really great. It can even promote events like International Drawing Day or groups that focus on a greater cause, like www.no-spec.com. You can even take it further by guest writing on a website or blog about something you do, something you support or a blurb about the business.

Remember, you are one of a kind—your opinions and observations are going to be as unique as you are. As mentioned in earlier chapters, a good way to throw in some creative observations is by creating your own blog. You can also speak up by teaching, providing seminars or being a presenter at an industry conference. Always be on the ready to point out the positives. This industry can forever use more promoters.

WAYS TO MAKE THINGS HAPPEN

• **Blogs or group websites:** Many group blogs post a weekly "theme" for illustrators to participate in. This is a great way to get your creative juices flowing. The feedback you gain is priceless, and the sense of community is a win-win situation. Better yet, start your own theme or challenge on your own blog. This makes you creatively accountable to sketch and create daily.

• **Group shows:** Many illustrators have gotten together to create gallery shows; what a great opportunity to gain a new audience for your work. Group shows are a great change of pace from the norm.

• **Creative-business websites:** Online websites and blogs that promote the fine art of creative business are worth reading, participating in and promoting. Not only do you get those elusive questions answered, also you can join in and be seen as a valuable contributor.

- **Forums:** Message boards are great places to ask questions and solicit much-needed advice if you have a pricing question or a how-to inquiry. Forums also spotlight jobs, events and other great sites to check out. You can use forums to promote yourself and ask for critiques of your work as well.

- **Participate in a book like this one:** What better way to "get together" than a book? This book was an excellent way for me to get to know all the contributors. It has been educational and inspiring for me. Not only do I get to promote the business of illustration and all the good things going on with it, I get to promote the illustrators I respect and admire who in turn help promote this industry, too. Getting permission to showcase their images and Q & As was like Christmas. Not a bad deal all around.

"A single act does make a difference ... it creates a ripple effect that can be felt many miles and people away."
—LEE J. COLAN

What happens when illustrators get together? It makes a ripple. This ripple can be contagious. Novice illustrators are learning this earlier in the careers and more easily, which is a vital asset to have. I wish the online community had been around when I left art school.

Our little corner of the world needs a sense of place in which we can all come together. We aren't designed to create completely alone: Illustration needs feedback. As long as we create imagery for clients, we need open discussion attached to it. It's our industry, so why wouldn't we want to make sure we're all on the same page? The illustration industry is in a very interesting and good place right now. I believe this is because of those who participate online every single day. Their dedication is catching on.

THE CREATIVE THINK TANK

"No art, however minor, demands less than total dedication if you want to excel in it."

—LEON BATTISTA ALBERTI

Make something happen. As we all know, many industries are only as strong as those who participate in them. People who share a common direction and sense of community can reach a goal more quickly and easily. It's harder to do something alone than together. Open dialogue seems to be one of the best ways to get people to exchange ideas, and because the majority of us work in home studios, the Internet has become an extremely valuable tool. If you want a community, there are endless opportunities for the taking.

John Martz has this to say about having a blog:

"I had been keeping a personal blog for a few years and was enjoying it. At the same time, I saw blogs like Boing Boing and Cartoon Brew thriving on sharing cool links, information and commentary on subjects I was interested in. I saw a need for a similar site, but one focused on a more specific range of illustration, comics, animation, cartooning and popular art.

"I don't really have criteria for the types of things I post about; I simply post things that I, myself, find interesting or inspiring and trust that my audience agrees. Each of the site's contributors has different interests, but collectively we share a similar aesthetic, I think, which has helped define the blog's focus.

"Luckily for me, being associated with Drawn! (http://drawn.ca) has helped get my name out there more than any other type of promotion. The Internet is a busy place, and it's difficult to grab people's attention, so simply having a website or an online portfolio isn't enough, and I've found that having side projects like Drawn! and the community that it has developed, and offering things like free fonts on my personal website, all help drive traffic to my portfolio."

An illustrated blog can be a huge asset to your online portfolio. A website can evolve slowly, but a blog can be updated daily, depending on what you're up to. This is one of the easiest ways to create community. Trying out a new style or theme? Post it on your blog—the feedback is invaluable. Themes are a great way to motivate your fans to return to your blog. Not a bad way to drive traffic to your work. This is also a great way to come up with a show for your work in your portfolio or in a gallery.

This simple act of getting together to network, participate in a group show or participate in a convention are always good excuses to step away from the studio. It breaks up those really dry times and those really crazy deadlines when you wish you could be doing something different. Create a blog community. Penelope Dullaghan created Illustration Friday a few years back, and it has exploded in support. Many illustrators have "met"

each other online by participating in this really great site, including myself. The nice thing is that it's free but can lead to invaluable new projects, interests and promotion and can help fill your portfolio with new things.

Make sure you have time to keep up on the sites you've joined. Some sites require that you post work and writing. Go for what interests you. Make sure they allow you to remain flexible while giving you what you're looking for. Narrow it down; that way, being a part of great groups will help inspire you and support you the best way possible.

Another approach is to get associated. Memberships and associations have endless benefits. Look for what suits your needs. Some require that you "get invited." Others are a little more open and flexible. Some memberships require a certain amount of experience. These "experience" categories are often listed, and you can often get involved, even if you're a novice. The benefits to getting associated can be discounts, invitations to conferences and seminars, industry market books, insurance and great contacts. Some sites allow you to add your links, and some have space available for you to post an online portfolio to spotlight your work. However, many can be expensive, so make sure you join what's going to benefit you. Try to remember that those benefits will outweigh the cost if it means community, business tips and exposure. Best of all, you can participate in forums and conferences and gain knowledge from those who have years and years of experience. It's hard to put a price tag on that.

NETWORK ONLINE

"A creative man is motivated by the desire to achieve, not by the desire to beat others.
—AYN RAND

I asked seven illustrators if they network online and then asked how having an online presence has helped them in their careers.

Roz Fulcher

"Freelancing can feel isolating at times, so having a blog helps me feel connected to other illustrators. That sense of camaraderie is very important to me, and it's also a great way to network. Having an online portfolio is a must for me professionally. Several publishers use the Internet as a quick way to get a feel for an artist's work, so it's in your best interest to have that option available to them. If they like what they see online, they can always request hard-copy samples for review."

John Martz

"I wouldn't have a career without an online presence. I worked for several years in broadcast design, and it was only after building up an online presence over several years that I was able to have the courage to quit my job and pursue illustration full time. By the time Drawn! had become one of the biggest illustration destinations on the Internet, I was still at my design job doing only the occasional illustration assignment in my spare time. Not having an online presence in today's world makes no sense, and I can't imagine how an illustrator could even survive without one. I don't consider myself a mentor, but I do think I've been successful at building an online presence—that's something that comes with experience and understanding and a genuine passion for the Internet and how it can be used to communicate and interact with people."

Susan Mitchell

"My blog is http://itsawhimsicallife.blogspot.com. I work at home and don't get to socialize much, but by having a blog, I have been able to communicate with other artists all over the world. It's wonderful and inspiring and makes working from home feel a lot less isolated. I am also a member of a group of illustrators that I met over the Net. We have a forum where we chat about work, do promotion together, talk over ideas and critique each other's work. It is really nice to be part of this group—we all feel like friends even though we live in different

parts of the world. It's a great place to stay motivated even when work is slow. We recently also started up a group blog: http://illustrationforkids .blogspot.com.

"I also used to contribute regularly to www.illustrationfriday.com. Each week there is a new topic to illustrate, and everyone submits their work to the site, and you can leave feedback for each other. It is a very encouraging and fun environment. I treated it as an illustration exercise and challenged myself to experiment a bit and try new things. I really miss it and hope to find some time to take part again."

Jim Bradshaw

"For years I have followed a pretty traditional course for marketing myself, such as direct-mail campaigns and advertising in directories. In August of 2006, I decided to check out the possibilities on the web. I started off with creating my first illustration blog. Within one month, someone e-mailed me to tell me my blog was featured on the Drawn! website. It was then I realized the potential of the web. I spent my whole career disconnected from my peers, isolated in my little studio, wondering how to connect to the people that would hire me and, even more important to me, the people who do what I do. I'm all about community. I have my blog and participate with other artists on theirs, as well as posting news about myself on awesome blogs like www.littlechimpsociety.com, Illustration Mundo, www.sugarfrostedgoodness.com."

Kimberly Schwede

"It's been a *huge* help! I can e-mail my online portfolio to people all over the world and do research on all kinds of target clients. There is no way I could have made a living if I only worked within the San Francisco Bay Area dragging my portfolio around to potential clients."

Lori Joy Smith

"I have always found the online community very inspiring and rewarding. Even more so now that I have moved. In Vancouver pretty much all of my

friends were related to my career. It was great for bouncing ideas off of [each other] and inspiration and support. Now here in PEI, I don't have that kind of support (yet I am hopeful!) and rely on the online community. It is great to upload something I have been working on and to see what people have to say about it."

Penelope Dullaghan

"This is such a cool question for me. I feel like if I put myself out there and tell my truth, even if it's just a glimpse into my whole life, I get lots of feedback from people who are going through the same things or have been through it before and can offer some perspective. That's such a wonderful thing and definitely inspires and motivates me to keep sharing.

"I also have an online critique support group that I lean on for advice and help with my work. And Illustration Friday is a huge source of inspiration. I mean ... I post a new topic each Friday and look at all the interpretations that pop up! It's very inspiring to think that there's never just one or two solutions to a problem or topic, but hundreds and hundreds. So seeing all that awesome artwork online is a good reminder of that."

Von R. Glitschka

"The Internet is great for viral marketing. The key, however, isn't merely posting to post or linking to link, it's rather about sharing informative, entertaining and valuable content online. So everything I tend to post I try to make enjoyable for the reader or viewer. I want them to get something from it, learn something they might not already know, and when you can do that consistently, networking is a natural by-product.

"I used to look at blogs and brush them off, but I decided to try it out, and over the past three years it's proven to be a very valuable part of my marketing and personal branding."

PROTECT YOURSELF ONLINE

Mimi Bobeck: "I cracked Mr. Wick's secret password. It's *Mr. Wick.*"

Drew Carey: "He might as well just use the word *password.*"

—*THE DREW CAREY SHOW*

If you have a web presence online, you most likely have many, if not bucketsful, of passwords and ID names. Be crafty with your identity online and remember to mix your numbers and letters. Believe it or not, but two of the most common passwords are *123* or *123456*. *Letmein* is popular, and then there's *qwerty*, which are the first six keys on the left side of your keyboard. Even more obvious than *123* is *password*. The funniest very common password has to be *trustno1*, which is from *The X-Files*.

"Treat your password like your toothbrush. Don't let anybody else use it, and get a new one every six months."

—CLIFFORD STOLL

Use that big, creative brain and come up with something a little less obvious than some of those above-mentioned gems. It's a good idea to keep your ID names and passwords somewhere safe where you can access them when your mind goes blank. Another good rule of thumb is to change your passwords often. Make sure the sites you pick are trustworthy to begin with. Lastly, think before you post. Whatever you post can end up on someone's site, and it can be easily spread around. Controversial photos, negative comments or that borderline-compromising text just doesn't say "professional." Be on top of what you put online.

NETWORKING AROUND THE CORNER

"Real learning comes about when the competitive spirit has ceased."

—JIDDO KRISHNAMURTI

As convenient as it is to mingle online, don't forget to think locally. You might be surprised how many like-minded creatives—and illustra-

tors—live near you. I found that out when I moved back to Nova Scotia. There were a few illustrators I'd heard of, or some I'd mingled with online, that I was surprised to find out lived near me. Illustrators such as Eric Orchard, Diane Lucas, Kathy Kaulbach, Ray Fenwick, and Kate O'Connor—to name a few—all very talented, inspirational and unique in their own right.

Why is it important to find out what illustrators are up to in your town? It's another way to support your trade. It can also create face-to-face networking so you can escape the studio and talk to a real person. Better yet, start a local chat group that meets monthly—it's a great excuse to leave your creative space and do something different. The nice benefit from this is an inspired meeting that will have you working at your desk better than ever.

Often we don't derive our incomes from where we live. Many of us take work from all over the globe. We become so tied to the computer we miss what's taking place right under our noses. It's easy to lose touch of the convenient creative community, which can always use another mind to throw new ideas and personality into the mix.

Hop on some local social networks, find out who's doing what and join in. The nice thing about talking is that it's free. Free does not make it easy, but the more you talk, the easier it gets. That common ground will happen, and you could even enjoy yourself!

ON CREATIVE COMMON GROUND

"A good question is never answered. It is not a bolt to be tightened into place but a seed to be planted and to bear more seed toward the hope of greening the landscape of idea."
—JOHN CIARDI

As we get older, we lose trust in ourselves and become hesitant to ask questions. We feel we should know all this stuff already. We fall into a habit of thinking we're asking dumb questions, so we censor ourselves

and ultimately end up avoiding the very things that we want to know. Later we feel bad for not taking a chance. What you do not ask can very well hurt you and your business.

> "Lean into the sharp points and fully experience them. The essence of bravery is being without self-deception. Wisdom is inherent in (understanding) emotions."
> —PEMA CHÖDRÖN

If you think about it, asking requires courage, so try to look at questions as good risks. We don't know the answer, but at the same time, we need help. Asking questions can be a humbling exercise because it says you're okay with not knowing everything but are interested in what someone else knows. This experience and knowledge are priceless.

Hang out in the spaces you're uncertain about. This is when the best ideas happen. Believe it or not, the hardest questions are the ones we ask ourselves—these are the questions that typically go into that "later" pile or end up not being answered at all.

You're taking a proactive role in your own education. The interesting thing about queries is the more you ask, the better listener you become. Asking questions can also lead to more patience and tolerance. Are there any bad questions? Maybe. Often "bad questions" are only the result of bad timing. Sometimes too many questions all at once can come off as overwhelming for the receiver. Aggressive questions may make the listener feel they're being put on the spot to "fix" whatever's wrong. Coming off as too needy and too demanding isn't the goal here. Keep it casual. Keep it light.

Have you ever stopped and thought about the importance of asking questions? What does it say about you when you ask questions? It says:

1. You're a self-motivator.
2. You're superinterested in just about anything and everything.
3. You're opening yourself up to thought.
4. You're letting go of fear and uncertainty.

5. You're ready for a productive dialogue.

6. You want to discover and uncover something.

If you want to delve deeper, seek out a mentor. Mentors are worth their weight in gold and will allow you to foster a knowledge-based relationship—like looking at a problem through someone else's eyes. But the best thing about a mentor is it is a win-win situation because both parties benefit. There's plenty of advice for the taking. This industry has a really nice camaraderie to it, so take advantage of that opportunity. Where can one find a mentor? The best place is online. Seek out illustrators who "speak" to you visually. Do they have a blog? Do they discuss the business at all? Are they doing something you want to accomplish? Start there.

Holli Conger created a blog called www.livingthecreativedream.com, which is a very helpful website. I asked if she enjoys mentoring and helping aspiring illustrators and if she, herself, has ever had a mentor. "I really love helping people get to where they need to be in their career. I am all for the freedom of working for yourself. I've never had a mentor of my own or anyone that really helped me start my career. If I had, I wonder how much more I would know!"

Mentoring is very informal and pretty much self-directed. It's a flexible type of problem solving, changes your perspective and challenges what you know and what you thought you knew.

I asked Andi Butler in what ways she supports the industry—by mentoring, supporting peers or by participating in associations? Here's her insightful response:

"I do advise, when asked, but I also ask for advice. I think illustration is such a wonderful career because there are no tangible, set ways to do everything. Every assignment, situation, artist and client creates a different outcome every time ... and to benefit from those experiences, from those having gone through them, is worth so much! Illustration is all about problem solving, and I don't think there's ever only one way to solve a problem. I think we all help each other by sharing all

this knowledge with one another. I think illustrator groups are a great way to do that, either themed participant submissions like [Illustration Friday] online, or three or four illustrators meeting for coffee once a month at their local [shop], sharing ideas and experiences. I don't know what I'd do without all the people I've met online; between them and my friends off-line, I've learned a great deal! I was a member of the Graphic Artists Guild, but I think I will join the AIGA. I also am a member of the [Society of Children's Book Writers & Illustrators], and again, people sharing their knowledge—it's better than a textbook!"

I asked Claudine Hellmuth what advice she would give aspiring illustrators. Here's what she had to say:

"What I have learned in my short career as an illustrator is that you have to be persistent; keep sending out those postcard mailers—you never know where the next job will come [from]! For me, my illustration jobs always seem to come when I least expect them, totally out of the blue! Which is frustrating and exciting at the same time. I still have not figured out how to get a regular flow of illustration work from illustration alone."

John Martz responded to my question about advice this way:

"I'd give the same advice that I hear from most other successful creators, and that's to be true to yourself. Experiment, keep a sketchbook and constantly push yourself to develop your own personal voice and style—you'll create your best and your most honest and your most enjoyable work.

"With critiques, I think it is important to be honest, but I like to keep critiques positive and objective by focusing on strengths and offering constructive suggestions on how to improve any weaknesses. No one improves by having someone make them feel bad about themselves or their work."

Send out a friendly introduction letter to a possible mentor describing why you sought them out. Ask them if you can ask for advice. Nine times out of ten, they'll welcome you with an open mind. Once you ask them for advice, always, always thank them for their time. Follow up with any progress you make; they'll be happy to hear it.

I really love questions. Questions say "interested." I like asking questions, receiving questions and asking myself questions as well. Often my best questions come to me from those really good, quiet times. They open up the mind. I love when others ask me questions because it changes my thoughts and focus. It says they trust me and trust my opinions, and they feel comfortable putting themselves out there to receive an answer they might never have imagined. It makes me wrap my head around something different. I get to feel something else for a change. I get to tap into new ideas. I also learn as much as they do—that's what I like the most.

YOU ARE AN EXPERT ON SOMETHING

"An expert is one who knows more and more about less and less."
—NICHOLAS MURRAY BUTLER

We are all experts on something. I have often heard recent grads say they really cannot offer too much to their field. I disagree. We bring life experience along for the ride whenever we do something new. Often my response to this is, "Are you good at being a student? Are you experienced at beginning your illustration career? Are you good at the techniques you use to create your work? Are you good at coming up with ideas?" The answers are always yes.

I asked David Sones if he sees himself as an expert. "I would only consider myself an

Illustration by David Sones

expert at being myself. There isn't one correct way to become an illustrator. Everyone is inspired in a unique way and develops a different process for creating their work, but I am always happy to give friendly advice when asked. There are an overwhelming number of decisions to make starting out as an illustrator, and I am happy to share my experiences if they can help others make their own decisions."

What are illustration experts? Well, they can be reliable sources of information, techniques and skills. Experts are big sponges of information and experience. They have skills, knowledge and often a special focus that makes them stand out.

HOW YOU CAN BE SEEN AS AN EXPERT

1. Be confident.
2. Be outgoing.
3. Have a huge inner creative drive to be in this field.
4. Don't be afraid of self-improvement and reinvention.
5. Don't be afraid to get your hands dirty.
6. Research the industry and be interested in making it better.
7. Make many, many, many mistakes and learn from them!

"As long as the world is turning and spinning, we're gonna be dizzy and we're gonna make mistakes."
—MEL BROOKS

Mistakes are the things that count. Why? Because it says you tried. You learned, and it didn't kill you. On the upside, it builds creative character. You lived and pushed ahead and can now talk about it. Mistakes are humbling and create a nice relationship with patience and simplicity. This opens you to creative solutions. Too many times we see experts who know it all and don't need to explore the boundaries anymore. Becoming a real

expert goes beyond knowledge and means being open and allowing others in to gain your knowledge and experience. You can help, and you can gain much from those around you. Experts never leave empty-handed. They, too, gain information from those who tap into their brains. Most importantly, experts are still curious and want to play with the ideas they love.

"Never become so much of an expert that you stop gaining expertise. View life as a continuous learning experience."

—DENIS WAITLEY

CREATIVE ADVICE

"Something that has always puzzled me all my life is why, when I am in special need of help, the good deed is usually done by somebody on whom I have no claim."

—WILLIAM FEATHER

In art school we used to call creative advice and observation "critique." We sat in the class and discussed our latest assignments. Some critiques would go well, and some went very badly. I even had an instructor who would place the piece in question into the garbage can if he felt it was complete rubbish. It was a shocking act that was never well received. It didn't serve any purpose outside of inflating his ego, and it was hard to witness someone else's work being thrown away, let alone to watch your own work after you pulled an all-nighter to complete it.

There are good ways to offer advice and observations and wrong ways that can only alienate you quite quickly if you don't watch your words. The idea is not to mix your words. Be straightforward and positive. Try to remember that this is someone's illustration. They spent a lot of time planning and making it. There's always something good about a piece. You may not love the theme, but you can try to appreciate why they created it.

I asked Claudine Hellmuth if she's ever mentored or given advice to an aspiring illustrator before and if she's ever been mentored. "I usu-

ally get lots of e-mails from various people starting out as artists and illustrators, and I answer those and try to help where I can. Since I am still growing and figuring out my illustration business myself, we can all learn from each other, and I always appreciate advice, and I like to be helpful, too!"

Ask a lot of questions. Ask what they used to illustrate the project. How long did it take? What market is it for? What do they intend to use it for? All this can change your opinion of the project. Draw the illustrator out to gain what inspired them. Often this can be a great way to get to know them and to gain inspiration from the discussion as well.

When you're critiquing someone's work, always watch your *buts*.The problem about the word *but* is that it can divide a thought and create a reaction not initially intended. *But* joins two thoughts together that could cause much confusion to the listener. This happens if you're describing how you feel about a certain illustration. *But* can often cancel out a previous statement. For example, "I really like this illustration, but the orange is really distracting." What part of what you said do you think the listener is now focused on? The first part of that sentence doesn't matter anymore; it's long gone, and now you might have a lot of explaining to do.

A further word of advice when giving a critique: Choose your words carefully. We connect ourselves to our work. It's unavoidable. Treat the person you're critiquing with respect—it's what we all want when it comes to our careers and ideas. Be supportive, and your illustration friends will support you back.

THE BEST ADVICE I EVER GOT WAS ...

"Advice is like snow; the softer it falls, the longer it dwells upon, and the deeper it sinks into the mind."
—SAMUEL TAYLOR COLERIDGE

The best advice I ever got were two statements.

1. "There isn't a box." When I began art school, it became evident that narrow-minded thinking wasn't going to get me very far. When I heard the "work outside the box" declaration, it got me thinking: Who'd decided we needed a box in the first place? Recycle it!

2. "Leave your inhibitions at the curb," I was once told that creativity and illustration have no place for inhibitions. Things that restrain, block or suppress your natural desire to be inventive and free in this field will only serve to hold you back. Fear, doubt and lack of confidence need to be kicked to the curb. Embrace mistakes, boneheaded moments and freedom to just do what you need to do. Believe that experimentation is a huge component to being an illustrator.

GOOD CREATIVE ADVICE

"If you have a talent, use it in every which way possible. Don't hoard it. Don't dole it out like a miser. Spend it lavishly, like a millionaire intent on going broke."

—BRENDA FRANCIS

My Advice

Feel what you need to creatively feel. Want what you need to creatively have. Let yourself get those creative things you need to be successful. Do what you know comes naturally to you. Don't deny yourself the career you know you can have. Never let money, inexperience or mistakes stop you. Lastly, do the things others don't. See an opportunity and fill that need.

Illustration by Holly DeWolf

Andi Butler

"Be willing to ruin your work! You have to push it as far as you can. If you have to start over, you have to start over. And you're thinking, what? Someone I used to work with told me this, and I think it's helped me tremendously. I think when we stay too safe, we get stale—pushing things and mixing them up a bit, being a little uncomfortable, is a really good thing."

Roz Fulcher

"Leave your ego at the door. My mentor, the late Elaine Garvin, taught me this early on in my career, and it has never left me: When dealing with clients, you are trying to re-create their vision. Finding a happy balance between what they want and who you are is a challenge, and sometimes you won't see eye to eye. Revisions are not personal. Also, when you are working hard to build your portfolio, receiving insights from fellow illustrators or art directors is invaluable. Give it time to sink in and see if it resonates with you before you let the ego blow it off."

Jannie Ho

"The choice to freelance is not irreversible. I used to dream about a freelancing life, but I was scared. I always thought of it as an all-or-nothing situation. Then I realized I could go back to a full-time job if necessary. That gave me the courage to finally take the plunge and quit my day job. It is one of the best decisions I've ever made. I'm still a freelancer working from home. The best kind of job in the world!"

Kimberly Schwede

Kimberly Schwede's advice is actually advice from Buddah who once said: "The secret of health for both mind and body is not to mourn for the past, worry about the future or anticipate troubles, but to live in the present moment wisely and earnestly."

Susan Mitchell

"It might sound clichéd, but [my advice] is never to give up. I often felt discouraged over the years, compared myself to other artists and felt like I

wasn't good enough. But I kept on painting, and then jobs started to come along that helped me develop my style and build my confidence."

David Sones

"The best advice I ever got was to draw every day. I think that is the one piece of advice that can be truly useful to every illustrator."

THE BRIGHT SIDE OF THE BUSINESS

"Design adds value faster than it adds cost."
—JOEL SPOLSKY

Despite changes to our economy, illustrators will always be in big demand. Imagery will always be seen as important; we're hardwired for it. Illustration is a necessary constant as long as we have eyes and big imaginations. Pictures are a fundamental, creative need. We will always need to express ourselves visually, and there will always be an audience wanting to look at it to experience it fully.

Unfavorable and unflattering industry problems always seem to get people talking about many things, not just illustration. Can pointing out constant faults about this industry be the best way to create change? I think there's a need for balance. Yes, we have to point out issues. On the other hand, we need to focs on all of the innovative and creative things going on in our field.

What are some of the issues? Lack of jobs is a big one I read about daily. Lower-paying jobs are another. Illustration trends that get stale and promote work that looks the same happen a lot. Speculative work is still being practiced, unfortunately. Another issue is the lack of business understanding.

Recognizing these issues is the first step. I'm convinced that with a lot of business thinking integrated into this career, this industry can adjust some of these issues. It will never be perfect, but the good news is we have two sides of our brains. We might as well use them!

> "My optimism wears heavy boots and is loud!"
> —HENRY ROLLINS

There are many great positives going on in illustration. This is what I see:

- A huge creative community
- The chance to create your own opportunities
- More markets and unconventional markets
- Endless marketing and networking opportunities
- Endless educational opportunities
- Open dialogue and illustrators speaking up
- Endless styles of work
- Various ways to promote yourself and your work

Illustrators think differently. That's why we need to approach business from a different angle—the conventional business angle won't work for us. Business for us can be enjoyable if interjected with some much-needed creativity. A simple yet creative approach may be all we need to get the business side of us going.

No one ever said there were rules to being an illustrator. That's a good thing. We get to be creative while breaking the law, so to speak—how fun is that? We break business and marketing rules. We alter the expected and push perception and imagination in another direction. We even alter the rules to tooting our own horns. Who said your business card has to be that typical conventional size? You don't even need to use paper if you don't want to! You can reinvent yourself and focus on more than one market or style. There's nothing wrong with tackling children's illustration and dabbling in steampunk if you want to. If it's important to you, do it.

Have you ever asked yourself how much you really need to be an illustrator? Can you make it on a tight budget without an agent—or a website, for that matter? To me, anything is possible if you want it badly enough. No office and no technical help, combined with very little money, are just

another set of problems to be solved as an illustrator. Start with talking. You've heard that talk can be cheap. Well, it literally can be. Connect by phone or query letters. Are you putting your efforts and time into the right things? Don't forget to connect and focus on what's really important to you. Too many things going on at once can be a distraction. Never lose sight of the real reason you're doing what you're doing. Fancy gadgets are nice but only if you really need them and can afford them. Work your images and your networking skills so you'll get what you need. Remember, this career isn't about gimmicks or tricks or who has the most toys, it's about talent, business know-how, promotion and that inner creative drive. There isn't a software program or one set of rules that will give this career to you. What you feel and create is the real deal. Focus on that, and the rest will follow.

"I've become a real believer in not defining every single thing. Seems like every time you think you've figured out what something is, it just becomes something else."
—FELICITY

WHAT DO WE WANT FOR THE FUTURE OF ILLUSTRATION?

"The future belongs to those who believe in the beauty of their dreams."
—ELEANOR ROOSEVELT

Penelope Dullaghan

"I like how it is now. I feel like it's pretty noncompetitive, and everyone's just doing their own thing, making art and enjoying the freedom that comes with choosing this field. It's hard work, but I like that people are expressing themselves through their artwork where they can and just letting the rest go. Or maybe that's just my perspective. There's probably an ugly illustration world out there, and if that's so, I'd rather not know about it. Oh, it'd be nice if editorial paid a little more. That's all."

Lori Joy Smith

"I think the illustration world is so exciting right now. It is a great time to be in this field. I would just hope it would continue growing and attracting such talented people who are willing to try new things."

Kimberly Schwede

"I think it's heading in a great direction. There are always new creative souls entering the industry, which gives everyone new inspiration. I definitely would not like illustration to go completely digital. I still find such beauty in hand-drawn, naive artwork."

Illustration by Kimberly Schwede

Susan Mitchell

"I would like to see illustration become increasingly appreciated as art rather than a commercial endeavor. There are truly stunning works of art created by illustrators; however, they don't always receive the kind of attention and respect that gallery artists often enjoy. This seems to be changing, however. I would also love to continue to see more illustration move in more exciting directions, combining both new media and traditional techniques, and breaking new ground."

Andi Butler

"Sometimes I think I would like to see some kind of standardization with some practices (rights granted, payment terms, etc.) from clients. But that's usually when I'm having a bad day! I know it's impossible—just the number of client/illustrator combinations would create too many variables! I would like to see more illustrators hold on to their rights. I've worked for print studios and companies that buy all rights or have work-for-hire contracts. But if we all just bit the bullet a few times and turned

down those jobs, I would hope WFH contracts would become obsolete! It is hard to tell an illustrator that when they might be living paycheck to paycheck in the beginning."

Claudine Hellmuth

"I would like to see more companies using illustrators again. With all the stock imagery out there on the Internet, there has been a huge decline in the number of companies that see the value of custom illustration work. All my friends who are also illustrators all say the same thing. Work is declining, which is sad."

David Sones

"I see a lot of illustrators finding ways to reinterpret traditional illustration styles and techniques in digital illustration. In the future I imagine even more illustrators will be working digitally, but I would like to see the traditional techniques continue to be represented in digital illustration."

Illustration by David Sones

Jannie Ho

"It's already happening now—where illustration crosses boundaries and industries beyond publishing, such as fashion, toys—and [it's] even viewed as fine art. I also would like to see more women illustrators being recognized in the field. There are definitely a lot of great women illustrators out there, but I feel like men still dominate the field."

Holli Conger

"[I hope to see] some really great work come out of up-and-coming illustrators. I love seeing new style and mediums."

Von R. Glitschka

"[I want] to see my daughter develop her artistic skills and make her dad look like a hack."

John Martz

"I don't know if there's anything I can wish for for the future of illustration other than to hope that there continues to be a steady, growing market for illustration and cartooning. In the same way that desktop publishing has made the art of sign painting nearly extinct, digital photography, stock houses and CGI are becoming cheaper and more readily available, and those, I think, are illustration's biggest threats. I can only hope that people never lose their appreciation for the creativity and the human touch that illustration brings to the world of imagery."

"Recognizing the need is the primary condition for design."
—CHARLES EAMES

My own hopes for the future of illustration

As for me, I would like to see the use of traditional materials continue to be practiced and promoted by illustrators. The old ways of doing things are still quite important as we enter a huge market of digital imagery. Technology is a great asset to many of us. My hope is that digital and traditional styles can mingle nicely together.

The business side of illustration is a huge asset, and hopefully it will become more of a focus by being discussed more online and in our schools. Institutions that promote this now understand the true need of our future talent so they can become successful. This will be a huge plus.

"Imagination is the true magic carpet ride."
—NORMAN VINCENT PEALE

My true hope is that the illustration community continues to grow stronger and closer. I have enjoyed the support over the years from many supertalented and inspiring illustrators. I owe much gratitude to those who

helped me leave the creative bubble and my shell to enter a very large, visually packed world. We love this industry, and it shows. We join and support each other in a very noncompetitive way that makes me really proud to be part of this dynamic field of image makers, creators and idea generators. I wish you the best creative and successful career as an illustrator. Thank you.

RESOURCES

WEBSITES

http://drawn.ca

http://en.wikiquote.org

http://floggedmagazine.com

http://thelittlechimpsociety.com

http://todaysinspiration.blogspot.com

www.childrensillustrators.com

www.coolquotes.com

www.creativeshake.com

www.creativesource.ca

www.etsy.com

www.hireanillustrator.com

www.howdesign.com/dailyheller

www.ibccsite.com

www.illoz.com

www.illustrationfriday.com

www.illustrationmundo.com

www.theispot.com

www.marketing-mentor.com

www.on-my-desk.blogspot.com

www.quoteland.com

www.quotedb.com

ASSOCIATIONS

Graphic Artists Guild: www.gag.org

Society of Children's Book Writers & Illustrators: www.scbwi.org

Society of Illustrators: www.societyillustrators.org

The Canadian Association of Photographers and Illustrators in Communications: www.capic.org

BOOKS

6 Steps to Free Publicity by Marcia Yudkin

Business and Legal Forms for Illustrators by Tad Crawford

Children's Writer's and Illustrator's Market by Alice Pope

Crumble Crackle Burn: 120 Stunning Textures for Design and Illustration by Von R. Glitschka

Inside the Business of Illustration by Steven Heller and Marshall Arisman

Living Out Loud: Activities to Fuel a Creative Life by Keri Smith

Time Management for the Creative Person by Lee Silber

Wreck This Journal by Keri Smith

ACKNOWLEDGMENTS
KUDOS ALL AROUND

"The essence of all beautiful art, all great art, is gratitude."
—FRIEDRICH NIETZSCHE

Jeff Andrews

Jeff Andrews does it all: a husband, son, grandson, brother, uncle, nephew, cousin, mentor, friend and finally, graphic designer, illustrator and amateur photographer.

www.jeffandrewsdesign.com
www.sugarfrostedgoodness.com
www.diinterviews.com
http://myblogadventures.blogspot.com
jeff@jeffandrewsdesign.com

Von R. Glitschka

Von Glitschka has worked in the communication arts industry for more than twenty years. He now refers to himself as an "illustrative designer." In 2002, he started Glitschka Studios, a multidisciplinary creative firm. He has worked as a hired gun for both in-house art departments and medium to large creative agencies working on projects for such clients as Microsoft, Adobe, Pepsi, Rock and Roll Hall of Fame and Museum, Major League Baseball, Hasbro, Bandai, John Wayne Cancer Foundation, Allstate, Disney, Lifetime and HGTV.

He's authored *Crumble Crackle Burn*, a book on textures, and *Drip Dot Swirl*, a book on illustrative patterns. Glitschka also teaches advanced digital illustration at Chemeketa College and operates the website

www.illustrationclass.com, where visitors can download free tutorials documenting his illustrative design creative process on a variety of diverse project types.

www.glitschka.com
www.illustrationclass.com
www.artbackwash.com
von@glitschka.com

Holli Conger

Holli Conger is a multitalented illustrator with a bucketful of sites to check out.

http://hollicongerstudios.com
http://holliconger.com
www.junkadoodles.com
www.typographyphotography.com
www.thegigglingpickle.com
www.linkbacklove.org
www.agirlwhocreates.com
www.creativewarmup.com
www.thetypejunkie.com
www.livingthecreativedream.com
www.woogiewednesday.com
www.bigandlittleart.com
www.illustrationforkids.com
studio@holliconger.com

Jannie Ho

Born in Hong Kong and raised in Philadelphia, Jannie Ho studied illustration at Parsons The New School of Design in New York. She worked as a graphic designer at Nickelodeon and Scholastic and as an associate art director at *TIME Magazine for Kids* before deciding illustration was her true calling. Also known as Chickengirl, Jannie now creates digital

illustrations for children's books, magazines and a variety of other clients. Much of her work and style has been inspired by Japanese and retro art. Her books include *The Haunted Ghoul Bus* (Sterling, 2008), written by Lisa Trumbauer; *The Mixed-Up Alphabet* (Scholastic, 2007), written by Steve Metzger; and *The Penguins' Perfect Picnic* (Innovative Kids, 2007), written by Tish Rabe. Jannie currently works and plays in New York.

www.chickengirldesign.com
jannie@chickengirldesign.com

Andi Butler

Andi Butler is a children's illustrator based in Illinois. She's been getting paid to draw since 1991, jumping between staff positions and freelancing. Andi got her start in apparel, but since has had many opportunities illustrating educational books, magazines, character development, toys and social expressions. She still creates textiles—quite a few, actually—and also tee graphics, appliqués and embroideries in the children's wear market. She has been a member of the Society of Children's Book Writers & Illustrators for nearly twelve years. Most importantly, she's a wife and a mom of two—they're both her little teachers!

www.mrsbillustrations.com
www.blog.mrsbillustrations.com
andi@mrsbillustrations.com

Jim Bradshaw

Jim Bradshaw loves creativity. Everything about it. Jim is filled with wonder and inspired by almost everything around him. He works full time as an art director at a corporation in south Jersey, but his heart is for art and illustration. He loves using his spare time to draw, paint, illustrate and anything that will feed his creativity. He has been freelancing for years, mostly in magazines, and has illustrated two children's books and done some television, as well as other markets. He recently entered the gallery scene and is also messing with toys, sculpture and woodwork.

www.jbradshaw.net
www.jimbradshawillustration.blogspot.com
spaceheadjim@yahoo.com

Kathy Weller

Kathy Weller creates whimsical art, paper and product art, and pet portraits. She is represented by Tugeau 2, Inc. (www.tugeau2.com).

www.kathyweller.com
www.wellerwishes.blogspot.com
www.kathyweller.blogspot.com
kathyweller@mac.com

Claudine Hellmuth

Hip art for playful hearts! Claudine Hellmuth creates custom artwork using your photos.

www.collageartist.com/commissions.htm
www.collageartist.com
www.claudinehellmuth.blogspot.com

Roz Fulcher

Roz is a freelance illustrator for the children's publishing market and has been working professionally for eight years. She creates with felt, fabric and embellishments. She has added a new technique to her repertoire: "digital felt" style, which is created directly on the computer using scanned felt and materials. She is represented by Janet DeCarlo.

www.rozfulcher.com
www.rozzieland.blogs.com
rozf@charter.net

Kimberly Schwede

Kimberly Schwede is an established graphic designer and illustrator based in San Francisco who specializes in women and kids' design. Her

inspirations come from her love of travel, color, fashion, children and animals. If one can smile with delight at her work, she feels it's a job well done. Projects include custom illustrations, logos, greeting cards, packaging, brochures and web design. Clients include Swatch, American Girl, Klutz, Tiny Prints, Janie and Jack, City of South San Francisco and Running Press.

www.kimberlyschwede.com
kim@kimberlyschwede.com

John Martz

John is a cartoonist and illustrator living in Toronto, Ontario. He gets paid to draw funny pictures and goof off on the Internet. John is also currently the chair of the Canadian chapter of the National Cartoonists Society and the editor of the very popular illustration blog Drawn!

www.johnmartz.com
www.robotjohnny.com
www.drawn.ca
john@johnmartz.com

Penelope Dullaghan

Penelope is a supertalent and the creative brains behind the much frequented site called Illustration Friday. She is represented by Scott Hull Associates.

www.penelopeillustration.com
www.penelopeillustration.com/blog
www.illustrationfriday.com
penny@penelopeillustration.com

David Sones

David is a digital illustrator from Ontario, Canada. He describes his work this way: "[My] illustrations are bright, silly and definitely fun. They're the closest thing you can get to a barrel of monkeys, and you don't need any bananas!"

www.davidsones.com

www.gopickledoggo.com/blog

wwww.scribbleguild.com

www.davidsones.creativesource.ca

studio@davidsones.com

Susan Mitchell

Susan is a freelance children's book illustrator. She also likes to make things out of fabric and bits and pieces, just for the fun of it. She currently resides in Montréal, Quebec. Susan is represented in the U.S. by Shannon Associates.

www.susan-mitchell.com

www.itsawhimsicallife.blogspot.com

Irisz Agocs

Irisz is an illustrator living in Budapest, Hungary. Her work is created in watercolor. She says, "I like to paint more than anything else." She and her husband have a small graphic studio where they make online and off-line graphic design at www.artistamuvek.hu.

http://artistamuvek.blogspot.com

irisz@artistamuvek.hu

Paul Chenard

Paul Chenard says, "I have always had a passion for the history of motor racing and the cars and people that made it happen. I create art on racing history as I see it."

www.automobiliart.com

www.automobiliart.blogspot.com

paul.chenard@automobileart.com

AND A BIG THANKS GOES TO ...

Darren Di Lieto

www.apefluff.com

www.hireanillustrator.com

www.mailmeart.com/going-postal

Anna Goodson Management

www.agoodson.com

info@agoodson.com

Nate Williams

www.n8w.com

www.illustrationmundo.com

Lee Silber

www.creativelee.com

Keri Smith

www.kerismith.com

Tony Dusko

www.notebookbabies.com

Jeff Fisher

www.jfisherlogomotives.com

Steven Heller

www.hellerbooks.com

http://blog.printmag.com/dailyheller

PERMISSIONS

INDEX